MW01194723

C. S. Lewis and the Christian Worldview

C. S. Lewis and
the Christian Worldview

MICHAEL L. PETERSON

OXFORD

UNIVERSITY PRESS

OXFORD
UNIVERSITY PRESS

Oxford University Press is a department of the University of Oxford. It furthers
the University's objective of excellence in research, scholarship, and education
by publishing worldwide. Oxford is a registered trade mark of Oxford University
Press in the UK and certain other countries.

Published in the United States of America by Oxford University Press
198 Madison Avenue, New York, NY 10016, United States of America.

Library of Congress Cataloging-in-Publication Data
Names: Peterson, Michael L., 1950– author.
Title: C. S. Lewis and the Christian worldview / Michael L. Peterson.
Description: New York, NY : Oxford University Press, 2020. |
Includes bibliographical references and index.
Identifiers: LCCN 2019034321 (print) | LCCN 2019034322 (ebook) |
ISBN 9780190201111 (hardback) | ISBN 9780190201128 (updf) |
ISBN 9780190201135 (epub) | ISBN 9780190065409 (online)
Subjects: LCSH: Lewis, C. S. (Clive Staples), 1898–1963. |
Christian philosophy. | Christianity—Philosophy.
Classification: LCC BX4827.L44 P48 2020 (print) |
LCC BX4827.L44 (ebook) | DDC 230.092—dc23
LC record available at https://lccn.loc.gov/2019034321
LC ebook record available at https://lccn.loc.gov/2019034322

For Rebecca,

*My wife, my partner, my lover, my pastor, my closest friend, and the best person
I have ever known . . .*

A city that is set on a hill cannot be hidden.

Neither do we light a candle, and put it under a basket,

But on a candlestick;

And it gives light to all that are in the house.

Matthew 5:14–15

Contents

Preface

In writing this book on the Christian philosophy of C. S. Lewis, I have accumulated many debts of gratitude to many persons for their different contributions to the final product. My friend Devin Brown, professor of English and well-known Lewis scholar, advised on several points regarding Lewis's literature and biography. Mara Eller gave me invaluable suggestions for improving the style and organization of the book. Chris Holland, my research assistant, worked tirelessly on many aspects of the book, from checking the accuracy of citations to proofreading the chapters and offering helpful commentary. Lin Maria Riotto created the book's very thorough index.

Many thanks are also due to my editor, Cynthia Read, for her vision for the book and direction during the writing process, and to her assistant Drew Anderla, who worked patiently with me on the many mundane matters of book preparation.

My special gratitude is hereby given to the Archives of Ashland University for allowing me to reproduce in Appendix B recently discovered correspondence between C. S. Lewis and Thomas Van Osdall, an American scientist at Ashland University, which has never before been published. The correspondence, which occurred during the last year of Lewis's life, reveals his mind and heart on several topics treated in this book. I was honored to have been asked to speak on the importance of the correspondence at the unveiling ceremony on May 7, 2015.

Since writing a book is also a family affair that requires balancing time commitments, I must thank my family for their patience and support, particularly my wonderful wife to whom I dedicate this book.

Abbreviations of Lewis's Works

AMR *All My Road Before Me: The Diary of C. S. Lewis, 1922–1927.* Edited by Walter Hooper. Reprint, San Diego: Hartcourt Brace Jovanovich, 1991.

AOM *Abolition of Man.* 1944. Reprint, New York: HarperCollins e-books, 2009. Kindle.

AT "Williams and the Arthuriad." 1948. In *Arthurian Torso.* Edited by C. S. Lewis, 91–200. London: Oxford University Press.

CLI *The Collected Letters of C. S. Lewis, Volume I: Family Letters 1905–1931.* Edited by Walter Hooper. San Francisco: HarperSanFrancisco, 2004.

CLII *The Collected Letters of C. S. Lewis, Volume II: Books, Broadcasts, and the War 1931–1949.* Edited by Walter Hooper. San Francisco: HarperSanFrancisco, 2004.

CLIII *The Collected Letters of C. S. Lewis, Volume III: Narnia, Cambridge, and Joy 1950–1963.* Edited by Walter Hooper. San Francisco: HarperSanFrancisco, 2007.

CR *Christian Reflections.* 1967. Reprint, New York: HarperCollins e-books, 2014. Kindle.

DI *The Discarded Image: An Introduction to Medieval and Renaissance Literature.* Cambridge: Cambridge University Press, 1964.

EL *English Literature in the Sixteenth Century, Excluding Drama.* Oxford: Clarendon Press, 1954.

FL *The Four Loves.* 1960. Reprint, New York: Mariner Books, 2012. Kindle.

GD *The Great Divorce.* 1946. Reprint, New York: HarperCollins e-books, 2009. Kindle.

GID *God in the Dock.* Edited by Walter Hooper. 1970. Reprint, New York: HarperCollins e-books, 2014. Kindle.

GMA *George MacDonald: An Anthology.* 1946. Reprint, San Francisco: HarperSanFrancisco, 2001.

GO Clerk, N. W. [pseud]. *A Grief Observed.* 1961. Reprint, New York: HarperCollins e-books, 2009.

IOTI Introduction to *St. Athanasius on the Incarnation: The Treatise De Incarnatione Verbi Dei.* Translated and edited by A Religious of C. S. M. V. 1944. Reprint, Crestwood, NY: St. Vladimir's Orthodox Theological Seminary.

LB *The Last Battle.* New York: Macmillan, 1956.

LDGC *Letters: C. S. Lewis/Don Giovanni Calabria.* Translated by Martin Moynihan. Ann Arbor: Servant Books, 1988.

LTM *Letters to Malcomb: Chiefly on Prayer.* 1964. Reprint, New York: Mariner Books, 2012. Kindle.

LWW *The Lion, the Witch and the Wardrobe.* 1950. Reprint,
 New York: Macmillan, 1957.
LYC Introduction to *Letters to Young Churches: A Translation of the New Testament
 Epistles,* by J. B. Phillips, vi–ix. 1947. Reprint, New York: Macmillan, 1957.
M *Miracles.* 1947. Revised 1960. Reprint, New York: HarperCollins e-books,
 2009. Kindle.
MC *Mere Christianity.* 1952. Reprint, New York: HarperCollins e-books, 2009.
 Kindle.
MN *The Magician's Nephew.* New York: Macmillan, 1955.
OS *On Stories: And Other Essays on Literature.* 1966. Reprint, San Diego: Harvest
 Book, 1982.
PCE *Present Concerns: Essays by C. S. Lewis.* Edited by Walter Hooper. 1986.
 Reprint, San Diego: Harcourt Brace Jovanovich, 1987.
PER *Perelandra.* 1944. Reprint, New York: Macmillan, 1965.
PH Tillyard, E. M. W. and C. S. Lewis. *The Personal Heresy.* 1939. Reprint,
 New York: HarperCollins e-books, 2017. Kindle.
PP *The Problem of Pain.* 1940. Reprint, New York: HarperCollins e-books, 2009.
 Kindle.
PPL *A Preface to Paradise Lost.* London: Oxford University Press, 1942.
PR *The Pilgrim's Regress.* 1933. Reprint, New York: HarperCollins e-books, 2014.
 Kindle.
ROP *Reflections on the Psalms.* 1958. Reprint, New York: Mariner Books, 2012.
 Kindle.
SBJ *Surprised by Joy.* 1955. Reprint, New York: Mariner Books, 2012. Kindle.
SC *The Silver Chair.* New York: Macmillan, 1953.
SIL Lewis, C. S. with Alastair Fowler. *Spenser's Images of Life.* 1967. Reprint,
 Cambridge: Cambridge University Press, 2013.
SL *The Screwtape Letters.* 1942. Reprint, New York: HarperCollins e-books, 2009.
 Kindle.
SLE *Selected Literary Essays.* Edited by Walter Hooper. Cambridge: Cambridge
 University Press, 1969.
THS *That Hideous Strength.* 1946. Reprint, New York: Macmillan, 1975.
TWHF *Till We Have Faces.* 1956. Reprint, New York: Mariner Books, 2012. Kindle.
VDT *The Voyage of the Dawn Treader.* New York: Macmillan, 1952.
WG *The Weight of Glory and Other Addresses.* 1949. Revised 1980. Reprint,
 New York: HarperCollins e-books, 2009. Kindle.
WLN *The World's Last Night and Other Essays.* 1960. New York: HarperCollins
 e-books, 2017. Kindle.

Introduction

C. S. Lewis first captured the public eye during World War II when he delivered a series of radio broadcasts from 1941 to 1943, eventually resulting in his book *Mere Christianity*. His fame was further boosted in 1943 when *The Screwtape Letters* appeared, spurring sales of his books to more than one million copies worldwide within four years. In 1947, *Time* magazine called him "one of the most influential spokespersons for Christianity in the English-speaking world."[1] Over fifty years later, in 2000, Lewis was recognized by *Christianity Today* as the most influential Christian author of the twentieth century, and Amazon.com sales figures continue to show that he is one of their best-selling authors. His beloved children's fantasy series *The Chronicles of Narnia* has inspired several Hollywood movie adaptations, the newest iteration of which has grossed over $1.5 billion worldwide so far. Interest in C. S. Lewis is at an all-time high and continues to rise.

While Lewis's writings enjoy widespread popular appeal, they are shaped by serious thought and reflection. Readers have found that in whatever literary genre he wrote—fantasy, fiction, philosophy, theology, autobiography, the novel, poetry, or literary criticism—his depth of scholarship and erudition are evident. Moreover, Lewis always treated Christian ideas with clarity and creativity, showing their relevance to important philosophical problems and fundamental human issues.

After Lewis's death in 1963, professor Chad Walsh correctly stated that during Lewis's writing career he "had an impact on American religious thinking and indeed on the American religious imagination which has been rarely, if ever, equaled by any other modern writer."[2] Yet Walsh also predicted an eventual decline in Lewis readership, with the possible exception of the Narnia tales. As it turns out, however, sales of his books (now in almost fifty languages) have continued to increase dramatically. Year after year a steady stream of new books, biographies, films, conferences, magazines, and articles on Lewis fills shelves and webpages, clearly demonstrating his lasting impact on the Christian tradition and on Western culture generally.

Lewis's continuing influence is crucially dependent on his philosophical approach. Although he brought many assets to his craft—broad erudition, insight into human psychology, lucidity and wit, and creative imagination—his philosophical background was essential to his effectiveness. After taking triple firsts at

C. S. Lewis and the Christian Worldview. Michael L. Peterson, Oxford University Press (2020).
© Oxford University Press.
DOI: 10.1093/oso/9780190201111.001.0001

Oxford in philosophy, English literature, and Greats (Greek and Roman classics), he taught philosophy for a short time and remained deeply engaged with philosophy throughout his life. His background in philosophy provided him with an intellectual grasp of the big issues as well as the reasoning skills to navigate them. Although he frequently issued disclaimers that he was not a "professional" philosopher, almost all of his writings are philosophical at some level. *The Problem of Pain* and *Miracles*, for instance, are explicitly philosophical, while the Narnia stories are implicitly philosophical. Philosopher Victor Reppert has commented that Lewis was a first-rate thinker, whose "outstanding philosophical instincts" shaped everything he wrote.[3]

Classically, a *philosopher* was a person who searched for answers to life's major questions—about the nature of reality, humanity, knowledge, morality, and meaning—and attempted to live with integrity by the truth he found. Clearly Lewis was a philosopher in this vein because, during his long intellectual journey, he adopted a variety of philosophical viewpoints and tried to live by each one— from his early atheism to his eventual Christian faith. As a Christian thinker, he argued that Christianity can be rationally investigated, reasonably believed, and practically lived.

Commentators who recognize Lewis's Christian philosophical approach often characterize it as eclectic, drawing from different influences, particularly Neoplatonism, but we must further note that he never articulated his approach in a systematic, comprehensive way. Although Lewis himself did not methodically detail his worldview—a total consistent set of answers to the big questions that is philosophically competitive with alternative worldviews—the Christian perspective he arrived at can be sympathetically constructed, reasonably presented, and rigorously evaluated.

The present book fills the void by offering a systematic philosophical treatment of Lewis's overall Christian worldview. The few existing good books dealing with Lewis's Christian worldview are organized around certain of its key themes but do not portray its full scope and unity. For example, *C. S. Lewis* by Stewart Goetz focuses on several key philosophical issues that are central to his thought, as does *C. S. Lewis as Philosopher: Truth, Goodness, and Beauty*, edited by David Baggett, Gary Habermas, and Jerry Walls. Adam Barkman's *C. S. Lewis and Philosophy as a Way of Life* is a sizeable and highly technical study of Lewis's "philosophical formation" as well as his thinking on the main areas of philosophy.

The design of this book explicitly communicates the structure of Lewis's Christian worldview as a framework for exploration and analysis of his ideas and arguments. In this context, Lewis's thought is put into interaction with a variety of philosophical perspectives, both classical and contemporary. Although the current treatment tracks the conceptual contours of his thought and probes the relevant issues, it is not an exhaustive treatment and recognizes that further

analysis is always possible. Furthermore, our study includes numerous aspects of Lewis's personal story because his philosophy was closely intertwined with his biography. A number of passages from his fiction and fantasy are also cited for purposes of illustration and analysis.

As we begin, it is important to keep in mind that this book is not just about Lewis's philosophy but also about the Christian worldview as something in its own right, something beyond himself that he discovered and that transformed him intellectually and personally. He spent many years searching for a total understanding of reality on which he could base his life—and he found it in classical orthodox Christianity. It is Lewis's philosophical illumination of Christianity that this book explores.

1

Lewis's Intellectual Framework

Educated in the classical tradition, Lewis believed that every person has a *worldview*—a total interpretation of life and the world that provides a framework for making rational sense of things and charting one's practical direction. Philosopher George Mavrodes compares a worldview to the Rosetta Stone that helped archaeologists decipher Egyptian hieroglyphics. A worldview, he says, is a "conceptual framework" that interprets the meaning of "inscriptions" that are "scattered throughout the world"—and these inscriptions are the important phenomena of life and the universe.[1]

Mind, morality, and longing for the transcendent were "inscriptions" that Lewis sought for several decades to "interpret" philosophically. As he searched, he would adopt what seemed the correct philosophical view for a few years and then abandon it when its inadequacies became clear, moving on to the next view, hoping to find a total explanation of everything that was both intellectually credible and existentially satisfying. At the end of his long search, Lewis embraced Christian faith and the worldview it entails. In this chapter, we identify and discuss several major elements of Lewis's worldview framework.

Worldview Thinking

Philosophically speaking, a *worldview* is a comprehensive and coherent set of beliefs about the deepest matters—the nature of reality, humanity, morality, and meaning. All thinking persons, regardless of any formal acquaintance with philosophy, take such philosophical questions seriously—which means that we are all philosophers on some level. As Christian philosopher William Alston states, "human beings have a deep-seated need to form some general picture of the total universe in which they live."[2]

The term "worldview" is fairly recent in Western intellectual history, but the idea of a worldview is as old as thought itself and is found in every historical religion and philosophy in varying degrees of sophistication. Opinions differ, however, about the rational basis of a worldview. Plato sought a comprehensive view of reality informed by Truth, Goodness, and Beauty. Augustine and Aquinas appropriated Greek wisdom but brought a sacred dimension to their understanding of reality. However, during the Enlightenment, thinkers increasingly

C. S. Lewis and the Christian Worldview. Michael L. Peterson, Oxford University Press (2020).
© Oxford University Press.
DOI: 10.1093/oso/9780190201111.001.0001

dichotomized empirical questions from metaphysical and theological worldview questions and thus characterized the former as objective and the latter as subjective. In our day, postmodernists maintain that different worldviews are reflected in the narratives of different groups but that none of them can claim to represent objective reality—making postmodernism a version of anti-realism.

A resurgence of realism about philosophical worldview thinking has developed in recent decades and offers a positive alternative to anti-realist interpretations of worldviews as socially constructed "paradigms" or "conceptual schemes" that are projected onto the world. With roots in Aristotle and Aquinas, this kind of philosophical realism affirms both the existence of a world independent of our thoughts and the capacity of human thought to access that world. Contemporary philosopher William Alston has made a strong case for a "realist conception of truth" as correspondence between a proposition and the way things are objectively in the world.[3] Alston includes God and theological reality in the domain of the objective.

Lewis's approach to worldview thinking was at once more ancient and more forward looking—affirming the realist view that there is an objective reality beyond our minds and that we have the ability to know various truths about it. Although he was hesitant to claim that he found it, he was clearly seeking the permanently true philosophy—the *philosophia perennis*—which he embraced in Christianity coupled with philosophical realism. Theologian Alister McGrath observes that "the quest for a *philosophia perennis* . . . was unquestionably one of the factors in leading Lewis to rediscover the Christian faith."[4] Displaying this orientation, Lewis wrote, "all that is not eternal is eternally out of date" and took it as the business of the Christian philosophers "to present that which is timeless (the same yesterday, today, and tomorrow)" within his or her cultural context.[5]

Philosophy and Theology

The Christian worldview, for Lewis, combines philosophy and theology, two intellectual disciplines that generate knowledge in their own distinctive ways. Philosophy employs reason, utilizing commonly available information, to examine the most fundamental questions about life and the world. Theology draws from sacred scripture, church teaching, and the historical experience of the believing community to articulate and systematize knowledge about God. Like Thomas Aquinas, Lewis held that the knowledge generated by philosophy and theology is harmonious and can be integrated into a comprehensive worldview. The progress of his own intellectual journey shows that philosophy led him to theology and remained an essential ally of that theology in developing his Christian worldview.

Philosophy brought Lewis to *basic theism*, the belief that an all-powerful, all-knowing, and perfectly good being exists. However, Christian theology provided fuller information about God's nature and purposes—for example, that God is a Trinity and is incarnate in Jesus. As Lewis journeyed from atheistic materialism through various forms of idealism that posited an Absolute Spirit or Supreme Mind, he continued to discover inadequacies in each worldview he embraced. Although steps of his search are detailed in Chapters 2 and 3, it is important to observe here that he was eventually driven by intellectual honesty to a conclusion that he did not want to be true—namely, that God existed and that he must recognize God's authority over his life.

As he searched, it seemed that circumstances were conspiring against him. The books he loved (by Plato, Dante, Milton, and others) had a certain depth, a decidedly religious dimension, whereas the books by secular authors he was supposed to love (such as Voltaire, Mill, and Shaw) struck him as shallow and superficial.[6] Very different visions of the world were coming into sharp contrast for him. For example, G. K. Chesterton's *The Everlasting Man* reframed his thinking by articulating a reasonable Christian outline of history. Reflecting ironically on the factors that converged to convince him of the truth of theism, Lewis wrote, "A young atheist cannot guard his faith too carefully. Dangers lie in wait for him on every side."[7]

Even encounters with friends were nudging him in the direction of acknowledging the reality of God. While he was still trying to deny God, one of his staunchly atheist friends unsettled him by remarking that the evidence for the historicity of the gospels was surprisingly good.[8] During a lunch in his room, his friends Dom Bede Griffiths and Owen Barfield emphatically impressed upon him that philosophy was not merely an academic subject but was, as Plato taught, "a way of life." This awakening was a blow to his self-protective approach to philosophy and made him realize that an earnest search for truth would require self-abandonment—and the truth was increasingly looking like the God of theism.

At the brink of believing in theism, Lewis wrote to Barfield on February 3, 1930, that he felt God was actively approaching him:

> Terrible things have happened to me. The "Spirit" or "Real I" is showing an alarming tendency to become much more personal and is taking the offensive, and behaving just like God. You'd better come on Monday at the latest or I may have entered a monastery.[9]

Soon thereafter, Lewis gave in and "admitted that God was God," later describing himself as "the most dejected and reluctant convert in all of England."[10] He explains that this was an intellectual conversion to "simple theism," completely unemotional and accompanied by no beliefs in a personal God or an afterlife, nor

that joy and fulfillment would follow. Interestingly, Lewis incorrectly remembered that this conversion occurred in the Trinity Term of 1929, but we now know that it was during the Trinity Term of 1930.[11]

God was to be obeyed as a matter of principle, as Lewis expressed it, because of his status as "sovereign" of the universe. After his theistic conversion, he dutifully began attending chapel services at Magdalen College and church services at Holy Trinity in his local parish because he thought that one should "fly one's flag" to signal publically one's change of mind.[12] Nonetheless, he continued to struggle with philosophical questions about Christianity, its relation to other religions, and its claim that God entered history in Jesus Christ. He credits his famous "late night talk" with J. R. R. Tolkien and Hugo Dyson along Addison's Walk on September 18, 1931, as being extremely influential in this regard. He had advocated the literary and philosophical opinion that myth, while pleasurable, is pure falsehood—a theory which was completely overturned by Tolkien's more sophisticated theory of myth. Tolkien, on the other hand, explained that myth is a symbolic story that conveys higher meanings which cannot be fully captured in literal language.[13] From this perspective, Lewis could begin to see the "dying god" pattern in countless religions as revealing the deep fabric of reality. As he put the dying God pattern together with his friend's haunting comment that this God seemed to have entered history at a particular place and time, Lewis began to see Jesus Christ as the transcendent coming into the world of facts.

Lewis's thinking process was now focused on the Incarnation, which is central to Christianity. On September 28, 1931, while riding in the sidecar of his brother Warnie's motorcycle to Whipsnade Zoo, he came to believe in the divinity of Christ.[14] Three days later, in a letter to Arthur Greeves, Lewis wrote, "I have just passed on from believing in God to definitely believing in Christ—in Christianity."[15] Although he had not wanted it, at each intellectual step—from atheism to various idealisms to theism to Christianity—God had become more concrete and present.[16] By his description, it was less a decision and more a moment of lucid realization: "It was more like when a man, after long sleep, still lying motionless in bed, becomes aware that he is now awake."[17] Faithfully pursuing the truth philosophically had led him to truths available only in theology—and the content of those theological truths helped make sense of everything else.

Classical Orthodoxy

After his reluctant conversion, Lewis took it as his role to represent the deeper Christian unity amid the diversity of Christian traditions: "I am not writing to expound something I could call 'my religion,' but to expound 'mere' Christianity, which is what it is and what it was long before I was born and

whether I like it or not."[18] The term "mere" in this context is taken from Old English meaning "pure" or "unmixed"—and indicates an understanding of the core Christian beliefs unembellished by more secondary denominational teachings.

Lewis indicated that he intended to explain and defend "the belief that has been common to nearly all Christians at all times."[19] His criterion for what is central to Christianity harkens to the definition of orthodox doctrine by St. Vincent of Lérins in the fifth century AD as "that which is everywhere, at all times, and by everyone believed."[20] Interestingly, when Lewis was invited to deliver a series of BBC radio talks on the subject, he accepted because he believed that many people had never been given a clear, credible, attractive account of Christianity understood in this way.

His "mere Christianity" broadcasts dealt with what is common and universal in Christianity, but these talks hardly retreated to the lowest common denominator. Instead, they focused on the central intellectual content of the faith as summarized in the *Nicene Creed* (technically, in its final form, the *Niceno-Constantinopolitan Creed*)—for instance, the statement that Christ was of the same substance as God the Father.

It is as if Lewis anticipated the renewed emphasis on classical Christianity that has been occurring over the past several decades. Contemporary theologian Thomas Oden was a pioneer in this movement, pointing to "ancient orthodoxy" or "historic Christianity" as where "substantial agreement" among Christian traditions—Catholic, Protestant, and Eastern Orthodox—can be found. As Oden explains, orthodoxy is the "deeper consensus that has been gratefully celebrated as received teaching by believers of vastly different cultural settings, whether African or Asian, Eastern or Western, sixth or sixteenth century."[21] To emphasize Christian unity in diversity, Oden employs the image of a light passing through a prism:

> The varieties of the tradition may be viewed as if Christ were a spectral prism through which God's love is refracted on the changing surfaces of the evoluting world. The lens creates a burst of vibrant colors. It breaks up a single beam of light and reveals all the variety of colors already implicitly within that beam. . . . Yet the same unchanging, steadfast love of God in Christ is variably manifested in the entire polychromatic scale. Seen together historically, [the many colors] manifest the full rainbow of God's presence in the estranged world.[22]

To accent the unity of historic Christian doctrine does not invalidate differences in Christian traditions but rather accords them their proper role as avenues of access to orthodoxy.

Lewis distinguished between the universal essence of Christian faith and its concrete embodiments in specific denominations. A master of imagery himself, Lewis wrote that "mere Christianity" is

> like a hall out of which doors open into several rooms. If I can bring anyone into that hall I shall have done what I attempted. But it is in the rooms, not in the hall, that there are fires and chairs and meals. The hall is a place to wait in, a place from which to try the various doors, not a place to live in.[23]

After being drawn into the great common "hall" of orthodoxy, a person must choose a "room" in which to "live," by which he meant participation in a local church, for as he wrote, "The one really adequate instrument for learning about God is the Christian community, waiting for Him together."[24]

Christian Platonism

Commentators often indicate that Lewis drew from a wide variety of influences, particularly ancient and medieval poetry, literature, and philosophy. What some call his "syncretistic imagination" fused classical pagan ideas with Christian storytelling, particularly utilizing powerful unifying ideas from Platonism. Although the label "Christian Platonist" or "Platonic Christian" is often given to Lewis because he loved both Plato and the "Christian Neoplatonist" writers, such as Augustine and Boethius, the extent to which he was a Platonist or Neoplatonist is a matter for discussion. Lewis masterfully wove Platonic images and themes into his literary works, but Lewis scholar Adam Barkman warns that Lewis's fiction and fantasy are "not always an accurate depiction of his metaphysical beliefs."[25] Twin questions arise, then, regarding how Platonism informed the substance of Lewis's thought and how it shaped his literary craft.

Platonic philosophy is built on certain dualistic doctrines—chiefly, on the belief in a higher realm of transcendent Ideas or archetypes that makes intelligible the ordinary realm of sensible objects, which are imperfect copies of the Ideas. The Ideas (or "Forms") are eternal and changeless, whereas the objects of the senses are changing and perishable. Truth, Goodness, and Beauty are the highest forms, which are also partially reflected in varying degrees in the material world. Platonic anthropology exhibits the same dualism between ideal and material realms: the soul is a different sort of entity from the body, which it inhabits but does not depend upon for its existence. Genuine knowledge of anything, then, is knowledge of its Form, and the highest knowledge is of the highest Forms.

Neoplatonism was an important strand of Platonic philosophy founded by the Egyptian thinker Plotinus (204/5–270 AD) and developed by a

heterogeneous group of thinkers in the Greco-Roman era of late antiquity. The goal of Neoplatonism was to construct a grand synthesis of the intellectual heritage of the Hellenic tradition in philosophy, religion, and literature. It is anti-materialist in rejecting Stoicism and Epicureanism; it is idealist in asserting the principle that mind is prior in reality to matter. According to Neoplatonism, all things in the universe emerged from an original unitary divine principle—"the One" or "the Good"—that in turn brings about "mind" or "consciousness," which supplies the intelligible structure of all other beings. The procession of all other beings from the One results in the "great chain of being," from higher to lower, from Absolute Consciousness on down to soul and then to matter. For the nascent Christian religion, Neoplatonism supplied philosophical categories for parsing fine points in its official theological position—such as transubstantiation in the Eucharist and the divine and human natures of Christ.

Augustine was one of many medieval Christian theologians whose writings exhibit Platonic and Neoplatonic influence—particularly in taking the theory of Ideas as prefiguring the idea of heaven as a perfect world of which this material world is a copy and in elevating a vision of Truth, Goodness, and Beauty as the soul's deepest longing. One development in Neoplatonic thought was the idea of a "cosmic hierarchy," which became the basis for the "spiritual cosmology" of medieval Christianity, a gradated vision of creation in which the purpose of all creatures is to find and obediently accept their roles in a harmonious, ordered cosmos.[26] Within this cosmology, evil arises when the human soul directs its attention toward the material world, but the ascent of the soul occurs when it purifies itself of material entanglements, mastering its thoughts and desires, and journeys toward its true source.

In some of Lewis's writings, many broadly Platonic allusions indicate his philosophical outlook and inform his literary techniques. For example, Lewis alludes to the Platonic view that temporal things are "shadow copies" (less real) of their perfect heavenly (truly real) counterparts near the end of *The Last Battle*. When the Narnians reach the outskirts of Aslan's Country and are puzzled by seeing familiar things, Lord Digory explains:

> "When Aslan said you could never go back to Narnia, he meant the Narnia you were thinking of. But that was not the real Narnia. That had a beginning and an end. It was only a shadow or a copy of the real Narnia, which has always been here and always will be here: just as our own world, England and all, is only a shadow or copy of something in Aslan's real world."[27]

Lewis even used the reality/shadow distinction to explain how Christian believers on different educational levels can embrace the same substance of orthodox

doctrine while still associating it with their quite different thoughts: "What they agree on is the substance, and what they differ about is the shadow."[28]

Perhaps no Neoplatonic idea—or Neoplatonic image conveying it—was more compelling for Lewis than that of the "celestial dance": a conceptual model of medieval cosmology constructed as a complex synthesis of theology, science, and history. The implicit worldview of this model, as professor Peter Schakel writes, is that "the universe is a cosmos, a harmonious system, and that human life, as an integral part of that whole, also has order, unity, and meaning."[29] Having received the gift of existence from God, the medieval universe was in a sense alive, "dancing, ceremonial, a festival, not a machine."[30] As Lewis explains in *The Discarded Image*, medieval Christians did not think that their model of the cosmos was literally true but believed that it poetically captured a spiritual truth—that God is at the center and that the sun and the planets, and even humanity, must take their place in the joyous dance of life.

In addition to employing some Platonic ideas, Lewis largely agreed with Platonic aesthetics in holding that higher truths must be conveyed symbolically in myths because they cannot be conveyed literally. Plato was a mythmaker par excellence—as was Lewis. The comparison is obvious between the story of the cave of "dark enchantment" in *The Silver Chair* and Plato's "myth of the cave" in *The Republic* because both environments are falsely presented as the only reality. However, Lewis broke from the Platonic aesthetic principle that art and literature should never "perform or imitate" evil actions or character states but must always depict what is morally good and virtuous.[31] Indeed, some of the most compelling passages in Lewis's writings are his depictions of evil—the rationalizing delusions of Ghosts in *The Great Divorce*, the psychologically insightful advice from the devil Screwtape about tempting humans, and the destructive behavior of Eustace in the Narnia Chronicles.

Platonism, in its emphasis on the ideal as a reference point for the material, is the intellectual progenitor of later forms of idealism, which allows us to understand Lewis's indebtedness to philosophical idealism's belief in the ontological primacy of Mind as a bridge to theism and as a continuing influence on his Christian philosophy. For instance, the idealist affirmation of the Absolute or Supreme Mind as the ground of being helped Lewis recognize the Sovereign Creator God of theism. Moreover, F. H. Bradley's writings on absolute idealism spoke of the "hidden glory" behind the appearances of things, which Lewis adopted, for example, when he wrote of the "beauty" of good books or good music not being "in them" but "only coming through them."[32]

Some think that Lewis consciously wanted to be known as a Christian Platonist. At the end of *The Last Battle*, for example, when the Narnians die and go through the Door into the New Narnia, where they recognize more vibrant versions of familiar landscapes, Professor Digory explains to

Lucy, "It's all in Plato, all in Plato."[33] However, traces of the Stoics, Aristotle, and even pagan religion also appear in Lewis's writings, indicating that he was a classicist and humanist who attempted to synchronize any truth with Christianity as best he could. Philosopher and commentator Mary Carman Rose, therefore, calls his "Christian Platonism" interdisciplinary and eclectic.[34]

Commitment to Calling

Before becoming a Christian, Lewis committed to living with integrity by what he believed was true. When his friend Barfield clarified for him that the ancients saw philosophy as "a way"—a means of spiritual progress—Lewis realized that philosophy, in its literal meaning as the "love of wisdom," should be the vocation of all rational beings. Later, as a Christian, he built this idea firmly into his worldview. Walter Hooper, who was Lewis's private secretary, remarked, "Lewis struck me as the most thoroughly converted man I have ever met. Christianity was never for him a separate department of life."[35] Lewis came to see God as calling all persons most fundamentally to an intimate and transformative relationship with himself.

During his early years of searching philosophically for the truth, Lewis had viewed himself as taking the initiative, but after his Christian conversion, he realized that God had been seeking him all along. The Truth, Goodness, and Beauty that he loved were not pure abstractions, attributable at best to an inaccessible Absolute, but were actually reflections of a personal God who calls all created persons to himself. *The Silver Chair* portrays the idea of God's initiative toward us, as Jill and Eustace escape their unpleasant school one day and enter Narnia by chanting "Aslan, Aslan."[36] Yet, when Jill first encounters Aslan and is faced with his claim upon her, she attempts to deflect it by saying, "nobody called me and Scrubb" and, "it was we who asked to come here." Aslan replies, making the classical Christian point, "You would not have called to me unless I had been calling to you."[37]

Lewis embraced the idea of God's calling at a deep level and tried to help others embrace it in their lives as well. While the idea of being called by God is rich and multifaceted, he understood and taught that the primary call is for all persons to enter into relationship with God, as Jesus taught in the Greatest Commandment: "You shall Love the Lord your God with all your heart, soul, mind, and strength."[38] For Lewis, it is not simply a matter of becoming "religious" or trying to be a "decent" person—relationship with God involves the whole self in a process of transformation which reframes, uplifts, and integrates one's relationships, aims, and activities. Lewis's Christian worldview, then, explains

exactly why he modeled loving God by loving others, faithfully answering all correspondence and generously giving money to people in need.

Another aspect of calling that Lewis treated is more individualized, pertaining to a specific type of work or task that we believe God wants us to perform. Lewis stated that "sacred calling is not limited to ecclesiastical functions" and that "the man who is weeding a field of turnips is also serving God."[39] Indeed, as Lewis explained,

> All of our . . . activities will be accepted, if they are offered to God, even the humblest: and all of them, even the noblest, will be sinful if they are not. . . . The work of a Beethoven, and the work of a charwoman, become spiritual on precisely the same condition, that of being offered to God, of being done humbly "as to the Lord."[40]

When given to God, occupation becomes *vocation*. Lewis echoed the traditional wisdom that, in discerning one's particular calling, one's upbringing, talents, and circumstances should be considered.[41] We might rephrase, saying that calling is found at the intersection of one's background, gifts, and opportunities, but no one has said it better than theologian Frederick Buechner: "[Vocation] is the place where our deep gladness meets the world's deep need."[42]

The Christian teaching is also that God equips persons he calls—giving different "gifts" or "talents" to believers that are meant for the good of others. Lewis expresses this point in one of the famous scenes in *The Chronicles* that features Father Christmas giving different gifts to the Pevensie children—Peter a sword and shield, Lucy a vial with healing elixir, and Susan a bow and arrows.[43] Just as Father Christmas tells the children to use their gifts in the right circumstances, all Christians are to put their gifts to use in serving a common objective. In Lewis's attempt to live a Christian life, we see a person who sought to love God with his whole self and employed his gifts for the good of others. As Lewis wrote to Mary Willis Shelburne on March 19, 1956, "Each must do his duty 'in that state of life to which God has called him.'"[44] Faithfully following the call of God on his life made Lewis a better brother to Warnie, a better husband late in life to Joy Gresham, and a better counselor to countless fans who wrote to him for advice.

His worldview entailed not that the most spiritual way he could serve God was to enter official Christian ministry but rather that he must, as each believer must, find that place where his passions, abilities, and opportunities came together. Professor of English and Lewis expert Devin Brown elaborates on how Lewis lived out his vocation:

> He continued to hold his weekly tutorials, to give lectures, and to conduct scholarly research. In addition, he wrote fantasy fiction for commercial publishers,

spoke on the BBC, and created philosophical and apologetic materials intended to be understood by everyone.[45]

In other words, "Lewis responded to his own personal calling by remaining right where he was," finding his unique voice and engaging the larger world—both academia and general culture—from the platform he had been given on behalf of the Christian faith.[46]

2

Worldview Engagement

Early in his adult life, Lewis became dedicated to seeing things from the largest possible perspective. His extensive background in philosophy taught him world-view thinking, and his immersion in great literature exposed him to implicit worldview assumptions. His early atheism was no doubt colored by formative experiences—his mother's death, his father's emotional coolness, and his very strange private school teachers. In 1916, at the beginning of his adult intellectual life, he declared his atheistic outlook to his best friend, Arthur Greeves:

> I believe in no religion. There is absolutely no proof for any of them, and from a philosophical standpoint Christianity is not even the best. All religions, that is, all mythologies to give them their proper name, are merely man's own invention—Christ as much as Loki.[1]

From this perspective of nonbelief, his long philosophical and personal journey through various worldviews was to begin. Our discussion of this journey is primarily conceptual, focusing on the reasoning process that propelled the progress in his thought, although it also approximately tracks the chronological sequence of his views as well.

Alternative Explanations of Reality

Lewis stated that his conversion was "almost purely philosophical" and that its details were so deeply involved with "technical philosophy" as to be "useless to the general [public]."[2] He may have erred in downplaying the philosophical worldview arguments for a popular audience because, as Lewis biographer David C. Downing says, Lewis's "Christian books are compelling precisely *because* he spent so many years as an unbeliever," at one time or another, holding—and later rejecting—almost each of the major philosophical alternatives to Christianity.[3] For a selected timeline of Lewis's intellectual and personal journey, the reader is encouraged to consult Appendix A.

In his letters, Lewis reveals the impressive scope of his worldview journey: "I went from materialism to idealism, idealism to pantheism, from pantheism to theism, and from theism to Christianity."[4] His diary, *All My Road Before Me*, is

C. S. Lewis and the Christian Worldview. Michael L. Peterson, Oxford University Press (2020).
© Oxford University Press.
DOI: 10.1093/oso/9780190201111.001.0001

peppered with mentions of tweaking and readjusting within each philosophical stage. However, in his other writings, he typically generalized about these stages of his intellectual journey, omitting certain developments and sometimes misremembering key dates. He characterizes the "intellectual side" of his search as an "argued dialectic"—the critical interplay of ideas aimed at progressing toward the truth.[5] Yet he also acknowledged that his "lived dialectic" was the practical testing in experience of each position he held.[6] The present chapter essentially tracks his argued dialectic, while the following chapter discusses the more existential aspect of Lewis's search, with an eye toward understanding how Lewis saw the relationship between the two dialectics.

Lewis's effectiveness as a Christian intellectual stemmed from the fact that his worldview exploration equipped him to explain both the weaknesses of rival worldviews and the strengths of the Christian worldview. In effect, he had found and could share the philosophical Rosetta Stone—the true worldview—which could accurately interpret all the "important inscriptions" that are "scattered throughout the world." It is helpful to think about Lewis's rational process as seeking the worldview that provides the best explanation of the evidence. Assessing the explanatory power of worldviews is not in the last analysis a simple matter of deductive or inductive reasoning but is more like what C. S. Peirce called "abduction."[7] Often called "inference to the best explanation," the process of abductive reasoning seeks to arrive at a hypothesis that makes the most complete sense of some phenomenon. We may summarize the abductive reasoning process as follows:

1. The interesting or important phenomenon X exists.
2. If hypothesis H were true, X would be likely.
3. Hence, there is some reason to think that H would be true.

Medical diagnoses, forensic conclusions, and many ordinary judgments are based on this kind of reasoning. Of course, there never is just one possible hypothesis to consider, which makes abductive reasoning very much a *comparative* process of trying to identify the most probable hypothesis among alternatives. The process becomes increasingly complex when multiple phenomena require a consistent, plausible explanation. Lewis's intellectual search is best understood as this kind of comparative reasoning process regarding the explanatory power of different worldviews in regard to several important phenomena—and his "intellectual progress" was his episodic recognition that a given worldview explanation must be abandoned for a better one.

We may further elucidate Lewis's comparison of worldview explanations in terms of *antecedent probability*—which reflects the likelihood that certain phenomena would exist if a given statement were true: in the present context, how

likely is it that there would be such things as mind, morality, and personhood—
and all we know about them—in a world described by each worldview? Lewis
eventually concluded that the Christian understanding of reality provided a more
adequate explanation of these and other important phenomena than any other
worldview. Put symbolically, where P is antecedent probability, C is Christian
theism, W is any other worldview, and X is some important phenomenon,

$$P(X/C) > P(X/W).$$

The closeness or naturalness of the conceptual connections between a stated
worldview and a given phenomenon can be a major factor in determining ante-
cedent probability. For example, it appears that it is less antecedently likely that
finite rationality would stem from an ultimate reality that is nonrational at its
core than from an ultimate reality that is deeply rational. This approach gives
worldview assessment an epistemic dimension and leads to the notion of "epi-
stemic surprise" such that a given worldview can make the occurrence of a given
phenomenon more or less epistemically surprising. In the final analysis, Lewis
may be seen as arguing that assuming the truth of Christian theism makes mind,
moral awareness, and many other features of reality much less epistemically sur-
prising than assuming the truth of any other worldview.

Naturalism, Materialism, and Atheism

The period from about 1909 until 1923 is considered Lewis's materialist phase,
although he tweaked and modified his materialism during this time. His early
materialism followed Lucretius, who asserted that everything is atoms com-
bining and recombining in an infinite void and that the evil and disorder in the
world—what Lewis called the "argument from undesign"—was a compelling
atheistic objection to the existence of a God. Yet the underlying pessimism of
materialism haunted Lewis: "I was at this time living, like so many Atheists or
Antitheists, in a whirl of contradictions. I maintained that God did not exist.
I was also very angry with God for not existing. I was equally angry with him for
creating a world."[8]

Since atheism itself is not much of an explanation of anything and therefore
not a full-orbed philosophical perspective, it typically finds larger philosoph-
ical context in a naturalist worldview, which is based on the assumption that na-
ture alone is real. We may say that the "structure" of any worldview is what it
affirms regarding the main questions of philosophy—about reality, knowledge,
ethics, humanity, aesthetics, and so forth. In these terms, naturalism affirms

the following: that physical nature alone is real; that there is no supernatural; that authentic knowledge is based on empirical experience; that ethics derives somehow from our natural state but has no transcendent source; that beauty is not objective but is individually or culturally determined; and that a human person is purely a product of nature, differing only in degree from other products of nature.

Many naturalists hold, as Lewis did, that materialism is true—the belief that nature consists in nothing but the material or physical. Atheist philosopher Kai Nielsen identifies anti-supernaturalism as the unifying thread of all forms of naturalism:

> Naturalism denies that there are any spiritual or supernatural realities. There are, that is, no purely mental substances and there are no supernatural realities transcendent to the world or at least we have no good ground for believing that there could be such realities. . . . It is the view that anything that exists is ultimately composed of physical components.[9]

Materialist naturalism, then, explains all seemingly nonmaterial realities—not just God but consciousness, thought, choice, and values—in terms of the material. Because materialist naturalism serves a quasi-religious function, philosopher John Searle declares, "there is a sense in which materialism is the religion of our time."[10]

In *Pilgrim's Regress*, Lewis repeated his five philosophical stages but substituted "popular realism" for "materialism" to label his initial philosophical stage.[11] The particular brand of "realism" that the atheist Lewis embraced involved both metaphysical and epistemological commitments—to an objective material world independent of our thoughts and perceptions and to our ability to know it through sensory experience. In the early twentieth century, G. E. Moore, A. J. Ayer, and others articulated this "realism" in opposition to the "absolute idealism" of F. H. Bradley, who asserted metaphysically that reality was one, an infinite Absolute, and epistemologically that the many things in our experience are mere "appearances" and not reality. As Lewis, stated, he believed "nature to be quite independent of our observations, something other, indifferent, self-existing."[12] Yet this version of realism, in keeping with philosophical fashion, restricted reality and knowledge to the empirical and must not be confused with traditional philosophical realism that can also allow for nonphysical reality and modes of knowledge besides the empirical, as explained in Chapter 1.

In 1917, Lewis altered his materialism and flirted briefly with a certain version of cosmic dualism, only to return to a remodeled materialism in about 1919, which was his first year as a student at Oxford. Under the influence of his philosophy tutor, E. F. Carritt, he adopted what he called his "New Look," which

was "a sort of Stoical Monism" that identified ultimate reality with the material universe and not God.[13] As he said, his "New Look" also involved "chronological snobbery," the epistemological opinion that the beliefs of past cultures are to discredited because they do not reflect modern beliefs.

Lewis's "New Look" was "stoical" because it offered emotional protection against melancholy and pessimism in a meaningless universe by positing that everything that happens is necessary and must be accepted with acquiescent tranquility, as Bertrand Russell advised in his famous essay "A Free Man's Worship."[14] Russell articulated the scientific materialist vision of a meaningless universe in which human origins, hopes, fears, loves, and beliefs "are the outcome of accidental collocations of atoms" and in which all genius, artistic achievement, heroism, and devotion will inevitably come to ruin:

> The Stoic freedom in which wisdom consists is found in the submission of our desires but not of our thoughts. From the submission of our desires springs the virtue of resignation; from the freedom of our thoughts springs the whole world of art and philosophy, and the vision of beauty by which, at last, we half reconquer the reluctant world.[15]

As Russell declared in this piece, only on this "foundation of unyielding despair" can the soul find its proper bearing.[16]

Initially, Lewis was happy with his stark, doctrinaire New Look, but soon more anxiety than ever returned to his life. Just when he was settling back into his revised materialist universe, his friends Cecil Harwood and Owen Barfield "abandoned" him by becoming Anthroposophists, heralding ideas about spiritualism combined with science.[17] In fact, one of the most famous episodes of Lewis's life was his "Great War" with Owen Barfield—a friendly multiyear debate about whether there are truths accessible to the imagination that are not available to reason.

Exchanges with Barfield convinced Lewis that his materialist realism was inadequate:

> We had been, in the technical sense of the term, "realists"; that is, we accepted as rock-bottom reality the universe revealed by the senses. But at the same time we continued to make for certain phenomena of consciousness all the claims that really went with a theistic or idealistic view. We maintained that abstract thought (if obedient to logical rules) gave indisputable truth, that our moral judgment was "valid," and our aesthetic experience was not merely pleasing but "valuable." . . . Barfield convinced me that it was inconsistent. If thought were a purely subjective event, these claims for it would have to be abandoned.[18]

It became increasingly difficult for Lewis to see how materialism and empiricism could make sense of how three particular "phenomena of consciousness"— logical thought, moral judgment, and aesthetic experience—could "get at" or "relate to" something beyond themselves. As Lewis became increasingly convinced that our thoughts in these areas were reliable, he was compelled to give up his version of realism.

Although Lewis stated that he abandoned realism because it was an inadequate empiricist theory of knowledge, he also knew that the underlying materialist theory of reality was inadequate. The inadequacies of his views here were accented by the realization that mind was "no late-come epiphenomenon," a spin-off of material processes, but rather was original and fundamental in the order of reality.[19] And this must mean that "the whole universe was, in the last resort, mental; that our logic was participation in a cosmic Logos."[20] Recognizing that important phenomena of consciousness required some sort of spiritual metaphysic was devastating to Lewis's materialism.

Idealism, for Lewis, explained the phenomena of consciousness better than his materialism did. Put in terms of antecedent probability, the likelihood that these phenomena would occur in an idealist universe was considerably higher than that they would occur in a materialist universe. Expressing the comparative judgment symbolically, where R is valid rational thought, I is idealism, and M is materialism,

$$P(R \, / \, I) > P(R \, / \, M).$$

Of course, theism also makes rational thought much more probable than materialism does—and makes it at least as probable as idealism does—but Lewis's thinking had not yet progressed that far. Nonetheless, instincts were emerging that would later frame his famous "argument from reason," which is covered in Chapter 4.

Cosmic Dualism

During his service in World War I, from 1917 to 1919, Lewis saw the facts of evil as posing a serious challenge to his materialism—which he later called "a glib and shallow rationalism." For this brief interlude in his overall materialist period, he came to believe that some sort of cosmic dualism—which makes sense of the earthly conflict between good and evil by positing an eternal war between ultimate good and evil powers—was probably true. Although his view resembled Manichaeism and Zoroastrianism, in many ways it was simply the addition of

certain spiritual claims to his underlying materialist commitments, resulting in what David Downing calls "a kind of gnostic dualism."[21]

While a cosmic dualist, Lewis pursued his developing interests in metaphysics, epistemology, and ethics by reading Henri Bergson, George Berkeley, and Plato, all of which intertwined in his thinking to catalyze his eventual migration to idealism. Bergson's quasi-dualistic metaphysics in *Creative Evolution* posited the *élan vital* as the mysterious "life force" that impels biological life upward, thus giving Lewis an appreciation for the beauty of physical life to combine with his love of Romanticism and mythology.[22] Berkeley's argument that all things that we mistakenly think are material are actually either spirit or ideas thought by spirit challenged Lewis's simplistic view that matter exists in its own right independently of mind.[23]

In reading Plato's *Phaedrus*, *Phaedo*, and *Republic*, Lewis became convinced that Beauty was a perfect, objective, transcendental object. Combining this belief with his Bergsonian orientation, he took Beauty as a synonym for Spirit. Whereas Plato taught that material nature is beautiful insofar as it participates in the perfect spiritual form of Beauty itself, Lewis followed Berkeley's argument that secondary qualities such as beauty are actually not "in" things themselves:

> You say that nature is beautiful, and that is the view we all start with. . . . [You call a tree] beautiful because of its shape, color, and motions [But] these colors etc are sensations in my eye, produced by vibrations in the aether between me and the tree: the real tree is something quite different—a combination of colorless, shapeless, invisible atoms. It follows then that neither the tree, nor any other material object can be beautiful in itself. . . . The beauty therefore is not in matter at all, but is something purely spiritual.[24]

The notion that transcendental qualities "come through" earthly things became a persistent theme in Lewis's writings.

Lewis's cosmic dualism assumed that Nature and God were the warring principles, that "nature is wholly diabolical & malevolent and God, if he exists, is outside of and in opposition to the cosmic arrangements."[25] Lewis explained in a letter to Arthur Greeves,

> My views at present are getting almost monastic about all the lusts of the flesh. They seem to me to extend the dominion of matter over us: and, out here, where I see spirit continually dodging matter (shells, bullets, animal fears, animal pains) I have formulated my equation Matter=Nature=Satan. And on the other side Beauty, the only spiritual & not-natural thing that I have yet found.[26]

This position expresses what Barkman calls Lewis's "pseudo-Manichean stage."[27] However, Lewis's assignment of opposing moral values to the material and the spiritual realms ultimately had to be corrected in accordance with the Christian understanding that Nature and all of creation is "good," coming into being by the will of a perfectly good God; the human problem, then, is not material embodiment but moral and spiritual rebellion, which affects every aspect of our humanity. Nonetheless, this cosmic dualist phase strengthened Lewis's resolve to live according to virtue, an intention that carried over into his Stoical materialist stage already discussed.

Later, when Lewis became a Christian, he was able to argue effectively against cosmic dualism—that it has "two fatal difficulties, the one metaphysical and the other moral."[28] The first flaw is cosmic dualism's inability to articulate the metaphysical relation between the supposedly ultimate good and evil powers. Dualism posits "two things which simply co-exist and have no other relation"—a situation that is extremely unlikely and probably inconceivable:

> We really imagine [the Good and Evil powers] side by side in some kind of space. But of course if they were both in a common space, or a common time, or in any kind of common medium whatever, they would both be parts of a system, in fact of a "Nature."[29]

Dualism "has not yet reached the ground of being," he maintained, because "you cannot accept two conditioned and mutually independent beings as the self-grounded, self-comprehending Absolute."[30] The logical conclusion he drew was that there must be some third thing above the first two things.

Lewis argued that theism—which asserts that there is uniquely one supremely good being—is rationally preferable to cosmic dualism with its two morally opposed ultimate beings.[31] In terms of antecedent probability, where T is theism, D is cosmic dualism, and $G\&E$ is the admixture of good and evil in the world,

$$P\big(G\&E\,/\,T\big) \; > \; P\big(G\&E\,/\,D\big).$$

Of course, what got Lewis thinking about cosmic dualism in the first place was the increasingly credible prospect that it explains good and evil better than materialism explains these phenomena.

The second error of dualism, according to Lewis, is that it cannot make sense of the moral categories of good and evil. Designating one cosmic power "good" and the other "evil" presupposes a third element for making the evaluation—an objective standard of good and evil:

Each presumably thinks it is good and thinks the other bad. One of them likes hatred and cruelty, the other likes love and mercy. . . . Now what do we mean when we call one of them the Good Power and the other the Bad Power? Either we are merely saying that we happen to prefer the one to the other . . . or else we are saying that . . . one of them is actually wrong, actually mistaken, in regarding itself as good.[32]

For the terms "good" and "evil" to be meaningful, they must be linked to some objective standard, but "then this standard, or the Being who made this standard, is farther back and higher up than either of them, and He will be the real God."[33]

Drilling down more deeply on dualism's inability to make sense of morality, Lewis argues that no being can be intrinsically evil or love evil for evil's sake. He contends that there is no way that an evil being can stand in the same relation to its evil that an ultimate good being can stand to its goodness:

We have no experience of anyone liking badness just because it is bad. . . . You can be good for the mere sake of goodness: you cannot be bad for the mere sake of badness. . . . Goodness is, so to speak, itself: badness is only spoiled goodness. . . . There must be something good first before it can be spoiled.[34]

Lewis's further attack on the idea of an ultimate evil power is devastating:

This Bad Power, who is supposed to be on an equal footing with the Good Power, and to love badness in the same way as the Good Power loves goodness, is a mere bogey. In order to be bad, he must have good things to want and then to pursue in the wrong way: he must have impulses which were originally good in order to be able to pervert them. But if he is bad he cannot supply himself either with good things to desire or with good impulses to pervert. He must be getting both from the Good Power. And if so, then he is not independent. He is part of the Good Power's world: he was made either by the Good Power or by some power above them both.[35]

Thus, for Lewis, good is morally prior to evil such that evil is damaged goodness and love of evil is desiring evil as though it is good.

Philosopher Erik Wielenberg contends that Lewis has not established that a being cannot love evil for its own sake:

To support the central premise, Lewis appeals to experience: we never encounter people who love evil for its own sake. . . . This argument is unconvincing. One problem is that from the fact that we have no experience of beings who love evil for its own sake it hardly follows that such beings are impossible.[36]

Although Wielenberg is correct that a rather rhetorical claim about our experience is insufficient to support the conclusion that loving evil for its own sake is strictly impossible, he fails to credit Lewis with making the stronger conceptual case that evil must be seen somehow as good. We should interpret Lewis on this point as squarely within the classical Christian tradition. For example, Augustine advanced the ontological principle that only a good God can bestow being on creatures and, therefore, that evil is "privation of the good."[37] Aquinas, moreover, held that "a rational creature chooses evil because it perversely judges it to fall under the category of the good."[38] For these reasons, Lewis the Christian thinker maintained that evil is dependent, defective, privative, and parasitic in multiple ways and therefore pressed the argument that theism makes better total sense of moral reality than cosmic dualism does.[39]

Idealism and Pantheism

While Lewis was still officially a materialist but going through his quasi-dualist period, George Berkeley's subjective idealism got his attention. In a letter to Greeves, Lewis expressed fascination with Berkeley's argument against matter and for the existence of God, calling it "very subtle but not difficult."[40] Berkeley held that the objects we perceive in the world are not material things with sensible qualities but are collections of qualities that exist in minds or spirits.[41] As Berkeley put it, "to be is to be perceived" (*esse est percipi*)—in other words, to exist is to be present as an idea in some mind. Although Lewis did not at the time embrace Berkeley's exact view that mind is the substrate of sensory experience, he was becoming increasingly convinced that reality is somehow mind-dependent.

In 1923, Lewis abandoned his Stoical materialism along with his New Look and embraced Bradleyan absolute idealism, a change of mind tracing to 1922, which was the beginning of what he affectionately called his "Great War" with his friend Barfield. Lewis had always maintained that imagination must be regulated by reason, but Barfield contended that the imagination could access truths beyond reason. The debate convinced Lewis that his "realism"—a combination of materialist metaphysics and strict empiricist epistemology—could not adequately support the objectivity of reason, the universality of morality, and the intrinsic value of art. Lewis scholar Lionel Adey explains that the Great War helped move Lewis first toward idealism and later toward theism and Christianity.[42]

Lewis followed Bradleyan idealism in affirming that reality is mind-coordinated and that both the intangibles of consciousness and the tangible objects of sensory experience are dependent on one mind, "the Absolute." Bradley's argument was that the notion of a multiplicity of separate objects which constitute reality is incoherent—and therefore that the Absolute, or Reality, *is* the

totality of all Appearances. According to this position, all the phenomena of our experience are projections or ideas of the Absolute Mind: "We perceive, on reflection, that to be real, or even barely to exist, must be to fall within sentience."[43] Bradley's position is that the Absolute is an infinite monistic whole that cannot be known by finite *thought* (which rests on the distinction between perceiver and perceived) but must instead be apprehended by *feeling* (which makes no such distinction).

No doubt, Lewis's intellectual attraction to absolute idealism was reinforced by his emotional attraction—which was perhaps inspired by Bradley's talk of the "hidden glory" of Reality showing through the veil of all Appearances, that the glory of the world is "a show of some fuller splendor" that lies behind "the sensuous curtain."[44] For Lewis, absolute idealism had a quasi-religious character, offering "all the conveniences of Theism, without believing in God."[45] Belief in the impersonal Absolute "cost nothing"—for "It" was "there" and would never come "here" and "make a nuisance of Itself."[46] Lewis thought that this rather Platonic perspective "had much of the quality of Heaven," although we can never reach Heaven, for we are mere appearances.[47] After he became a Christian, the idea that Heaven shows itself through earthly things became a significant theme in his thought.

During the 1924–1925 academic year, Lewis took a temporary position teaching philosophy at University College, Oxford. When he found that absolute idealism could not be taught to students because it was confusing and unteachable, he migrated to subjective idealism:

> I was now teaching philosophy (I suspect very badly) as well as English. And my watered Hegelianism wouldn't serve for tutorial purposes. A tutor must make things clear. Now the Absolute cannot be made clear. Do you mean Nobody-knows-what, or do you mean a superhuman mind and therefore (we may as well admit) a Person? After all, did Hegel and Bradley and all the rest of them ever do more than add mystifications to the simple, workable, theistic idealism of Berkeley? I thought not. And didn't Berkeley's "God" do all the same work as the Absolute, with the added advantage that we had at least some notion of what we meant by Him? I thought He did. So I was driven back into something like Berkeleyanism; but Berkeleyanism with a few top dressings of my own.[48]

Although he modified his idealism, it was still about an abstract God:

> I distinguished this philosophical "God" very sharply (or so I said) from "the God of popular religion." There was, I explained, no possibility of being in a personal relation with Him. For I thought He projected us as a dramatist projects his characters, and I could no more "meet" Him, than Hamlet could

meet Shakespeare. I didn't call Him "God" either; I called Him "Spirit." One fights for one's remaining comforts.[49]

However, Lewis abandoned subjective idealism after a couple of years because, as Adam Barkman comments, it seemed to imply something like solipsism—the view that oneself alone exists—and that there is no contact between finite spirits.[50] He labeled his new position "pantheism," which was his synonym for absolute idealism as an escape from "extreme subjective idealism."[51] Pantheism—the view that God is (or is the hidden essence of) everything—allowed that one could be in contact with other individual spirits as part of one's own spirit, which in turn is an aspect of Absolute Spirit.[52] Clearly, the various versions of idealism that Lewis held served as an important bridge to theism, giving him a more secure onto-logical and epistemological grounding for important mental phenomena than materialism gave him. Yet over time he found that individual personhood, the status of matter, and even transcendent longing were all problematic on idealism but well explained on theism.

Basic Theism and Christian Theism

Good friends, good books, and a recurring sense of longing influenced Lewis along his thinking process from idealism to theism.[53] After finishing degrees in philosophy and Greats by 1922, he remained at Oxford to earn a credential in English. Soon he became friends with the most brilliant student in the class, Nevill Coghill, a person with courtesy and honor who, shockingly, was also a Christian believer.[54] Similarly, to his surprise, the classic books he loved most were all religious, if not explicitly Christian—Plato, Virgil, Milton, and the Romantics. He even stated that the writings of George MacDonald, his favorite contemporary author, conveyed a quality of "holiness."[55] Lewis already admired Chesterton's writings, but Chesterton too was a Christian. In retrospect, Lewis understood that his "theory of life," which included a deep aversion to religion, was increasingly at odds with his "actual experience as a reader."[56]

When Lewis was appointed to an English position at Magdalen College, Oxford, in 1925, two new colleagues, J. R. R. Tolkien and Hugo Dyson, partic-ularly influenced his thoughts toward Christianity. Two books he read during this time became influential as well. Reading Euripides's *Hippolytus*—"Oh God, bring me to the end of the seas; . . . let me escape to the rim of the world, where the tremendous firmament meets the earth"—brought back his deep longing for something beyond this world.[57] Lewis felt his heart "at once broken and ex-alted"—and he decided never again to dismiss this kind of powerful experience. From Samuel Alexander's *Space, Time, and Deity*, Lewis learned the technical

distinction between two aspects of mental experience in relation to an object of thought—"enjoyment" as the subjective act of thought and "contemplation" as the awareness and consideration of the object as distinct from the subjective experience of it. This distinction helped Lewis realize that if "one essential property of love, hate, fear, hope, or desire was attention to their object," then his recurring sense of longing must also have an object and was not reducible to a subjective mental state. Clyde Kilby remarks that this corrected his mistake of treating longing or Joy as a desirable subjective state, as "a thing inside one's own head and isolated from its object."[58]

In incorporating this new insight into his absolute idealism, he thought that Joy must be our yearning for union with the Absolute. However, he eventually concluded that it is impossible for us ever to achieve Joy because union with the Absolute means ceasing to be our fleeting, phantasmal selves. Although his idealism provided an inadequate explanation of Joy, this belief that Joy was among the important phenomena that an adequate worldview must explain moved him closer to theism. He concluded that Something out there, then, must be the object of longing or Joy—but he continued to hope that this something, or this Spirit, would not demand anything of us, or more specifically, of him.

"This new dovetailing of my desire-life with my philosophy," he wrote, "foreshadowed the day, now fast approaching, when I should be forced to take my 'philosophy' more seriously than I ever intended."[59] As an idealist, Lewis believed that his "acts, desires, and thoughts were to be brought into harmony with universal Spirit."[60] He reasoned, however, that "conscious recourse to Spirit" must mean something like what ordinary people call "prayer to God." Yet impersonal Spirit is passive and offers no practical assistance: "Idealism can be talked," he wrote, "and even felt; it cannot be lived."[61] If prayer for living virtuously is to be effective, this Spirit must be active, not passive. But finite persons are powerless to form a relationship with Spirit, which means that the initiative must lie on this Spirit's side: "If Shakespeare and Hamlet could ever meet, it must be Shakespeare's doing."[62]

The God Lewis had posited as a "philosophical theorem" he now understood as a "living presence"—the sovereign God of the universe was approaching him and requiring complete surrender.[63] As he thought his way through to theism, he felt his resistance begin to break down:

> You must picture me alone in that room in Magdalen, night after night, feeling, whenever my mind lifted even for a second from my work, the steady, unrelenting approach of Him whom I so earnestly desired not to meet. That which I greatly feared had at last come upon me. In the Trinity Term of 1929 I gave in, and admitted that God was God, and knelt and prayed: perhaps, that night, the most dejected and reluctant convert in all England.[64]

Although we now know the correct date is 1930, we also know that Lewis's acceptance of theism was momentous and brought him much closer to Christianity.

Lewis's theistic conversion was driven by the growing conviction that theism was preferable to idealism in two ways—it explained relevant phenomena better than idealism could and was able to be lived, whereas idealism could not be lived. Regarding the phenomenon of finite individual personhood, for example, where P is the independent ontological status of finite persons, T is theism, and I is idealism, Lewis reasoned that

$$P(P / T) > P(P / I).$$

Now, if theism is true, then we are distinct personal beings and God is our transcendent creator, and we owe obedience to him. Thus, the philosophical truth of theism had practical implications.

English professor and Lewis commentator Devin Brown observes that Lewis's theism developed through two identifiable phases: "he first came to believe in an impersonal Spirit and then in a personal God."[65] For Lewis's "pure and simple" theism, God was the impersonal sovereign of the universe.[66] Later, Lewis reasoned that God's sovereign commands must be reflections of God's perfectly good nature—of "what he is in himself."[67] It follows, Lewis concluded, that our ultimate fulfillment is union with that nature, not sheer obedience.[68] But perfect moral goodness can only be ascribed to a personal being—and if God is a personal being, then he undoubtedly seeks relationship with us. Although Lewis became intellectually convinced that God was a personal being, he did not yet suspect that God was the object of his deep longing. Nonetheless, moving from impersonal theism to personal theism brought him even closer to Christianity.

Certain important experiences continued moving Lewis further along in considering the possible truth of the Christian worldview. Griffiths, his chief companion at this time, became a Christian believer. And Lewis remembered how *The Everlasting Man* by Chesterton had helped him understand the Christian outline of history. And Lewis had never shaken off the disturbing conversation with atheist T. D. Weldon years earlier:

Early in 1926 the hardest boiled of all the atheists I ever knew sat in my room . . . and remarked that the evidence for the historicity of the Gospels was surprisingly good. "Rum thing . . . All that stuff . . . of Frazer's about the Dying God. Rum thing. It almost looks as if it had really happened once." . . . If he, the cynic of cynics, the toughest of the toughs, were not—as I would still have put it—"safe," where could I turn? Was there then no escape?[69]

Lewis's friend George Sayer reports that the impact of this encounter on Lewis "was shattering" because it acknowledged evidence that the dying god pattern may have been instantiated in human history.[70]

Exchanges with Barfield convinced him that the great pagan myths were not purely false but were glimpses of truth:

> The question was no longer to find the one simply true religion among a thousand religions simply false. It was rather, "Where has religion reached its true maturity? Where, if anywhere, have the hints of all Paganism been fulfilled?"[71]

It was precisely Christianity's central historical claim—that God was in Jesus—that Lewis had to face. He now believed that God was personal, but what more could we know about this personal God?

During this time in his thinking process, Lewis confessed to being in a "muddle" over imagination and reason—which in turn "muddled" his understanding of the relationship between myth and truth.[72] His late-night talk with Dyson and Tolkien in September of 1931, helped him work through that muddle. The three friends strolled around Addison's Walk, discussing the nature of metaphor and myth. Lewis maintained that all myths are "lies breathed through silver," but Tolkien countered that great myths are not pure falsehoods but are, in the technical literary sense, symbolic narratives that convey important truths that are inexpressible in literal language.

Theologian Alister McGrath explains how Tolkien's approach helped the rationalistic Lewis engage the Christian narrative: "The issue was not primarily about truth, but about meaning. When engaging the Christian narrative, Lewis was limiting himself to his reason when he ought to be opening himself to the deepest intuitions of his imagination."[73] Tolkien urged Lewis to allow the Gospels to convey the full significance of Christianity by seeing them as framing historical facts in symbolism that reveals higher meaning. McGrath emphasizes that a crucial awakening for Lewis was his coming to understand "how reason and imagination may be both affirmed and integrated within a Christian vision of reality."[74] Perhaps it is not surprising that Lewis would later become one of the foremost Christian mythmakers.[75] As reason and imagination for him became reconciled, Lewis moved much closer to Christian faith, but he was not quite ready for the next step.

An expert in literary criticism, Lewis knew the gospel reports were not pure myth: they were not crafted like the elegant pagan myths, and they contained concrete detail the others lacked. Once he admitted this distinction, the historicity of the Incarnation of God in Jesus Christ became clearer to him: "Here and here only in all time the myth must have become fact; the Word, flesh; God, Man. This is not 'a religion,' nor 'a philosophy.' It is 'the summing up and actuality

of them all.'"[76] As his thoughts on the subject came together, he found himself believing that Jesus was the Son of God, writing to Arthur Greeves on October 1, 1931, "I have just passed on from believing in God to definitely believing in Christ—in Christianity. I will try to explain this another time. My long night talk with Dyson and Tolkien had a good deal to do with it."[77] In grasping both the truth and the significance of Christianity, Lewis opened himself to a total reorientation of his life such that he was later able to represent Christian faith as holistic—intellectually persuasive, emotionally satisfying, and existentially fulfilling. Regarding the capacity of Christianity to provide a compelling explanation of the relevant data—such as mind, morality, personhood—Lewis eloquently wrote, "I believe in Christianity as I believe that the Sun has risen, not only because I see it, but because by it I see everything else."[78]

3

Joy and the Meaning of Life

As a Christian, Lewis understood that his long journey to faith was motivated by an intense lifelong desire for something beyond this world. He often referred to this special experience as "Joy," capitalizing it and making it a technical term in his works. Here we examine the important role Joy played in Lewis's personal search, including his evolving understanding of it and its relation to his intellectual acceptance of the Christian worldview. It is a charming coincidence that Lewis late in life met and married an American woman named Joy, with whom he found a deeply meaningful relationship that he had never thought possible in this life.

Desire and Lewis's Personal Journey

Lewis frequently stated that his journey to Christianity was "almost entirely philosophical" because he was dedicated to finding a worldview that would provide an adequate explanation of important phenomena such as mind, morality, and personhood. We are now familiar with his journey from atheistic materialism through forms of idealism to theism and finally to Christianity, which he thought explained these important phenomena better than competing worldviews explained them. However, Lewis also clearly emphasized that the central story of his life was mainly about "Joy"—about his persistent search to possess this important experience and to understand its deeper nature.[1] In his Christian conversion, as he explains it, the intellectual and existential aspects of his life converged, giving him a sense of wholeness and completeness.[2]

From childhood, Lewis had a rich imaginative life that brought him much enjoyment—fantasy worlds to live in, with talking animals and other fantastic creatures. Yet the early death of his mother, bad boarding schools, and exposure to the atheistic perspectives of his early teachers were all factors serving to suppress his interest in imaginative things. Furthermore, he began early adulthood as a materialist and atheist, who classified Joy as subjective experience. Nevertheless, Lewis explains, that "old stab" or "old thrill" would often return when he was reading fantasy literature like *Squirrel Nutkin* or Norse mythology, which he loved. But the different philosophical perspectives he adopted provided

C. S. Lewis and the Christian Worldview. Michael L. Peterson, Oxford University Press (2020).
© Oxford University Press.
DOI: 10.1093/oso/9780190201111.001.0001

no adequate categories for understanding the significance of this recurring experience.

Although Lewis would from time to time be captivated by the poignant experience that he variously called a "sensation" and a "flutter in the diaphragm" and "that old bittersweet," he never quite captured it. What he did know was that it was a kind of unsatisfied wanting which itself was a delight and that the wanting suggested an elusive, mysterious object. Lewis commentators have their own ways of speaking about the mysterious, undefined object of this special desire. Although many commentators call it "desire for God," Peter S. Williams calls it "desire for divinity"; Peter Kreeft declares it "desire for heaven," while Adam Barkman terms it "heavenly desire"; John Haldane takes it as "desire for transcendent fulfillment," whereas Arend Smilde uses the term "desire for meaning."[3] Yet all commentators agree that God is the ultimate ground of heaven, fulfillment, meaning, or happiness, such that desire for any of these is a way of desiring God, knowingly or unknowingly. Although for Lewis this intense desire was initially undefined, he eventually came to see it as a desire *for* something beyond this world, "a desire for something longer ago or further away or still 'about to be.'"[4] In other words, the *direction* of the search became clear before the exact nature of the *object* became known. Let us use the term "transcendent desire" or "transcendent longing" as an umbrella term ranging over all of the other terms.

Elements of Transcendent Desire

"Transcendent desire" for Lewis seems to be constituted by several elements that may be identified and analyzed as we gain a greater understanding of how Lewis thought about this special desire. Barkman has identified six terms Lewis used for "transcendent desire," which signal six important concepts that we must now briefly survey: Platonic *eros*, Romanticism, the *numinous, Sehnsucht*, Joy, and hope.[5] The first concept built into Lewis's theory of transcendent desire is *eros*, from Plato's writings. The *Phaedrus* mythically portrays *eros* as the soul's passionate love of Beauty, which it once enjoyed directly in heaven but indistinctly remembers even in its earthly embodiment.[6] The *Symposium* associates *eros* with the sexual need to be made complete, inspiring the theme in Lewis that the soul is attracted to Beauty to be made complete but must not mistake earthly copies of Beauty for Beauty itself.

Romanticism is the second element in Lewis's theory of transcendent desire, invoking the concept of the sublime as reflecting the immanence of God, an approach associated with the literary movement of the turn of the eighteenth century. Lewis subtitled *The Pilgrim's Regress* "An allegorical apology for Christianity, Reason, and Romanticism," revealing his love of the Romantic movement, as did

his mentions of sources such as Coleridge's "Kubla Khan." He even extended the term "Romanticism" to cover his love of stories of dangerous adventure, Nature itself, and the marvelous, such as fairies and nymphs.[7] He explained in the Preface to the third edition of *Regress* that he had used the term "Romanticism" for his sense of transport and longing, which gave it a "private meaning": "What I meant was a particular recurrent experience which dominated my childhood and which I hastily called 'Romantic' because inanimate nature and marvelous literature were among the things that evoked it."[8] Regardless of stimuli, the feeling was a painful but delightful sense of hunger for an object that is not given in experience, which Lewis often characterized as the longing for one's true home, an experience that he portrays in his Narnia series. Upon arriving in the New Narnia, Jewel the unicorn exclaims, "I have come home at last! This is my real country! I belong here. This is the land I have been looking for all my life, though I never knew it till now. The reason why we loved the old Narnia was that it sometimes looked like this."[9]

In 1936, Lewis read Rudolf Otto's *The Idea of the Holy*, which contributed the third element of his theory of desire—the idea of the *numinous* as state of mind. For Otto, "the *Numen*"—or "the Holy"—is the Sacred considered apart from any moral or rational aspects and the *numinous* is the creature's powerful emotional response of being "submerged and overwhelmed."[10] Lewis believed that Otto had identified "the seed of religious experience in our experience of the Numinous," which religion then defines as direct experience of "a Being who is more, but not less, than the God whom many reputable philosophers think they can establish."[11] Otto believed that fairy story and myth were infused with the *numinous*, a point not lost on Lewis. For example, the Pevensie children in the Narnia stories had feelings of awe when Mr. and Mrs. Beaver said that Aslan was really a lion, not a man:

> "Then he isn't safe?" said Lucy.
> "Safe?" said Mr. Beaver; "don't you hear what Mrs. Beaver tells you? Who said anything about safe? 'Course he isn't safe. But he's good. He's the King I tell you."[12]

As Otto explained, the *numinous* is both fascinating and dreadful.

The fourth component in Lewis's theory of transcendent desire is *Sehnsucht*, a German term he probably learned while studying with Kirkpatrick and reading the German Romantic writers Goethe and Novalis. "They taught me longing—*Sehnsucht*," Lewis wrote.[13] He typically used the term *Sehnsucht* to speak of "our lifelong nostalgia," which for Lewis was a Christianized Platonic *eros*: "if we are made for heaven, the desire for our proper place will already be in us, but not yet attached to the true object."[14]

The fifth element in Lewis's theory of transcendent desire was "Joy"—a term he originally used in his 1924 poem "Joy" and continued to use in *Surprised by Joy*. Lewis describes Joy as "an unsatisfied desire which is itself more desirable than any other satisfaction" and then continues,

> I call it Joy, which is here a technical term and must be sharply distinguished from both Happiness and Pleasure. Joy (in my sense) has indeed one character-istic, and one only, in common with them; the fact that anyone who has experi-enced it will want it again.[15]

Joy is distinct from Happiness and Pleasure because it is an instrumental good that leads to those intrinsic goods. What Joy has in common with Platonic *eros*, "Romanticism," the *numinous*, and *Sehnsucht* is clear: they all contain the dual experience of *loss* (which results in pain) and *desire* (which is compelling and all consuming).

Lewis knew well that Joy shares with the other elements of transcendent de-sire the quality of being seductive and addictive if sought as an end in itself. He portrays Edmund's attraction to Turkish Delight that he received from the wicked Queen to reflect the danger:

> At last the Turkish Delight was all finished and Edmund was looking very hard at the empty box and wishing that she would ask him whether he would like some more. Probably the Queen knew quite well what he was thinking; for she knew, though Edmund did not, that this was enchanted Turkish Delight and that anyone who had once tasted it would want more and more of it, and would even, if they were allowed, go on eating it till they killed themselves.[16]

Sought as an end in itself, Joy, like Turkish Delight, leads one astray, but when we understand Joy as the desire for something else—for true happiness, for God—it can guide us to its proper target.

In Lewis's later writings, Joy as the desire for happiness became an increasingly important theme emphasizing its teleological import—that there is a reason why people have been given an "appetite for beatitude" and that we all have been made for "infinite happiness."[17] Lewis identified Happiness itself with God be-cause God's own intrinsic life is one of eternal happiness or beatitude—which then allows him to define human happiness as total fulfillment in relation to God. In *Till We Have Faces*, Lewis's retelling of the myth of Psyche and Eros, be-fore Psyche is to be sacrificed to the god of the Mountain, she tells Orual of her longing to go there:

"The sweetest thing in all my life has been the longing—to reach the Mountain, to find the place where all the beauty came from . . . my country, the place where I ought to have been born. Do you think it all meant nothing, all the longing? The longing for home? For indeed it now feels not like going, but like going back. All my life the god of the Mountain has been wooing me."[18]

Before his theistic conversion, Lewis held the Kantian view that we must do the right thing on principle without any motivation for benefits, such as Joy or heaven. However, in reflecting on his Christian conversion, he realized that the purpose of Joy as transcendent longing is to lead us to Happiness—that is, to God.[19] John in *Pilgrim's Regress* says, "I am not high-minded like you, Vertue: it was never anything but sweet desire that led me. . . . [You must] give in. For once yield to desire. Have done with your choosing. *Want* something."[20] Following desire in regard to Happiness is simply the humble admission of our human need and insufficiency as well as our attraction to God as source of all happiness.

Hope is the sixth concept that Lewis associated with transcendent desire. While hope shares with the previous concepts the *natural* sense of longing for divine fulfillment, Lewis took hope as a distinctively *supernatural* desire for God in the life of a Christian believer, identifying it as one of the three theological virtues (with faith and love) which are given by God through grace. Hope, for Lewis, is "a continual looking forward to the eternal world" that serves to put in perspective our calling to serve the present world.[21] Hope joins the other five concepts to elucidate "transcendent desire" in Lewis's writings.

Happiness and God

Millions of readers have found Lewis's description of his search for Joy to be fascinating and compelling, and the attraction to his story can be explained in two ways. Joy in Lewis's journey may be appealing to readers because of the colorful particularities of his intellectual and emotional profile—his love of imagination, his sense of being beckoned to something beyond, the poignancy in his moments of bliss. However, it may also appeal to many readers because it captures something universal in every person. After all, if Lewis's search for Joy is completely explicable in terms of his unique personality and emotional triggers, then it was purely idiosyncratic while still producing a remarkable life transformation. On the other hand, if Lewis's search reflects a generically human longing for transcendent fulfillment that was embodied in his personal experiences, then we must come to terms with its larger human significance. Lewis seems to have been fully convinced of the latter explanation, although he confesses to expressing it too subjectively on many occasions.

Devin Brown observes that Lewis's frequent "use of an all-inclusive you" when writing of Joy "makes it clear that Lewis believes this is a longing we all have felt." Brown adds, "Lewis might say this is the central story of everyone's life."[22] It is impossible for every person to have exactly the same intellectual background or emotional tone as another person, yet Lewis tried to characterize the common thread:

> There have been times when I think we do not desire heaven, but more often I find myself wondering whether, in our heart of hearts, we have ever desired anything else . . . tantalizing glimpses, promises never quite fulfilled, echoes that died away just as they caught your ear. But if . . . there ever came an echo that did not die away but swelled up into the sound itself—you would know it. Beyond all possibility of doubt you would say, "here at last is the thing I was made for."[23]

Although this point is expressed in experiential terminology that is meaningful to Lewis but not to everyone, it still affirms that transcendent desire, whatever our differing emotional triggers, is the universal human longing for something beyond experience that holds the key to our existence.

Indeed, thoughtful persons of all periods and cultures and backgrounds that we know of have expressed in their religions, art, great literature, and philosophical treatises a longing for something beyond this world. Even among agnostics and atheists, witnesses to this longing are abundant, such as Bertrand Russell's comment in a letter to one of his female intimates:

> *To Collette O'Neil:* The center of me is always and eternally a terrible pain . . . a searching for something beyond what the world contains, something transfigured and infinite—the beatific vision, God—I do not find it, I do not think it is to be found—but the love of it is my life . . . it is the actual spring of life within me.[24]

It is ironic that Russell desperately wanted there to be objective meaning to life, some kind of ultimate fulfillment, while his atheistic worldview considered the universe "a meaningless dance of atoms." Lewis's early search contained these same conflicting elements.

Testimony to a longing that cannot be fulfilled by earthly things is also voiced by countless Christian believers down through the centuries. Augustine put it well: "Thou hast made us for thyself, O Lord, and our hearts are restless until they find their rest in Thee."[25] According to orthodox Christianity, we are attracted to God because he has built into humanity a desire for himself. A finite

rational-moral-relational being can be fulfilled only in relation to the infinite rational-moral-relational being. Nothing less will do.

In this vein, John Haldane correctly considers Lewis to stand within the tradition of the "restless heart," which is attested to by writers down through the centuries. Classically, the overall meaning of human life is to find distinctively human happiness—or *eudaimonia* conceived as the fulfillment of the distinctively human *telos* (Greek: end, goal, purpose). Although many goods are available in human life (such as friendship and legitimate pleasures), only the highest good, the final good, makes for human flourishing. Since Lewis held that transcendent longing points us toward God as the source of true happiness, his view is a form of Christian eudaimonism. As a medievalist, he knew the literature on the search for the "beatific vision"—in Latin, *beatus* (happy); *facio* (I make); *visio* (a sight)—which completes the meaning of human life. The *Divine Comedy* epitomizes the search for the beatific vision, as Dante portrays himself journeying through Hell, Purgatory, and Paradise to find creaturely beatitude or blessedness that can be found only in God's beatitude, which is characterized by perfect, unending love, peace, and joy.

As Aquinas says, the "wish of the rational creature" for happiness—which was at the core of the transcendent longing Lewis experienced—is found by "participation" in the "good of all goods."[26] Lewis makes the same point in "Religion Without Dogma": "For the essence of religion, in my view, is the thirst for an end higher than natural ends; the finite self's desire for, and acquiescence in, and self-rejection in favor of, an object wholly good and wholly good for it."[27] The essential point is that Lewis saw in his own personal sense of transcendent desire a distinctively and universally human experience of longing for something beyond experience that holds the key to our existence.

Is There a Lewisian Argument from Desire?

Given the importance of transcendent longing in Lewis's prolonged journey to the Christian God, we would expect to find in his writings some line of reasoning, implicit or explicit, that articulates how this special longing supports belief in God. Lewis wrote about the "argued dialectic" of his philosophical progress and even of the "dialectic of Desire" that he followed, from which many commentators infer that he was speaking of an identifiable line of reasoning based on transcendent desire that concludes with God as its source.

Lewis critic John Beversluis actually coined the term "argument from desire" in his 1985 book *C. S. Lewis and the Search for a Rational Religion*, which was a full-scale attack on Lewis's arguments for Christian belief.[28] Then Peter Kreeft's

1989 essay "C. S. Lewis's Argument from Desire" made the idea of an "argument" common in the secondary literature.[29] Lewis's "argument from desire" is often said to complete a triad of peculiarly Lewisian theistic arguments, along with his arguments from reason and morality, which are treated in the next two chapters. Yet commentators and critics differ over the logical structure of Lewis's putative argument from desire.

Four main sources are considered to ground the Lewisian argument from desire:

- "Hope" in *Mere Christianity* (a BBC talk in 1943, included in the 1952 published book)
- "The Weight of Glory" (Lewis's most famous sermon given in 1941)
- *The Pilgrim's Regress* (Lewis's allegorical account of his own conversion published in 1933, with clarifications offered in his 1943 Preface to the 3rd edition, now an Afterword)
- *Surprised by Joy* (Lewis's autobiography published in 1955)

Lewis's autobiography does not contain an explicit argument but provides the reader key ideas—such as transcendent longing that requires explanation—from which an argument can be constructed.

The most frequently cited passage for his argument from desire is from *Mere Christianity*:

Creatures are not born with desires unless satisfaction for those desires exists. A baby feels hunger: well, there is such a thing as food. A duckling wants to swim: well, there is such a thing as water. Men feel sexual desire: well, there is such a thing as sex. If I find in myself a desire which no experience in this world can satisfy, the most probable explanation is that I was made for another world. If none of my earthly pleasures satisfy it, that does not prove that the universe is a fraud. Probably earthly pleasures were never meant to satisfy it, but only to arouse it, to suggest the real thing.[30]

In his sermon "The Weight of Glory," we find another familiar passage to this effect:

We remain conscious of a desire which no natural happiness will satisfy. But is there any reason to suppose that reality offers any satisfaction of it? . . . A man's physical hunger does not prove that any man will get any bread; he may die of starvation on a raft in the Atlantic. But surely a man's hunger does prove that he comes of a race which repairs its body by eating and inhabits a world where eatable substances exist. In the same way, though I do not believe . . . that my desire

for Paradise proves that I shall enjoy it, I think it a pretty good indication that such a thing exists and that some men will.[31]

The focus of the BBC broadcast was practical, and that of the sermon pastoral, but each offers the basis of an argument.

Perhaps the most explicit and fascinating rendition of what could be called a Lewisian argument from desire appears in the Afterword to *Regress*:

> It appeared to me therefore that if a man diligently followed this desire, pursuing the false objects until their falsity appeared and then resolutely abandoning them, he must come out at last into the clear knowledge that the human soul was made to enjoy some object that is never fully given—nay, cannot even be imagined as given—in our present mode of subjective and spatiotemporal experience. This Desire was, in the soul, as the Siege Perilous in Arthur's castle— the chair in which only one could sit. And if nature makes nothing in vain, the One who can sit in this chair must exist.[32]

The two previous passages lend themselves to inductive or probabilistic interpretations of the argument ("the most probable explanation" and "a pretty good indication"), but this passage seems to invite a stronger deductive interpretation ("must exist").

Among the various interpretations of the argument's structure, Kreeft's deductive syllogistic rendition of it is the most famous and provides the basis of our discussion:

1. Every natural and innate desire in us bespeaks a corresponding real object that can satisfy the desire.
2. There exists in us a desire which nothing in time, nothing on earth, no creature, can satisfy.
3. Therefore, there exists something outside of time, earth, and creatures which *can* satisfy this desire.

To the conclusion that a transcendent object exists, Kreeft adds a theistic identifier:

4. This [transcendent] something is what people call "God" or "Heaven."

We briefly note that Robert Holyer amends premise 1 to read "most" rather than "every," thus yielding an inductive interpretation.[33] Also, Gregory Bassham contends that no rendition of the argument, deductive or inductive, is viable on

its own but at best could be included in a cumulative case for Christian theism along with Lewis's arguments from reason and morality.[34]

Clearly, Kreeft's syllogism is deductively valid, which means that the evaluation of its overall soundness hinges on the truth or probability of its premises. In order to get a sense of their viability, let us consider criticisms of the premises offered by John Beversluis. Beversluis takes premise 1—the major premise—as an empirical claim because he learned from Roger Lancelyn Green and Walter Hooper's biography of Lewis that Lewis calls himself "an empirical theist" in his unpublished autobiography, "Early Prose Joy."[35] Then Beversluis attacks the grounds for the empirical premise:

> How could Lewis have known that every natural desire has an object that can satisfy it *before* knowing that Joy has one? I can legitimately claim that every student in the class has failed the test only if I first know that each of them has individually failed it. The same is true of natural desires.[36]

Beversluis accuses Lewis of supporting this claim "on the basis of nonempirical considerations" and therefore smuggling "a covert metaphysical theory" into the argument.

However, Lewis's self-description as an "empirical theist" indicated that he tested in practice the livability of his various worldview perspectives, particularly in regard to Joy, not that he had an empirical data set supporting premise 1 by some sort of induction. Lewis, of course, meant premise 1—the claim that all natural desires have satisfiers—as a *metaphysical claim* which is built into the concept of *natural desire*. The term *natural* here refers to properties, powers, and propensities that are inherent to *universal human nature* and thus part of the metaphysical structure of reality. As grounds for premise 1, Lewis cites the Aristotelian principle that "nature does nothing in vain"—which affirms that desires that are fundamental to human nature have teleological import and are not fraudulent.[37] There is no guarantee, of course, that every member of the human race will find adequate food or find the meaning to life, but that does not invalidate the hunger-food connection or the desire-meaning connection.

Attacks on the premise usually miscue on the meaning of the term "natural desire," trivializing or otherwise mischaracterizing it. For instance, Bassham comments that there is no guarantee that "natural fantasy desires" have objects that can satisfy them.[38] However, Lewis was not referring to fantasies, which can be whimsical; neither is he silly enough to say that conditioned or acquired desires automatically have satisfiers. Also, Beversluis interprets "natural desire" in terms of the "biological and instinctive," meaning what was produced by evolution for species survival. Since transcendent desire, according to Beversluis, has no survival value for *Homo sapiens*, he concludes that "it is almost completely

dissimilar" from all other natural desires and cannot claim universality across the race. But here Beversluis's own reductionist metaphysics is smuggled in, limiting the reality of our humanity to the tangible and physical. Besides, Lewis the Christian theist understood that many higher aspects of personhood, including transcendent desire, can be mediated by biological processes, including neurological processes.

Beversluis likewise attacks premise 2—the minor premise—which is the claim that we have a longing for something beyond this world. Although Lewis affirmed this premise for himself and believed that many thoughtful people also affirm it for themselves, Beversluis asks, "What, then, of people who know nothing about Joy, who look askance at the mention of 'inconsolable longing,' who neither have nor want to be 'stabbed' by this 'bittersweet sense of loss'?"[39] Admittedly, Lewis does not always make it easy to defend universal transcendent desire when he describes it in terms of his own idiosyncratic feelings, which will not resonate with all people. Nonetheless, philosopher Richard Purtill affirms Lewis's deeper point that in various ways "almost everyone" has experienced transcendent longing.[40]

Although much more remains to be discussed regarding an argument from desire in Lewis, we know that, if both premises are reasonable to believe, then the conclusion is reasonable to believe. Of course, the conclusion does not establish everything that is popularly or even theologically understood by God or heaven, but it does point to something beyond the natural world that is the object and the only possible satisfier of our transcendent longing. This direction of thought is faithful to Lewis's reasoning as he turned from longing *for longing* and realized that his intense longing was *for something beyond this world*—call it an unknown X—which began a process of more specific identification of this something—this X—that led him to the theistic God and then to Christ.

The Lived Dialectic of Desire

Not all commentators detect in Lewis an *argument* from desire to God, but their reasons for this opinion vary. Lewis commentator Joe Puckett, for example, explores the role Joy played in bringing Lewis to belief in God, comparing it to Alvin Plantinga's theory of "properly basic belief"—which asserts that some beliefs are rationally warranted if they are produced by an appropriate cognitive faculty (such as perception) functioning normally under appropriate conditions (such as adequate lighting). Plantinga thinks that a cognitive faculty like John Calvin's *sensus divinitatis* (sense of the divine) can produce belief in God in us under appropriate circumstances. Puckett simply includes Joy, or transcendent longing, as able to work through the *sensus divinitatis* in human persons.[41]

However, Arend Smilde not only denies that Joy has an argumentative role in Lewis but also denies that Joy is on the rational side of Lewis's search at all. Smilde's case depends largely on his interpretation of Lewis's distinction between his "argued dialectic" and his "lived dialectic," and then of how these two aspects of Lewis's experience "converged" in his Christian conversion. The following lines in the Afterword of *Regress* are key to this consideration:

> The dialectic of Desire, faithfully followed, would retrieve all mistakes, head you off from all false paths, and force you not to propound, but to live through, a sort of ontological proof. This lived dialectic, and the merely argued dialectic of my philosophical progress, seemed to have converged on one goal; accordingly I tried to put them both into my allegory which thus became a defense of Romanticism (in my peculiar sense) as well as of Reason and Christianity.[42]

Smilde believes that many readers mistakenly interpret Lewis's term "dialectic of desire" to be associated with the great tradition of Western rational argumentation on life's great issues, whereas Smilde takes the whole passage to be expressing a dichotomy between two kinds of dialectic—*argued* and *lived*—with desire completely on the "lived" or experiential side. It would be better, Smilde says, to speak of the "dynamic of desire," which was what Lewis's long experience suggested was the pattern of this unknown thing's "habit of alternately inviting and refusing identification with some other thing in the external or even internal world."[43]

The strict separation of the experiential and rational aspects of this process is crucial to Smilde's interpretation of *convergence* in Lewis:

> What his *lived* dialectic of Desire did, in its own way and by its own means, was to "converge on one goal" with his *argued* dialectic. There seems to have been no discernible "order of salvation" here, no pre-eminence for one or the other of the converging forces. While reason may seem rock-bottom basic at times, on the other hand so does "Joy"; but if left to its own devices Joy would be helpless.[44]

For Smilde, there is *argument* and there is *desire*, but there is no "argument from desire." The moment of "convergence" occurred, according to Smilde, when Lewis decided to take his peculiar experience of desire seriously as the desire for meaning, which he had already come to accept on rational grounds.[45] After all, Lewis had already rejected materialism because it could not account for rationality and meaning, and he had rejected idealism because it could not account for morality and personhood. Since he was already intellectually convinced that ultimate reality was supernatural, rational, moral, and meaningful, he was

prepared to conclude that something divine was the object of his deep longing for meaning.

However, Smilde seems to take Lewis's dramatic language about the "argued" and "lived" aspects of his journey to an extreme, which then allows Smilde to claim that the two entirely different aspects "converge" when Lewis embraces Christian faith. For one thing, while Lewis never officially formalized an argument from desire, this does not mean that his writings, which were meant for various purposes, do not contain the basis, which Lewis was aware of, for a line of reasoning from transcendent desire to God—a matter we shall pursue shortly. For another thing, a more holistic interpretation recognizes that the different elements were coming together in Lewis as a total person in a complex process of realignment and reorientation. His experiential side was always invested with rational categories and critical evaluations, just as his rational side was constantly receiving and sorting through input from practical experience.

One of Smilde's most insightful points is that desire in Lewis is best understood as desire for ultimate meaning—which we may take as an indication of the "restless heart" looking for its proper fulfillment. Nevertheless, Smilde rejects any notion of a Lewisian *argument from the desire for meaning* to the existence of ultimate meaning, while affirming that Lewis's reasoned conviction that theism was true led him to consider something divine as the "best explanation" of his persistent desire.[46] This is an odd construal of Lewis's thinking because an *argument to the best explanation* is still an *argument*—and an argument to the best explanation of *desire* is still an *argument from desire*.

Alister McGrath, with whom Smilde explicitly disagrees, interprets Lewis's argument from the desire for meaning as an "argument to the best explanation," stating,

> Lewis then develops an *"argument from desire,"* suggesting that every natural desire has a corresponding object [He] argues that the Christian faith interprets this longing as a clue to the true goal of human nature. God is the ultimate end of the human soul, the only source of human happiness and joy. . . . Like right and wrong, this sense of longing is thus a "clue" to the meaning of the universe.[47]

McGrath characterizes Lewis's overall approach as follows:

> This is not about "proving" anything; it is about trying to identify which, of several possible explanations, is the best. . . . Lewis's argument is best seen as the commendation of a "big picture," an overall way of seeing things which appears to position elements of reality in a plausible manner.[48]

McGrath's "big picture" is best taken as a comprehensive worldview explanation of the key phenomena of life and the world—not only of desire, but of morality, mind, and personhood as well. Worldviews can be compared and evaluated in terms of how well they explain these key phenomena—and while worldview comparisons on these points are not proofs, as very few arguments about reality are, they still have argumentative significance.

How probable is it that humanity's deep existential desire for meaning would occur if the Christian worldview were true? Alternatively, how probable is it that this desire would exist if materialism were true? Or if idealism were true? In Chapter 2, we indicated that many of Lewis's arguments are abductive—arguments to the best explanation. Lewis argues *comparatively* that all important phenomena of life are much more likely if the Christian worldview is true than if other competing worldviews are true. Other worldviews distort or deny the phenomenon of transcendent desire because they cannot fit it in, whereas in the Christian worldview, as Lewis remarked, "Joy, as I now understood it, would fit in."[49] Put symbolically, where D is transcendent desire, C is Christianity, and W is any alternative worldview, his comparative claim is as follows:

$$P(D/C) > P(D/W).$$

In the language of Chapter 2, Christianity (C) provides a more adequate explanation than its worldview competitors because of the closer conceptual connections between the deep desire for meaning and fulfillment and the God described by Christianity. Expressed in terms of "epistemic surprise," the existence of transcendent desire (D) is far less epistemically surprising assuming that Christianity (C) is true than assuming any other worldview (W) is true.

As always, much more remains to be discussed, but it is reasonable, all things considered in Lewis, to interpret his desire for meaning as playing an important role in *both* converging aspects of his experience—his developing rational line of argument and his emerging clarity on the satisfaction of his existential need. His conclusion that the object of his desire—that is, ultimate meaning or a Being who could give ultimate meaning—"must exist" is, then, invested with both *rational* and *existential* necessity. Rationally, all of the other worldview explanations had been eliminated; no other account of reality did justice to this desire. So, he reasoned, if the object of desire does not exist, then the universe really is meaningless. And existentially this would entail that Lewis's own life was meaningless.

Besides, quite apart from the familiar desire passages under discussion, Lewis argued in various locations that there *must* be objective meaning that satisfies our desire for meaning or else life and the world are meaningless:

Surely the dilemma is plain. Either there is significance in the whole process of things as well as in human activity, or there is no significance in human activity itself. It is an idle dream, at once cowardly and arrogant, that we can withdraw the human soul, as a mere epiphenomenon, from a universe of idiotic force, and yet hope, after that, to find for her some *faubourg* where she can keep a mock court in exile. You cannot have it both ways. If the world is meaningless, then so are we; if we mean something, we do not mean alone.[50]

From Lewis's days as a materialist, he knew that, if the human soul is nothing but a by-product (epiphenomenon) of a mindless, meaningless universe, then life has no objective and ultimate meaning. Human persons cannot pretend to inhabit some outlying suburb (French: *faubourg*) of the universe in which we can carry on the sham of meaning (in a mock court).

Either there is meaning, and hence we mean something—or not. If there is meaning, then we are not alone in the universe because ultimate meaning is possible only if the heart of reality is a supremely good, powerful, and purposeful personal agent who in himself is the ground of meaning. All other worldview alternatives project realities that are inadequate to the task. Essentially, this reasoning tracks Lewis's *argued dialectic of desire*, which eliminated rationally other putative realities that could not make full sense of transcendent desire and propose false satisfiers. Similarly, Lewis's *lived dialectic of desire* eliminated existentially other potential satisfiers of desire as inadequate in lived experience. Thus, Lewis had two dialectics of desire—*argued* and *lived*—which "converged" and led to his conversion to Christianity.

On the rational or argued side, although it is *logically* possible that theism and Christianity are false, the argument from desire is that Christianity provides a more adequate explanation of meaning than all other worldview alternatives provide, thus giving good rational grounds for believing it. Besides, what if we believed Christianity on rational grounds but were mistaken? Lewis pressed the argument as follows:

> But supposing one believed and was wrong after all? Why, then you would have paid the universe a compliment it doesn't deserve. Your error would even so be more interesting and important than the reality. And yet how could that be? How could an idiotic universe have produced creatures whose mere dreams are so much stronger, better, subtler than itself?[51]

Again, the desire for meaning is hard to account for in a meaningless universe, as is rationality in an irrational universe and morality in an amoral universe. So, if the universe really is meaningless, it is extremely difficult to account

philosophically for how humans, as a product of the universe, could perceive that it is meaningless, much less to desire that meaning.

On the "lived" or existential side, it is natural to seek satisfaction for the deep desire for meaning, trying to clarify the nature of the object that could provide that satisfaction. However, it is also natural to experience a degree of fear or reluctance in encountering the Source of all meaning, for as Lewis realized, relationship to the Source would mean surrendering control of one's life. As Rudolf Otto indicated, in the presence of the *numinous*, the ultimate holy being, one feels both fascination and dread, the typical approach/avoidance response.

The Silver Chair portrays this kind of response in Jill Poll, who becomes lost in a strange wood and walks in search of water, alone and desperately thirsty. She finds a clear, inviting stream but stops dead in her tracks and does not drink, for beside the stream lies the Lion who was at once both wonderful and terrifying:

> "Are you not thirsty?" said the Lion.
>
> "I'm *dying* of thirst," said Jill.
>
> "Then drink," said the Lion.
>
> "May I—could I—would you mind going away while I do?" said Jill.
>
> The Lion answered this only by a look and a very low growl. And as Jill gazed at its motionless bulk, she realized that she might as well have asked the whole mountain to move aside for her convenience.
>
> The delicious rippling noise of the stream was driving her nearly frantic.
>
> "Will you promise not to—do anything to me, if I do come?" said Jill.
>
> "I make no promise," said the Lion.
>
> Jill was so thirsty now that, without noticing it, she had come a step nearer.
>
> "*Do* you eat girls?" she said.
>
> "I have swallowed up girls and boys, women and men, kings and emperors, cities and realms," said the Lion. It didn't say this as if it were boasting, nor as if it were sorry, nor as if it were angry. It just said it.
>
> "I daren't come and drink," said Jill.
>
> "Then you will die of thirst," said the Lion.
>
> "Oh dear!" said Jill, coming another step nearer. "I suppose I must go and look for another stream then."
>
> "There is no other stream," said the Lion.[52]

In Jill's conversation with Aslan, Lewis portrays poignantly the mixed feelings an encounter with the Source generally evokes. In the end, Lewis recognized that "God cannot give us a happiness and peace apart from Himself, because it is not there."[53]

4

Mind, Miracle, and Nature

Over the course of his journey, Lewis abandoned atheistic materialism for absolute idealism, seeking a more adequate worldview explanation of Joy and of the phenomena of consciousness generally. Although he eventually found all versions of idealism to offer inadequate explanations of these same important phenomena, he retained from his idealist days a keen interest in finding the best explanation of rational thought as an important aspect of consciousness. In essence, he asked the comparative worldview question: in what kind of universe does rational thought make best sense? When rational thought is conceived as the power of "following logical rules" and of achieving "genuine insight into reality," Lewis believed that some form of supernaturalism—particularly theism—provided the best explanation. In his book *Miracles*, which was first published in 1947 and later revised in 1960, he articulated what is now known as his "argument from reason," his most important contribution to contemporary philosophy. He framed the argument as a comparison of naturalism and theism in regard to the validity of rational thought, contending that rational thought requires the possibility of an event that is not the product of a natural process—what is technically a "miracle" on the classical definition.

Consciousness, Mind, and Self

Although not original to Lewis, since he picked up the idea of an argument from reason in reading G. K. Chesterton and Arthur J. Balfour, Lewis gave the argument his own sustained treatment and expression.[1] Regarding the appearance of consciousness, Lewis was well aware of the general explanation provided by evolutionary science: "Chemical conditions produce life. Life, under the influence of natural selection, produces consciousness. Conscious organisms which behave in one way live longer than those which behave in another. Living longer, they are more likely to have offspring."[2] Lewis did not make these scientific claims his target; neither did he pursue the hotly debated question these days of how consciousness can come from matter. Rational thought itself was the touchstone for his argument.

Lewis's argument engaged the prevailing naturalism of his day over its capacity to explain rational thought—and for simplicity we follow Lewis's general

C. S. Lewis and the Christian Worldview. Michael L. Peterson, Oxford University Press (2020).
© Oxford University Press.
DOI: 10.1093/oso/9780190201111.001.0001

identification of naturalism with reductionist materialism, the view that all phenomena are reducible to the material. In our own day, reductionist materialism has its representatives, such as Daniel Dennett, who holds that "only a theory that explained conscious events in terms of unconscious events could explain consciousness at all."[3] Unable to display Dennett's confidence, however, many contemporary materialists now admit with philosopher Jerry Fodor that "nobody has the slightest idea how anything material could be conscious" or have phenomenal experiences that are introspectively available.[4]

Lewis specifically focused his argument on the phenomenon of rational thought as the key phenomenon that must be distinct from other phenomena of consciousness such as pains or mental images, which are "the whole mass of non-rational events whether physical or psychological."[5] Quoting biochemist J. B. S. Haldane, who was his contemporary, Lewis expresses his worry in regard to a materialist theory of mind: "If my mental processes are determined wholly by the motions of atoms in my brain, I have no reason to suppose that my beliefs are true . . . and hence I have no reason for supposing my brain to be composed of atoms."[6] Haldane's remark exposes the common problem of most naturalist accounts of rational thought: all such accounts ultimately involve determination of thought by causal processes.

The problem of determinism and rational thought arises because rational thought has classically been understood as the power of judging truth according to arguments and evidence. According to Lewis, if causal laws determine what we think—whether those laws are physical, biological, or neurological—then our thinking process is not free in the relevant sense. He also knew that indeterminism—the supposed opposite of determinism—is equally problematic because it still makes rational thought a product of natural forces, in this case, random physical behavior at the subatomic level.[7] In recently discovered correspondence dating to the last months of his life, Lewis explains to Thomas Van Osdall, an American scientist, that "random variability and mechanical necessity were . . . the opposites of what we mean by freedom"—undercutting both freedom of moral choice and freedom of rational thought.[8] Protecting a clear boundary between reason and nature—which he described as nonconscious and nonrational in itself—was of great importance to Lewis to guard the dignity of humanity on several counts. In the present instance, the activity of the nonrational threatens anything we would call rational thought: "Nature is quite powerless to produce rational thought: not that she never modifies our thinking but that the moment she does so, it ceases (for that very reason) to be rational."[9]

A proper understanding of consciousness, mind, and rational thought was crucial for Lewis in understanding what it means to be a "self." For Lewis, the self is a relatively enduring center of consciousness that can form rational beliefs and make moral choices. A self has first-person awareness, which entails interiority

and persistent identity: "Every train of thought is accompanied by what Kant called 'the I think'"—a subject that has the thought.[10] Moreover, Lewis held that "rational thought" is essential to the self considered as an "agent" with power "to alter the course of Nature."[11] To affirm the reality of the self, understood in this fashion, Lewis held that it must be distinct from nature in important ways that are only supported in some sorts of nonmaterialist views. At the same time, Lewis recognized that human selfhood, and therefore human personhood, is intimately related to the physical and biological realm in other ways—that a human being is a "composite creature" that calls itself "I" and "Me."[12]

Knowledge and Natural Laws

Philosopher Victor Reppert claims that Lewis's "argument from reason" unfolds in three phases: (1) describing inferential reasoning as essential to our epistemic life; (2) showing that inferential reasoning can occur only in a universe in which rational explanations are fundamental in accounting for rational thought; and (3) arguing that theism (or some other mentalistic worldview which takes mind as fundamental in reality) is necessary to account for these rational explanations.[13] In this and the next two sections, we track the development of these phases of Lewis's argument.

First, Lewis seeks to establish that all knowledge depends on the trustworthiness of *inferential reasoning*:

> All possible knowledge, then, depends on the validity of reasoning.... A theory which explained everything else in the whole universe but which made it impossible to believe that our thinking was valid, would be utterly out of court. For that theory would itself have been reached by thinking, and if thinking is not valid, that theory would, of course, be itself demolished. It would have destroyed its own credentials.[14]

Lewis's use of the term "valid" here essentially means epistemically "justified" or "warranted" or "reliable" in generating true beliefs. His claim that "all" possible knowledge depends on inferential reasoning is exaggerated and reflects the view known as phenomenalism, which was common in the early twentieth century.[15] Nonetheless, inferential reasoning is vital to our epistemic activities.

Given the nonnegotiable importance of inferential reasoning, Lewis then addresses the question of its necessary conditions, which would be supported within a certain kind of universe and not others. Interestingly, he initiates his discussion by asking whether miracles are possible, where "miracle" is defined as "interference with Nature by a supernatural power." Two major worldview

philosophies are diametrically opposed on this question: *naturalism*, which asserts that nature in its totality comprises everything that exists, and *supernaturalism*, which asserts that there is something distinct from nature. Emphasizing the key point of naturalism, Lewis writes, "For by Naturalism we mean the doctrine that only Nature—the whole interlocked system—exists. And if that were true, every thing and event would, if we knew enough, be explicable without remainder . . . as a necessary product of the system."[16]

The cause-effect operations of the system can be codified as "laws of nature" or "natural laws." However, we must distinguish laws of nature from two other important types of laws: *logical laws*, which are necessary principles of thought true across all possible worlds; and *moral laws*, which are self-evident truths about moral life. Lewis's concern was that the whole network of physical laws constitutes a deterministic universe in which everything that happens must happen as parts of the physical system. This is the case, Lewis also observes, whether the system is characterized in Newtonian terms as an interlocking machine or in Darwinian terms as aimed at biological survival.

Determinism can be portrayed using the language of virtually any of the sciences. In "Is Theology Poetry?" Lewis refers generally to brain science:

> If minds are wholly dependent on brains, and brains on biochemistry, and biochemistry (in the long run) on the meaningless flux of the atoms, I cannot understand how the thought of those minds should have any more significance than the sound of the wind in the trees.[17]

No type of natural cause can produce rational thought—"acts of insight" or real "knowledge." For Lewis, the key was to find a way of articulating why philosophical naturalism could not do justice to rational thought while naturalists assert the position as rationally held.

After Lewis articulated first his argument in *Miracles* in 1947, he presented it to the Oxford Socratic Club on the evening of February 2, 1948. He read Chapter 3—entitled "The Self-Contradiction of the Naturalist"—to the group, where G. E. M. Anscombe was present. A Catholic Christian and professional philosopher who studied under Ludwig Wittgenstein, Anscombe exposed certain mistakes in Lewis's argument by utilizing the latest methods of linguistic analysis. The debate that ensued between Lewis and Anscombe gave rise to what has been called the "Anscombe Legend"—which is the narrative that Lewis's argument was so thoroughly refuted that he was discouraged from doing any more explicitly philosophical work. A. N. Wilson states that Lewis turned from overtly philosophical projects to his fiction, in which his philosophy could be implicit.[18] Others counter that in subsequent years Lewis wrote plenty of philosophical essays defending Christian faith, which appear in *The World's Last Night* and

Christian Reflections, among other sources. Nonetheless, in a letter to Professor Van Osdall, Lewis admitted the much-discussed weakness in the original edition of *Miracles*: "I made a mess of one argument."[19] All things considered, however, Jerry Root is surely correct in calling for commentators to abandon the "myth" that Lewis's philosophical confidence was devastated by the debate and never recovered.[20]

As it turned out, Anscombe's remarks helped Lewis articulate more precisely the incompatibility between rational thought and natural processes, which he did in the next edition of *Miracles*. In the debate, Anscombe sharply distinguished between two very different senses of the word "because," which we use in giving two distinct types of explanation. We may use "because" to indicate either *entailment*—that one proposition logically supports another, as when we say, "Sophia believes that Olivia is her friend *because* Olivia has been kind to her many times in the past." Or we may use "because" to signal *causation*—that a natural but nonrational cause produces an effect, as when we say, "Sophia believes that Olivia is her friend *because* Sophia has a chemical imbalance in her brain that makes her consider everyone a friend." In the revised version of his argument, Lewis profitably employed the entailment/causation distinction to stress that naturalism ultimately explains thought in terms of *causation*—physical causation, which thus invalidates thought by making it the product of nonrational forces.[21] If a belief is produced by natural forces, Lewis contends, it cannot be rational. Genuinely rational thought requires that we have the power of forming a belief based on evidence and logic.

Naturalism's Fundamental Flaw

Lewis's substantially rewritten chapter for the 1960 edition was entitled "The Cardinal Difficulty of Naturalism" to signal that he was dropping the charge of "self-contradiction" and advancing a subtler but more telling objection. Essentially, his argument was that belief in naturalism is self-defeating, that it undercuts rational thought itself and thereby undercuts even the naturalist's thought that naturalism is true. The second phase of his argument, then, is Lewis's attempt to show that the naturalist assumption that every event is a product of the total system entails that thought is also caused by the total system, whether the cause is characterized in terms of physical dynamics, Marxist economic forces, Freudian psychological complexes, or biochemical reactions in the brain.

"Anything," Lewis wrote, "which professes to explain our reasoning fully without introducing an act of knowing thus solely determined by what is known, is really a theory that there is no reasoning."[22] Thus, the "cardinal difficulty" of naturalism is created by its own claim that everything is physically

or mechanically caused, which undercuts the naturalist's claim that naturalism is a rational belief. "[Naturalism] offers," Lewis continues, "what it professes to be a full account of our mental behaviour; but this account, on inspection, leaves no room for the acts of knowing or insight on which the whole value of our thinking, as a means to truth, depends."[23] Lewis's point is not that he has shown naturalism to be false but rather that he has shown that, if naturalism is true, it cannot be *known* to be true.

To argue for the self-defeat of naturalism, Lewis offers the following passage, in this case, citing natural selection as the relevant mechanism causing the thinking process:

> It is agreed on all hands that reason, and even sentience, and life itself are late comers in Nature. If there is nothing but Nature, therefore, reason must have come into existence by a historical process. And of course, for the Naturalist, this process was not designed to produce a mental behavior that can find truth. . . . The type of mental behavior we now call rational thinking or inference must therefore have been "evolved" by natural selection, by the gradual weeding out of types less fitted to survive.
>
> Once, then, our thoughts were not rational. That is, all our thoughts once were, as many of our thoughts still are, merely subjective events, not apprehensions of objective truth. Those which had a cause external to ourselves at all were (like our pains) responses to stimuli. Now natural selection could operate only by eliminating responses that were biologically hurtful and multiplying those which tended to survival. But it is not conceivable that any improvement of responses could ever turn them into acts of insight, or even remotely tend to do so. The relation between response and stimulus is utterly different from that between knowledge and the truth known.[24]

In the end, if a mechanistic explanation of thought, by naturalistic evolution or any other physical cause, is fundamental, then genuinely rational thought does not exist.

In essence, the argument from reason shows that, if we are capable of rational inference, then the basic explanation for that capability must be *teleological*, in terms of reasons, not merely mechanical in terms of natural laws. Given naturalism, the most fundamental kind of explanation is mechanistic, in terms of physical causes. Important here is the distinction between basic and nonbasic explanations. In the final analysis, naturalism maintains that any teleological explanation is nonbasic and that it must ultimately rest on mechanistic explanation, which is basic. So, if we are truly capable of rational inference, then there must be at least dual explanations, which allow both mechanistic and teleological explanations as basic, but this is anathema to naturalism.[25] In present terms, the

point is that if teleological explanation is not basic, then there are no rational grounds for believing that anything is true, including believing that naturalism is true.

The contemporary Christian philosopher Alvin Plantinga credits Lewis's argument as being a forerunner of his own argument from the reliability of our rational faculties for truth, which he formulates in technical terms of contemporary epistemology. In *Warrant and Proper Function*, he cites the New Atheist Richard Dawkins, who insists that all explanation of the physical world—including the living world—is mechanistic, not purposive. "Natural selection, the blind, unconscious automatic process which Darwin discovered, and which we now know is the explanation for the existence and apparently purposeful form of all life," has, Dawkins asserts, "no purpose in mind."[26] Plantinga responds that all thinkers who concur with Dawkins—in enlisting Darwinian evolutionary theory in the service of philosophical naturalism—have a serious problem accounting for rational thought.

In a debate with Daniel Dennett, another New Atheist and philosophical compatriot of Dawkins, Plantinga employed his evolutionary argument against naturalism, famously known as EAAN. To begin, Plantinga affirms that our epistemic life rests on the belief that our cognitive faculties—reasoning, perception, memory, and so forth—are reliable for truth; that is, when these faculties are functioning properly, they produce a large number of true beliefs relative to false beliefs. However, contemporary naturalists are typically committed to the mechanical explanation that our cognitive capacities originally arose via an evolutionary process aimed at adaptive fitness, which entails that truth is irrelevant, since only survival value results in selective advantage. Thus, as Plantinga estimates, the conditional probability that our faculties are reliable for truth, given naturalism and evolution, is low.

Put symbolically, where P is probability, R is the proposition that our cognitive faculties are reliable for truth, N is the proposition that naturalism is true, and E is the proposition that we have evolved through the natural selection of adaptive behavior, then the argument proceeds as follows:

1. $P(R/N \& E)$ is low.
2. One who accepts $N \& E$ and also sees that 1 is true has a defeater for R.
3. This defeater can't be defeated.
4. One who has a defeater for R has a defeater for any belief he or she takes to be produced by his or her cognitive faculties, including $N \& E$.

Therefore,

5. $N \& E$ is self-defeating and can't rationally be accepted.

We now must review the support for the premises.

A brief argument for premise 1 goes as follows. Assume there are beliefs. Then, since naturalists generally are materialists about human persons, they hold that a belief is an event or structure in the brain, presumably involving certain neurons and the like. However, if it is a belief, it will also have a mental property: it will have a *content*; that is, it will be the belief that *p*, for some proposition *p*. Since natural selection regards only the adaptive fitness of the belief and not its truth, the falsehood of the belief does not necessarily interfere with the adaptivity of its neurophysiological properties. Plantinga illustrates the point using the example of Paul, a prehistoric hominid, whose survival calls for him to display tiger-avoidance behavior.[27] But successful avoidance behaviors that aid survival (such as running away) could be grounded in false beliefs—say, the belief that the tiger is friendly combined with the belief that the best way to get close to it is to run away from it. On purely evolutionary grounds, then, there is no reason to think that rationality reliably tracks truth—that is, that rationality generates a large proportion of true beliefs in comparison to false beliefs. When naturalism incorporates evolution into its worldview framework, it is able to provide no reason to think that natural selection *on its own* would produce rationality that would reliably track truth.

Plantinga frames premise 2 in terms of *epistemic defeat*—specifically, in terms of an *undercutting* defeater, not of a *rebutting* defeater, for a given belief. Thus, anyone who realizes that the probability of 1 is low and still accepts *N* & *E* has an epistemic defeater for *R* in his or her own case—that is, a reason for rejecting the belief in the reliability of rationality. Premise 3 indicates that this defeater cannot be defeated because any defeater of this defeater would have to take the form of a rational argument, which would already assume the reliability of rationality and therefore be epistemically circular.[28]

Dennett replied directly to Plantinga's argument but completely missed the point:

> It is precisely the truth-tracking competence of belief-fixing mechanisms that explains their "adaptivity" in the same way that it is the blood-pumping competence of hearts that explains theirs. Hearts are for circulating the blood and brains are for tracking the relevant conditions of the environment and getting it right.[29]

Dennett mistakenly thinks that an account of how natural selection was involved in developing my capacity to recognize truth is an explanation of my *ground* for trusting my rationality. But rationality must first be trusted as reliable for truth—as Dennett unwittingly does—in order to give the account in the first place. Dennett also glosses over importantly different ways in which our cognitive

powers can be said to "get it right" and thus fails to address the special sense in which rationality operates with respect to truth as distinct from survival.

The upshot of this interchange is that one cannot rationally accept *both* philosophical naturalism and evolutionary science—which means that the conjunction of *N* and *E* must be denied. However, since evolutionary theory (*E*) is highly confirmed science, it is difficult to deny on factual grounds; thus, it is naturalism (*N*) that must be rejected on philosophical grounds. Naturalism is always the root problem, no matter what part of science it enlists, as Lewis had argued decades earlier. In Chapter 9, we explore in more detail how Lewis positioned himself with respect to other issues related to naturalism and science, particularly evolutionary science. For present purposes, however, let us note the key realist epistemological insight shared by Lewis and Plantinga: we must first assume that our rational powers are generally reliable for truth before we can have any other rationally warranted beliefs. Conversely, for any person to hold any position that implies skepticism about our rational powers, such as naturalism, is to undercut anything she believes, including the belief in naturalism itself.

Reason and Theism

Both Lewis and Plantinga recognize that the argument from reason *against* naturalism actually leads to an argument from reason *for* theism. Lewis repeatedly states that "knowledge" must be "an act of insight [into reality] sufficiently free from nonrational causation to be determined (positively) only by the truth it knows."[30] Now, the argument from reason does not require that our cognitive functioning be completely unaffected by physical causes, evolutionary or otherwise, but recognition of the appropriate independence of reason from nature is essential in the argument against naturalism and becomes central in the argument for theism. Consider Lewis's basic line of argument on the point: if naturalism is true, then there is no knowledge; but there is knowledge; therefore, naturalism is false; if naturalism is false, then there must be something distinct from nature that is operative in knowledge. Reason, Lewis states, requires "something" distinct from nature, independent of its operations and laws, yet naturalism maintains that nature is the great totality of everything that exists and, therefore, the ultimate ground of all explanations.

Reppert observes that this line of argument shows only that any mentalistic or supernaturalistic philosophy that posits a Supreme Mind independent of nature—not necessarily theism—offers potential support for knowledge, observing that Lewis initially embraced absolute idealism for the advantages of a mentalistic perspective.[31] We note, however, that Lewis eventually abandoned all forms of idealism for theism, in large part because of their own failures to

account fully for rational thought. As Lewis discovered in his search, not just any ultimate mentalistic reality can adequately explain rational thought. Although he was committed to the principle that "something beyond Nature operates when-ever we reason," his journey included continual clarification of that "something." As an idealist, Lewis held that "eternal Reason"—or the Absolute—"occasionally works through my organism," but as a Christian theist, he realized that this per-spective is unable to account for our inner awareness of what reasoning is like:

> Reasoning doesn't "happen to" us: we *do* it. Every train of thought is accompa-nied by what Kant called "the *I think*." The traditional doctrine that I am a crea-ture to whom God has given reason but who is distinct from God seems to me much more philosophical than the theory that what appears to be my thinking is only God's thinking through me.[32]

For idealism, God as ultimate reality is rational but is not a creator of finite ra-tional minds, such that it cannot account for the unity of consciousness in the act of knowing, or the conviction that we are knowing a world independent of our minds, or the fallacies of reasoning we sometimes commit. This provides an auxiliary Lewisian argument from reason against idealistic philosophies and for theism as the rationally preferable mentalistic philosophy.

Returning to the main philosophical competitors in Lewis's argument from reason—theism and naturalism—Lewis focuses the controversy on their cru-cially different views of the nature of fundamental reality:

> The Supernaturalist agrees with the Naturalist that there must be something which exists in its own right; some basic Fact whose existence it would be non-sensical to try to explain because this Fact is itself the ground or starting-point of all explanations. But he does not identify this Fact with "the whole show." He thinks that things fall into two classes. In the first class we find either things or (more probably) One Thing which is basic and original, which exists on its own. In the second we find things which are merely derivative from that One Thing. The one basic Thing has caused all the other things to be. It exists on its own; they exist because it exists. They will cease to exist if it ever ceases to maintain them in existence; they will be altered if it ever alters them.[33]

The Fundamental Reality that is proposed must be sufficient to give rise to everything else—and thus to serve as the basis for explanation of everything else—including finite rational thought. Lewis's principle is that the nonrational cannot give rise to the rational and thus that naturalism is not true. Hence, theism—which holds that a self-existent, rational God is prior to and yet the source of everything else that exists—is philosophically superior to naturalism.

And if a self-existent, rational God is prior to matter and to finite minds, then the most fundamental kind of explanation of finite rational thought is teleological, pertaining to the purposes of a rational God, rather than mechanical, pertaining to how matter produced mind.

Pursuing the idea that finite minds come from an Infinite Mind, Lewis writes, "if any thought is valid, an independent eternal Reason must exist and must be the source of my own imperfect and intermittent rationality."[34] Moreover, the "rational element" in our humanity must itself be properly independent of the natural world and its processes. Lewis develops the point further:

> Human minds, then, are not the only supernatural entities that exist. They do not come from nowhere. Each has come into Nature from Supernature: each has its tap-root in an eternal, self-existent, rational Being, whom we call God. Each is an offshoot, or spearhead, or incursion of that Supernatural reality into Nature.[35]

Interestingly, finite reason is "supernatural" in the technical sense that it is distinct from nature; God as Infinite Reason is "supernatural" to all else as the creator of both nature and the minds that occur within it.

Theism straightforwardly asserts the existence of a supremely intelligent being who chose to create a universe in which finite rational beings would emerge. Although Nature cannot give rise to rational thought, it is accommodating to rational thought as an exception to or "violation" of what it would have produced of its own accord. As Lewis says, "rationality is the little tell-tale rift in Nature which shows that there is something beyond or behind her."[36]

Lewis's argument from reason reflects insights from the classical realist tradition—its epistemological realism affirming the general trustworthiness of human reason for gaining knowledge and its metaphysical realism affirming the existence of a real world which reason knows. Since a theistic teleological explanation is—whereas a naturalist mechanical explanation is not—adequate to explain all we understand by rational thought, theism is philosophically preferable on this point. Or where P is probability, R is the proposition that rational thought yielding knowledge occurs, T is the proposition that theism is true, and N is the proposition that naturalism is true, we get the following:

$$P(R \,/\, T) > P(R \,/\, N).$$

Basic theism tells us that finite reason traces to Infinite Reason. Christian theism tells us that reason is a key feature of God's image in human persons.

Nature and Supernature

Lewis begins the book *Miracles* with the question of whether miracles occur—that is, whether there is ever a violation of natural laws by a supernatural power. By arguing that human reason is a miracle conceived as a violation of natural laws by a power distinct from nature, he has thereby shown that miracles are possible in the structure of reality. However, he cautions that it is "useless" at this stage to turn to the empirical question of whether other miracles have occurred. Answering the empirical question would presumably require consulting direct experience and historical evidence, but assessment of experience and evidence depends on a person's worldview assumptions. After all, if one holds naturalistic assumptions, which rule out all miracles in principle, empirical inquiry about historical miracles is pointless, and, as Lewis believes, rational thought itself is undercut. By contrast, assuming theism provides metaphysical support for rational thought and, by extension, allows that historical miracles are at least possible.

Science identifies causal laws, but it is philosophical naturalism that categorically pronounces that those laws cannot be interrupted and thus that nature is causally closed to outside influence. Yet the case of finite rational thought indicates that nature can be penetrated by the activity of something distinct from nature—and the phenomenon of rational thought is best explained by theism. Theism, in turn, entails the ontological possibility of other miracles, and we will find that Christianity provides direction about the probability and proper role of other miracles. With this backdrop, let us explore some of Lewis's further thoughts about nature and its relation to supernature.

Although miracles are typically defined as "violations" of the laws of nature, Lewis argues that, given Christian theism, in a certain sense they are not violations. He emphasizes that natural laws operate unfailingly, with physical necessity, only if the initial conditions hold—that all laws have an implied ceteris paribus clause, "other things being equal."[37] If "any agency, natural or supernatural," tampers with the initial conditions, then the result must differ: event *x* will not be followed by the otherwise regular occurrence of event *y*. In this case, the law has not been broken but remains true; the initial conditions under which the law holds have simply been changed.

Lewis advanced the theistic claim that nature is a "creature," a product of the Infinite Mind:

> I do not maintain that God's creation of Nature can be proved as rigorously as God's existence, but it seems to me overwhelmingly probable, so probable that no one who approached the question with an open mind would very seriously entertain any other hypothesis. In fact one seldom meets people who have

grasped the existence of a supernatural God and yet deny that He is the Creator. All the evidence we have points in that direction, and difficulties spring up on every side if we try to believe otherwise.[38]

Contrary to naturalism, nature is not self-existent but is instead a creature with a determinate character for generating events in law-like fashion. However, nothing about its creaturely status prevents the Creator from inserting new events that would otherwise not have occurred in nature's normal operation. Even the genuine physical "necessity" reflected in the laws of nature cannot block or preempt the special activity of the Creator. But how does Lewis think further about what this divine activity might be like?

Lewis differentiates between different models of supernatural miraculous events. Fairy tales and pagan myths, he acknowledges, contain many miracles—beasts turning to persons, trees talking, magic rings that execute selfish wishes, and the like—but these miracles suggest an "alien power" invading nature because they fit no coherent, meaningful pattern. Moreover, miracles in other religions are sometimes conceptually odd given the content of their teachings—such as the Buddha preaching that nature is an illusion to be escaped but reportedly doing miracles that engage him in the illusion.[39]

Lewis makes the case that Christian miracles display a "fitness" that other miracle stories do not:

> The fitness of the Christian miracles, and their difference from these mythological miracles, lies in the fact that they show invasion by a Power which is not alien. They are what might be expected to happen when she is invaded not simply by a god, but by the God of Nature: by a Power which is outside her jurisdiction not as a foreigner but as a sovereign. They proclaim that He who has come is not merely a king, but the King, her King and ours.[40]

Lewis thus claims that the Christian miracles have a much greater "intrinsic probability" in virtue of their organic connection with one another and with the whole structure of the religion they exhibit.

Indeed, the Incarnation, which is "the Grand Miracle," provides the connectedness: "every other miracle prepares for this, exhibits this, or results from this."[41] The Christian miracles are not disconnected or bizarre raids on nature but rather steps of an unfolding revelation of God's purposes. The fitness—and therefore the credibility—of any particular miracle must be considered in relation to the Grand Miracle, which itself exhibits inherent "fitness" because it proceeds from the character and purposes of God to invite humanity into the divine life. Thus, conceptually, according to Lewis, the intrinsic probability of the Grand Miracle is very high because God would desire to reveal just how close he wants to be

with humanity. With this understanding of the Incarnation's intrinsically high probability, Lewis thinks that more objective and intelligent historical inquiry as to whether it happened can reasonably occur, which we explore in Chapter 6. For now, we note that Lewis believed that "if the thing happened, it is the central event in the history of the Earth—the very thing that the whole story has been about."[42]

Lewis's argument from reason thus presents theism as the best explanation for the existence of rational thought and must be considered along with his argument from desire as mounting a strong case for a teleological universe in which mind and personhood are fundamental. His argument from morality, which we examine next, provides the third part of his triad of theistic arguments.

5

Moral Law and the Structure
of Personal Reality

After his Christian conversion, Lewis wrote extensively about the importance of morality and its relationship to God. He began *Mere Christianity* with the observation that people make moral evaluations according to some standard of conduct. Morality, for Lewis, provides an occasion for philosophical reflection that leads eventually to theism and, along with the arguments from longing and reason, completes the famous triad of his arguments for theism. Interestingly, all three of Lewis's theistic arguments utilize what he called "inside information."[1] After all, we have only two broad sorts of evidence, nature and ourselves, and we know nature through "external observation," whereas we know about human longing, reason, and morality immediately and directly by virtue of being human.[2] Lewis concluded that, as philosopher Robert Holyer comments, "these three human phenomena are most at home in the Christian vision of things."[3] The present discussion begins with Lewis's analysis of moral experience, interacts with objections and alternative views, and explores why he thought that Christian theism explains morality better than other worldviews explain it.

Moral Law and Moral Awareness

Human experience, according to Lewis, includes "moral phenomena"—we make ethical judgments, praise and blame, and have feelings of obligation and guilt, and all in reference to an assumed standard. Moral phenomena are connected to the strong human belief that some actions are right and some are wrong, which he says implies an assumed moral standard, what he calls "the Law of Human Nature," traditionally called the Natural Law.[4] In the context of morality, the term *natural law* is the law of our specific human nature, how we should act and be treated, although in the context of science, the term refers to physical laws. A moral law is *prescriptive* of what humans ought to do freely, whereas a scientific law is *descriptive* of what natural objects actually do automatically.[5]

In ethics, the traditional realist position is that the moral law is based on real moral properties and facts which we are capable of accessing. A fully developed ethical realism is realist about substantive ethics (the content of our moral

C. S. Lewis and the Christian Worldview. Michael L. Peterson, Oxford University Press (2020).
© Oxford University Press.
DOI: 10.1093/oso/9780190201111.001.0001

duties) and realist about metaethics (the analysis and nature of morality). For Lewis the moral realist, the fundamental substance or content of the moral law is *objective* and *universal*, and thus it is fundamentally the same across different cultures and traditions.

The starting point of Lewis's argument crucially depends on the moral law being understood in realist terms, both metaphysically and epistemologically. In *Mere Christianity*, the moral law is a set of ethical principles or truths telling us how human beings should act and be treated. These moral truths are not abstract Platonic entities but are instead metaphysically rooted in the reality of universal human nature, which distinguishes human persons from all other things in the universe. The Law of Human Nature, then, is objective and universal, grounded in the kind of thing we are and what is good for us. Knowledge of the law is epistemically available to us and, at the most fundamental level, self-evident. As Lewis wrote, "I believe that the primary moral principles on which all others depend are rationally perceived. . . . their intrinsic reasonableness shines by its own light."[6] Here he continues his theme that knowledge (in this case, moral knowledge) is rational "insight" into reality. After all, there is no "inference" to first principles because there is nothing more fundamental by which they can be established.[7]

Of course, versions of moral anti-realism are totally opposed to moral realism, asserting that the content of moral law is *subjective* (based on human preferences) or *relative* (variable among individuals or cultures). Consider atheist philosopher J. L. Mackie's "argument from relativity," which cites cross-cultural disagreement as evidence against moral realism. The following argument sketch is representative:

1. There are differences in moral standards among cultures and traditions.
2. The best explanation of these differences is that moral standards are a product of culture and tradition.
3. Therefore, there are no objective, universal moral standards.

This is a metaphysical argument about what morality *is*, reflecting the position that there simply are no moral properties or facts, in which case there are no standards about moral facts. Mackie's "error theory" is the view that all moral propositions are false because there are no moral facts that could make them true.[8]

To counter the widely used argument from cultural differences, Lewis makes a crucial distinction between basic moral principles and values, on the one hand, and how various cultures reflect them, on the other:

There have been differences between their moralities, but these have never amounted to anything like a total difference. If anyone will take the trouble to compare the moral teaching of, say, the ancient Egyptians, Babylonians, Hindus, Chinese, Greeks and Romans, what will really strike him will be how very like they are to each other and to our own.[9]

In the Appendix of *The Abolition of Man*, Lewis provides a detailed comparison of the moral and religious literature of great civilizations of the past in order to show the broad agreement on fundamental moral principles but variation in how they are articulated and applied. Broad agreement on basic morality is predictable for Lewis given that morality is grounded in our common human nature, which is everywhere and at all times the same.

Other objections to the idea of a universal, objective law of human nature typically offer alternative explanations for moral beliefs. One well-known anti-realist interpretation claims that moral beliefs arise from "herd instinct," but Lewis replies that humans have many instincts, impulses, and desires that often conflict and must be adjudicated by something higher than instinct:

If two instincts are in conflict, and there is nothing in a creature's mind except those two instincts, obviously the stronger of the two must win. But at those moments when we are most conscious of the Moral Law, it usually seems to be telling us to side with the weaker of the two impulses. You probably want to be safe much more than you want to help the man who is drowning: but the Moral Law tells you to help him all the same.[10]

In acting morally, we are not simply acting *from* instinct but are selecting which instinct is appropriate in a given situation.[11]

Evolutionary ethics in recent decades tends to be anti-realist, citing the "herd instinct" theme in a scientific explanation of what Charles Darwin called the "social instincts."[12] Given the contingencies of evolutionary history, the argument goes, certain behaviors (including ethical judgments and emotions) became adaptive and were passed on from our ancestors.[13] Natural selection has thus shaped our moral behaviors and evaluative tendencies for species survival, but had the contingencies of our evolutionary path been different from what they were, our morality would be different from what it is. Thus, there is no universal, objective moral law. As Lewis argued, if our sense of values is "a biological by-product in a particular species with no relevance to reality," then we cannot "continue to attach an importance to the efforts we make toward realizing our ideas of value."[14]

Another anti-realist explanation is that morality is merely "social convention"—a purely human invention—and thus is not objective and universal. But Lewis presses the considerable difficulty of denying moral realism:

> The moment you say that one set of moral ideas can be better than another, you are, in fact, measuring them both by a standard, saying that one of them conforms to that standard more nearly than the other. But the standard that measures two things is something different from either. You are, in fact, comparing them both with some Real Morality, admitting that there is such a thing as a real Right, independent of what people think, and that some people's ideas get nearer to that real Right than others. Or put it this way. If your moral ideas can be truer, and those of the Nazis less true, there must be something—some Real Morality—for them to be true about.[15]

Lewis argues that a society's ethical precepts and rules may *mediate*, but that they do not *create*, the moral law—that morality is not like rules of the road, which vary widely, but like the laws of mathematics which are in the class of "real truths" about reality.

Historically, many ethical theories have interpreted morality as social convention. Utilitarianism, for example, asserts that we have a moral obligation to seek the greatest happiness for the greatest number. For John Stewart Mill, the good is pleasure, and the higher pleasures are more desirable. But Lewisian questions arise: Why is pleasure good or valuable? And why are we obligated to seek pleasure? Only a deeper understanding of morality can anchor pleasure in a fuller vision of humanity.

For Lewis, all attempts to propose an alternative to objective, universal morality, or to otherwise deny or debunk it, are futile because such attempts succumb to their own critique, commit some other identifiable fallacy, or assume part of the moral law to attack the whole. Thus, he argues, the idea of the moral law as objective and universal is credible and invites philosophical investigation along two lines:

> First, that human beings, all over the earth, have this curious idea that they ought to behave in a certain way, and cannot really get rid of it. Secondly, that they do not in fact behave in that way. They know the Law of Nature; they break it. These two facts are the foundation of all clear thinking about ourselves and the universe we live in.[16]

We now turn to the task of unpacking Lewis's thinking based on these two points.

A Clue to the Meaning of the Universe?

According to Lewis, the idea of a law of human nature is connected to the larger question about the existence of a higher power:

> We want to know whether the universe simply happens to be what it is for no reason or whether there is a power behind it that makes it what it is. Since that power, if it exists, would be not one of the observed facts but a reality which makes them, no mere observation of the facts can find it. There is only one case in which we can know whether there is anything more, namely our own case. And in that one case we find there is. Or put it the other way round. If there was a controlling power outside the universe, it could not show itself to us as one of the facts inside the universe—no more than the architect of a house could actually be a wall or staircase or fireplace in that house.[17]

Human moral experience suggests to Lewis a line of reasoning to a supreme being: "The only way in which we could expect [this power] to show itself would be inside ourselves as an influence or a command trying to get us to behave in a certain way. And that is just what we do find inside ourselves. Surely this ought to arouse our suspicions?"[18]

Like his argument from reason, Lewis's essential moral argument here is best seen as abductive, seeking the best explanation of morality. Erik Wielenberg's interpretation of the argument goes as follows:

1. If there is a higher being, moral phenomena would be likely.
2. Moral phenomena exist.
3. Hence, there is some reason to think that there is a higher being.

Wielenberg notes that this argument is an exercise in natural religion, learning what we can about a higher being from reflection on the world rather than from biblical writings or church teachings.[19] On such grounds, Lewis writes, "we have not yet got as far as the God of any actual religion."[20] Nonetheless, the moral argument, along with the arguments from human longing and from reason, may be seen as part of a cumulative case for a higher being which Lewis later connects with the God of Christianity.

The strength of the moral argument for theism lies in its superior explanatory power relative to other worldviews. Lewis makes the case that no nontheistic worldview avoids distorting or denying all that we know about the moral phenomena to be explained. Or, where P is probability, M is the proposition that moral phenomena exist, T is the proposition that the theistic worldview is true, and X is the proposition that a given nontheistic worldview is true,

$$P(M/T) > P(M/X).$$

Effectively, we can substitute in for X a wide range of alternative worldviews and, with Lewis, find them lacking. Emergent evolution admires the striving of a blind force inherent in all things; idealism and pantheism place an impersonal Absolute beyond distinctions of good and evil; cosmic dualism incoherently envisions two opposed supreme powers.[21]

Lewis especially targets naturalism and its common materialist outlook as the chief rival of theism in academic circles and general culture. All materialist views essentially claim that the physical universe exists by chance and, through a series of chance events, eventually produced "creatures like ourselves who are able to think."[22] What Lewis calls the "religious view" holds that matter cannot be ultimate:

> [W]hat is behind the universe is more like a mind than it is like anything else we know. That is to say, it is conscious, and has purposes, and prefers one thing to another. And on this view it made the universe, partly for purposes we do not know, but partly, at any rate, in order to produce creatures like itself—I mean, like itself to the extent of having minds.[23]

No wonder the moral phenomena which we take so seriously are explained better by an ultimate reality that is rational, purposive, and moral than by an ultimate reality that is inherently nonrational, nonpurposive, and nonmoral. In comparative terms, where T is theism, N is naturalism/materialism, and M is moral phenomena,

$$P(M/T) > P(M/N).$$

Our moral experience is much more epistemically surprising on the assumption that materialism is true than on the assumption that theism is true. This is due to the close conceptual connections between the idea of an infinite conscious, purposive, moral being and the idea of finite conscious moral beings.

The Deep Nature of Morality

Probing further into the nature of morality prepares the way for later inquiry into the kind of reality that lies behind it. In this section, we prepare for that inquiry by examining first the role of moral law and the basis of its normative force and

second the internal qualities that morality promotes. We defer until the next section an exploration of morality in the context of the meaning of human life.

Lewis employs the analogy of a fleet of ships to elucidate three aspects of morality. The fleet must first have a set of instructions for sailing: they must sail in proper formation so that they will not collide or drift apart. Likewise, in moral life, the instructions are our duties to one another. But in ethical theory, two broad types of theories are commonly discussed. *Consequentialism*—sometimes called teleological ethics (from the Greek *telos*)—holds that the rightness of an action or rule is determined by how effectively it promotes some nonmoral good, such as pleasure or power. *Nonconsequentialism*—often called deontological ethics (from the Greek *deon* for "duty")—maintains that the rightness of an action or rule is based on some intrinsic feature, such as proper motive, rather than on any extrinsic result. It is fascinating to consider Lewis's journey in terms of its changing ethical positions.

Early in his atheistic materialist phase, Lewis's ethic was consequentialist, specifically Epicurean hedonism, which posits pleasure for the individual as the highest good. But later, as a Lucretian materialist, Lewis viewed the universe as meaningless and settled for pleasure (or happiness) simply as the absence of pain and fear—what Barkman calls "negative happiness."[24] Expressing the profound pessimism of this period of his life, Lewis wrote *Loki Bound*, a poem picturing Loki as justly rebelling against Odin for burdening creatures with existence.[25] As a Christian, Lewis recollects, "I had been far more anxious to avoid suffering than to achieve delight."[26]

During his brief quasi-Manichean phase, Lewis adopted something of a deontological ethic that recommended a stern ascetic approach to life. In a letter to Arthur Greeves, he wrote, "you may find in me . . . a vein of asceticism . . . of puritan practice without the puritan dogma."[27] Essentially, belief in a universal spirit that was at war with the material realm dictated vigilance against material temptations. Lewis soon returned to his atheistic materialist perspective but maintained the Stoic deontological orientation that we must do what is right as a matter of principle and not because it is pleasurable.

Utilitarianism is a form of ethical altruism that might have been an alternative to Lewis's Epicurean ethical egoism. Yet utilitarianism, as a version of consequentialism, holds that rightness is based on consequences—that an action or rule is morally right or obligatory if and only if it promotes happiness or utility for the greatest number of people. To the contrary, Lewis thought that "unselfishness" and "doing good for society" were concepts incapable of grounding normative force:

> If we ask: "Why ought I to be unselfish?" and you reply "Because it is good for society," we may then ask, "Why should I care what's good for society except

when it happens to pay me personally?" and then you will have to say, "Because you ought to be unselfish"—which simply brings us back to where we started.[28]

Lewis retained a strong distaste for all forms of consequentialism which anchor the normative force of moral action in extrinsic consequences.

This distaste is clear in his fiction. In *Dawntreader*, the honorable mouse Reepicheep is repulsed by utilitarian reasons to face danger to rescue the seven lords. As a foreboding darkness looms ahead, Drinian asks, "What manner of use would it be plowing through that blackness?" The brave mouse answers,

> "Use, Captain? If by use you mean filling our bellies or our purses, I confess it will be no use at all. So far as I know we did not set sail to look for things useful but to seek honor and adventure. And here is as great an adventure as ever I heard of, and here, if we turn back, no little impeachment of all our honors."[29]

Decisions in moral matters, Reepicheep asserts, are to be based on principle, not on anticipated outcomes.

Although Lewis eventually abandoned Stoical materialism and its stark deontological ethic, he remained attracted to Kantian deontological ethics. For Kant, on the subjective side of ethics, the only truly moral motive is "respect for duty." Merely acting in accord with duty will not do; "acting from duty"—from inward respect for moral law—is necessary for genuine moral action. On the objective side, there must be rational recognition of duty—of the moral law as having categorical force ("always do this"). Interestingly, Kant claimed that principled respect for morality does not guarantee happiness—and Lewis during his pre-Christian journey and even in his theistic conversion pursued duty without thought of happiness.

The second part of the fleet-of-ships analogy indicates that each individual ship must be in good internal working order—in other words, moral persons must acquire virtue in addition to simply obeying obligation. On this point, Lewis left Kant for the virtue ethics of Plato, Aristotle, and the Christian medievals such as Aquinas. Lewis accepts the four cardinal virtues laid down by Plato in Book IV of *The Republic*: prudence, moderation, fortitude, and justice.[30] As a Christian, Lewis saw even more clearly that morality is very much about developing virtue—that actions flow from the kind of person one is:

> There is a difference between doing some particular just or temperate action and being a just or temperate man. Someone who is not a good tennis player may now and then make a good shot. What you mean by a good player is a man whose eye and muscles and nerves have been so trained by making innumerable good shots that they can now be relied on. . . . In the same way a man who

perseveres in doing just actions gets in the end a certain quality of character. Now it is that quality rather than the particular actions which we mean when we talk of a "virtue."[31]

To Kant's inordinate praise for the morally immature person who struggles with temptation and finally does the right thing, one hears Aristotle's reply, "One swallow does not a summer make."[32]

Following Aristotle, Lewis the Christian thinker envisioned a deep organic connection between moral life and human fulfillment:

> Kant thought that no action had moral value unless it were done out of pure reverence for the moral law, that is, without inclination. . . . Yet against Kant stands the obvious truth, noted by Aristotle, that the more virtuous a man becomes the more he enjoys virtuous actions.[33]

The positive relation Lewis envisioned between morality and pleasure is connected to a larger discussion about whether to interpret Lewis as a "Christian hedonist" (who thought that happiness consists purely in pleasure) or a "Christian eudaemonist" (who thought that happiness is the total well-being of human nature). Stewart Goetz, for example, argues extensively for the former interpretation, but Adam Barkman argues for the latter interpretation.[34]

We cannot settle here the general issue regarding hedonism in Lewis, but we can venture a few remarks about his views on morality, human nature, and God. For instance, it seems clear that Lewis the Christian rejected all forms of consequentialism, including hedonism, "the gloomy philosophy which says that Pleasure is the only good."[35] Yet Lewis also rejects deontologism: he has John in *The Pilgrim's Regress* meet Vertue, who was once a Stoic or Kantian but eventually saw the need for desiring happiness as human fulfillment. Drawing from Plato, Aristotle, Boethius, and Richard Hooker, Lewis advocated that the desire for happiness—what we earlier termed "transcendent longing"—is equivalent to the desire for our proper fulfillment as human beings.

The *Tao* and Human Fulfillment

The third part of the ships analogy is the knowledge of "where the fleet is trying to get to"—or simply the understanding of "the general purpose of human life."[36] Human fulfillment, Lewis maintains, is complex, having both natural and supernatural dimensions. He agreed with the classical metaphysical principle—both ancient Greek and medieval Christian—that every kind of thing has a unique nature and purpose. For the rational creature, to fulfill its purpose or *telos* is

happiness, or *eudaimonia* (from the Greek *eu* for "good" and *daimon* for "spirit"). According to Plato and Aristotle, the human person naturally desires happiness, which they took to be a purely natural end, realized in part by moral life—essentially taken as a self-improvement project. As a Christian, Lewis held that moral virtue, or at least the desire for moral virtue, is indicative of true human fulfillment, of the kind of person we should become, both for this life and the next.[37] Lewis explained that "if people have not got at least the beginnings of those qualities inside them, then no possible external conditions could make a 'Heaven' for them—that is, could make them happy with the deep, strong, unshakable kind of happiness God intends for us."[38]

Aquinas offers a profound Christian answer to the fascinating question of whether humanity has one end (supernatural happiness) or two ends (both natural happiness and supernatural happiness). He affirms that humanity has one all-encompassing end with two aspects: our *telos* or end is *duplex non duo* (Latin: two-fold, not two). That is, humanity has one final end, a supernatural end, which is life in God, but it is an end that is "natural" to us, although it is given "supernaturally" by God.[39] Contrary to the Greek masters, who envisioned morally virtuous life as a condition of a natural, self-contained, earned happiness for humanity, Aquinas taught that even the best human efforts still need divine assistance for the complete fulfillment of our natures. Thus, as Aquinas explains, we have by nature an end that cannot be fulfilled by nature.[40]

Aquinas stated that nature is perfected by grace; likewise, Lewis said that the lower is taken up into the higher. Lewis asks the following rhetorical question to convey the perspective that natural moral virtue ultimately has a supernatural end:

> Does it not make a great difference whether I am, so to speak, the landlord of my own mind and body, or only a tenant, responsible to the real landlord? If somebody else made me, for his own purposes, then I shall have a lot of duties which I should not have if I simply belonged to myself.[41]

Seeking to be virtuous and doing good, while not of salvific merit, are nonetheless part of our responsibility to our natural selves and to our supernatural destiny. As Lewis says, morality beckons beyond itself toward that point at which we "can give up being good and start receiving good instead."[42]

For morality to factor crucially into an ultimately supernatural destiny for humanity, reality must have a certain structure, which for Lewis is seen in his conception of the universal, objective moral law and of the capability of human nature for virtue. In *The Abolition of Man*, originally three lectures delivered in 1943 at King's College of the University of Durham, he presented the moral law in essentially "secular" terms, never mentioning God or religion as its basis, but

nevertheless arguing that it is anchored in the fundamental structure of reality. In *Mere Christianity*, he identified individual conscience as evidence for the reality of the moral law, but in *Abolition* he cited the consensus of the major moral and religious traditions down through the history of civilization—Babylonian, Egyptian, Greek, Roman, Oriental, and more. Instead of speaking of the universal moral law as such, he used the Chinese term *Tao*—which means "the Way"—as a synonym, arguing that all great religious, moral, and cultural traditions have believed that the common moral truths are rooted in reality itself: "It is the doctrine of objective value, the belief that certain attitudes are really true, and others really false, to the kind of thing the universe is and the kind of things we are."[43] In the Hindu tradition, for example, *Rta* is the great pattern of nature and supernature forming the cosmic order. All the traditions essentially teach that harmony between finite persons and the universe is our proper destiny.

Since the moral law—or the *Tao*—is anchored in the fundamental structure of reality, it cannot be changed or overturned, and to it there can be no valid alternative:

> The *Tao*, which others may call Natural Law or Traditional Morality or the First Principles of Practical Reason or the First Platitudes, is not one among a series of possible systems of value. It is the sole source of all value judgments. If it is rejected, all value is rejected. If any value is retained, it is retained. The effort to refute it and raise a new system of value in its place is self-contradictory. There has never been, and never will be, a radically new judgment of value in the history of the world. What purport to be new systems or (as they now call them) "ideologies," all consist of fragments from the *Tao* itself, arbitrarily wrenched from their context in the whole and then swollen to madness in their isolation, yet still owing to the *Tao* and to it alone such validity as they possess.[44]

The content of the *Tao* constitutes a framework of value within which distinctively human life properly flourishes and outside of which it decays and dies. Societies at all times have recognized that values such as beneficence, courage, and honesty are part of the framework, whereas no normal society has ever valued malice, cowardice, and dishonesty.

Although there is an unchanging moral law not of our own making, Lewis argued that humanity's progressively deeper insights into and refinements of the moral law constitute genuine moral progress:

> In the *Tao* itself, as long as we remain within it, we find the concrete reality in which to participate is to be truly human: the real common will and common reason of humanity, alive, and growing like a tree, and branching out, as the situation varies, into ever new beauties and dignities of application.[45]

Real progress in morality can only be made from the inside, by those who know and love the *Tao*, not from the outside by those who would debunk or replace it. The movement from the Confucian precept "Do not do to others what you would not like them to do to you" to the Christian precept "Do as you would be done by" is a genuine moral advance—a clarification and extension of what the *Tao* entails. By contrast, the Nietzschean value of power is tantamount to the wholesale rejection of the *Tao*, or traditional morality, which makes it a failed innovation rather than a genuine moral advance.

Another aspect of the metaphysics of morals for Lewis is his concept of human nature, which relates to the *Tao*. As a Christian thinker, Lewis affirmed that the human person is a real mind-body composite—rationality and animality, what Aristotle called the "hylomorphic unity of form and matter." The "rational soul," Lewis wrote, "gives man his peculiar position" as a special kind of creature.[46] As animals, we share "lower" instincts and appetites with the animal realm—for self-preservation, food, sex, and the like. But as *rational* animals, our reason, which is informed and enlivened by the *Tao*, has the power to settle conflicts among competing instincts and drives, and thus to escape control by the forces of nature. Without the *Tao*, we cannot rise above animal life and realize our full humanity—the lower must be ruled and humanized by the higher.[47] Living within the *Tao*, obeying moral law, is authentic freedom; standing outside the *Tao* is slavery to impulse and instinct.[48] As Lewis indicated, objective value "demands a certain response from us"—our rational approval and endorsement and even our emotional resonance.[49] Of course, Lewis also knew that the tragic human tendency is to turn away from the good and choose our own way.[50]

God and the Good

We see in Lewis two broad lines of thinking about morality—first, that the moral law, our knowledge of it, and its role in human flourishing are best interpreted in terms of moral realism; second, that the metaethical moral realist interpretation of these moral phenomena is itself best explained by theism. Lewis further argues that Christianity provides the best account of the fuller nature of the theistic universe as deeply personal. Moral law, then, has normative force and morality is essential to human flourishing because personhood is intrinsically valuable. In a universe described by Christian theism, a perfectly good God creates finite personal beings with the capacity to reflect God's moral nature. As Mark Linville says,

> The value of human persons is found in the fact that, as bearers of the *imago Dei*, they bear a significant resemblance to God in their very personhood. God

and human persons share an overlap of kind membership in personhood itself, and human dignity is found precisely in membership in that kind.[51]

Personhood *just is* the kind of reality that is intrinsically and unconditionally valuable. According to the Christian worldview, human persons have been fashioned after the most ultimate and sacred feature of reality and thus participate in that sacredness.

The claim that God is wholly good raises the question of exactly how God and goodness are related. For over twenty-four hundred years, the Western intellectual tradition has pondered the dilemma Socrates posed in Plato's *Euthyphro*: "Is something good because God wills it, or does God will it because it is good?"[52] The actual dialogue is framed in terms of polytheism, but the conceptual issue has for centuries been processed within theistic thought. Euthyphro advocates *divine command theory*, otherwise known as *theological voluntarism*: the position that good is what is willed or commanded or favored by God. In opposition, Socrates represents a precursor of natural law theory, the view that goodness is what it is intrinsically, such that God's will cannot determine it.[53] Although Christian philosophers and theologians are divided on the issue, divine command theory has always been the minority report, which Lewis himself rejects:

> But how is the relation between God and the moral law to be represented? To say that the moral law is God's law is no final solution. Are these things right because God commands them or does God command them because they are right? If the first, if good is to be defined as what God commands, then the goodness of God Himself is emptied of meaning and the commands of an omnipotent fiend would have the same claim on us as those of the "righteous Lord."[54]

Lewis thinks that divine command theory makes divine commands meaningless and arbitrary: "that [it] might lead to the abominable conclusion . . . that charity is good only because God arbitrarily commanded it—that He might equally well have commanded us to hate Him and one another and that hatred would then have been right."[55] We cannot pursue this complex issue in greater depth, but we can offer a sense of what Lewis thought was at stake. The first horn of the dilemma—the dependence of the good on God's will—is unacceptable, but independence of the good from God is also unacceptable. As Lewis observes, the second horn seems to be "admitting a cosmic dyarchy, or even making God Himself the mere executor of a law somehow external and antecedent to His own being."[56]

Whereas naturalist philosopher Louise Antony maintains that the Euthyphro dilemma is devastating to any religious metaethical understanding because

both horns are unacceptable to religion, Lewis would refuse to be caught on either horn. Antony argues for objective morality independent of anyone's will or endorsement:

> I take it that theists and atheists will agree about what it means to say that morality is objective: first, whether something is right or wrong does not depend on any human being's attitudes toward it, and second, moral facts are independent of human will.[57]

Obviously, it would be very Lewisian to critique the idea that there can be objective moral facts in a naturalist universe in which necessary moral truths, as it were, come from nowhere.[58]

Regarding the dilemma, Lewis states that "both views are intolerable."[59] While sheer willing on the part of any being cannot be right making or value conferring, and while objective goodness and rightness must somehow be permanent and nonnegotiable, goodness cannot be utterly independent from God. Thus, Lewis offers the twin negations—that God neither *obeys* nor *creates* the moral law—and argues for a kind of middle way. Resonating with a Thomist position, he declares, "God's will is determined by His wisdom which always perceives, and His goodness which always embraces, the intrinsically good."[60] Aquinas says that God's "right reason" or "wisdom" perfectly understands what is good and imparts that wisdom to us through the natural law.[61] The interested reader will want to pursue the analysis of Lewis on morality in the debate between David Baggett and Erik Wielenberg.[62]

The Old Testament teaches that the entire cosmos was created by Wisdom;[63] John's Gospel uses the term *logos* (Greek for "word" or "wisdom") to identify Christ.[64] The *Tao*, then, can be set in a Christian context that is far larger than theism envisions: the eternal moral law is identified with Christ, who is God's wisdom and truth and goodness. Lewis writes, "Is not the *Tao* the Word Himself, considered from a particular point of view?"[65] Based on his Trinitarian commitments, Lewis articulates how Christ—the Word of God, the Eternal Expression of God—essentially includes perfect goodness:

> [W]hat lies beyond existence, what admits no contingency, what lends divinity to all else, what is the ground of all existence, is not simply a law but also a begetting love, a love begotten, and the love which, being between these two, is also imminent in all those who are caught up to share the unity of their self-caused life. God is not merely good, but goodness; goodness is not merely divine, but God.[66]

Some one thing from beyond our mode of existence might be perceived as two things when within our finite experience, and the limitations of our categories prevent us from correctly seeing the identity between the Word and the moral law.[67]

Placed in this larger framework, our desire for goodness provides a certain insight into transcendent desire. After declaring that "what I learned to love in *Phantastes* was goodness," Lewis explained further that perfect goodness is not "prosaic moralism" but a far more profound and sweet righteousness.[68] One Lewisian approach to the attractive nature of complete goodness was to distinguish between "need-love," which is the felt lack or sense of incompletion that can only be filled by another, and "gift-love," which is the free gift of another to fulfill need-love and is epitomized in God's self-giving for the sake of creatures.[69] Christian ethics, for Lewis, reflects need-love, which makes duty a "self-transcending concept"—that is, it expresses a kind of longing for moral completion and ultimate happiness.[70] In his essay "Man or Rabbit?" he states,

> Mere *morality* is not the end of life. You were made for something quite different than that. . . . Morality is indispensable: but the Divine life, which gives itself to us . . . intends for us something in which morality will be swallowed up.[71]

In that completed state, we will do the things duty requires "freely and delightfully."[72]

To speak of goodness as pure righteousness accents our paradoxical position: our only possible happiness depends on relationship with this perfectly good God and yet we too often fail to obey the moral law that is a reflection of this God's essential nature. Lewis writes,

> If the universe is not governed by an absolute goodness, then all our efforts are in the long run hopeless. But if it is, then we are making ourselves enemies to that goodness every day, and are not in the least likely to do any better tomorrow, and so our case is hopeless again. We cannot do without it, and we cannot do with it. God is the only comfort, He is also the supreme terror: the thing we most need and the thing we most want to hide from. He is our only possible ally, and we have made ourselves His enemies. Some people talk as if meeting the gaze of absolute goodness would be fun. They need to think again. They are still only playing with religion. Goodness is either the great safety or the great danger—according to the way you react to it.[73]

Philosopher J. Budziszewski, who refers appreciatively to Lewis in his own work on natural law, calls the Christian gospel a good news/bad news affair. Only by

understanding the "bad news" of personal sin and rebellion are we prepared "for the 'good news' of a doorway back to God."[74]

Through the miracle of the Incarnation, Lewis explains, Christianity provides us with the proper response to this predicament, one in which we recognize the "bad news" of our inability to perfectly fulfill the moral law and also recognize the "good news" of God's offer of perfect forgiveness and acceptance:

> Christianity simply does not make sense until you have faced the sort of facts I have been describing. . . . When you know you are sick, you will listen to the doctor. When you have realized that our position is nearly desperate, you will begin to understand what the Christians are talking about.[75]

Lewis's own journey is an example of facing these facts and responding positively. As he often said, it is a process of aligning of oneself with Reality.

6

Humanity and the Incarnation

The central Christian claim is staggering: that God became one with a human person, Jesus of first-century Nazareth, in order to fulfill his purposes for creation and to draw close to humanity. As Lewis indicated, the whole of Christian theology hangs on the doctrine of Incarnation, its meaning and truth. Our present task is to explore Lewis's orthodox understanding of the meaning of the claim that "God became human," both from the side of deity and the side of humanity. Furthermore, we consider his responses both to logical objections to the Incarnation and to alternative historical hypotheses aimed at discrediting the claim that Jesus was God. We also consider how Lewis saw the theological relationship between the doctrine of Incarnation and the doctrine of Atonement, which is essentially the claim that Jesus repairs the broken human relationship with God.

The Grand Miracle

Lewis called the Incarnation "the Grand Miracle" because it is God's own entry into human affairs, and thus the focal point of the whole Christian narrative and the essential historical affirmation of Christian theology. He explained, "The central miracle asserted by Christians is the Incarnation. They say that God became Man. Every other miracle prepares for this, or exhibits this, or results from this."[1] The statement "God became Man" asserts that God became bonded with the historical person of Jesus of first-century Nazareth. Ecumenical Christian orthodoxy defined the full meaning of the claim that God became human—and Lewis works faithfully within this framework. The Niceno-Constantinopolitan Creed of 381 AD contains these lines regarding how God was in Jesus:

> We believe in . . . one Lord Jesus Christ, the only-begotten Son of God, Begotten of the Father before all the ages; Light of Light, true God of true God; begotten not made, of one substance with the Father, through whom all things were made.[2]

Here we have the declaration of the coessential divinity of the Son with the Father, which simply means that Jesus is God.

C. S. Lewis and the Christian Worldview. Michael L. Peterson, Oxford University Press (2020).
© Oxford University Press.
DOI: 10.1093/oso/9780190201111.001.0001

We also have reference here to the preincarnational life of the Son, who was "begotten, not made." That is, the Son is coeternal with the Father and not a creature:

> What God begets is God; just as what man begets is man. What God creates is not God; just as what man makes is not man. That is why men are not Sons of God in the sense that Christ is. They may be like God in certain ways, but they are not things of the same kind.[3]

As Lewis says, the Son is "always, so to speak, streaming forth from the Father, like light from a lamp, or heat from a fire, or thoughts from a mind. He is the self-expression of the Father—what the Father has to say."[4]

The Son is the Word of God (in Greek, the *logos* of God), the Wisdom of God, or, we might say, the rational communication of God. The creedal statement also declares that the Son pre-exists "all worlds" and that through the Son "all things were made." The book of Colossians contains these lines:

> For in him all things were created: things in heaven and on earth, visible and invisible, whether thrones or powers or rulers or authorities; all things have been created through him and for him. He is before all things, and in him all things hold together.[5]

In short, for orthodox Christians, Christ is God.

The doctrine of the Trinity, discussed in Chapter 7, provides fuller context for the incarnational claim: that it was the Second Person of the Trinity, Christ, the eternally begotten Son, who is identical with God and yet became one with the historical person Jesus. The participation of Christ in human history is of paramount importance—from his humble birth in a stable, to attending weddings and eating with friends, to a life and ministry completely dedicated to pursuing divine purposes, which he accomplished. The Creed sketches salient details of the life and work of Jesus Christ:

> Who, for us and our salvation, came down from the heavens, and was made flesh by the Holy Spirit of the Virgin Mary, and became man; and was crucified also for us under Pontius Pilate, and suffered and was buried, and rose again on the third day according to the Scriptures, and ascended into the heavens, and sitteth on the right hand of the Father, and cometh again with glory to judge living and the dead, of whose kingdom there shall be no end.[6]

The Great Ecumenical Council of Chalcedon in the fifth century carefully specified the Incarnational claim:

[O]ne and the same Son, our Lord Jesus Christ, at once complete in Godhead and complete in humanity, truly God and truly human, consisting also of a reasonable soul and body; of one substance with the Father as regards his Godhead, and at the same time of one substance with us as regards his humanity; like us in all respects, apart from sin.[7]

Jesus was not God dressed up as a human person; rather, in Jesus Christ, God became identified with human nature.

The full humanity of Jesus is essential to Christology and includes all the particularities of being a concrete human being. As Lewis explained, "The Second Person in God, the Son, became human Himself: was born into the world as an actual man—a real man of a particular height, with hair of a particular color, speaking a particular language, weighing so many stone."[8] According to classical consensual orthodoxy, the specificity of Jesus allows him to be a representative of all humanity, for each person is concretely specific and lives at a particular place and a particular time.

Unless Jesus Christ was actually human, Anselm of Canterbury explained, humankind cannot be included in his salvific activity. And if Jesus Christ was not actually God, the redemption of humanity through his Atonement would be impossible.[9] Orthodoxy teaches that in the Incarnation both the human and divine natures remain what they intrinsically are. The statement "God became human" must not be understood as God changing or morphing into a human form, or as taking on a temporary disguise; the pagan gods did this, played tricks, raped women, and the like. By contrast, the metaphysics of the Incarnation mean that God never becomes not God and that humanity never becomes not human. As Athanasius said, the Incarnation was accomplished not because of the conversion of divinity into flesh and blood but because of the *assumption* of humanity by divinity.[10] Likewise, Lewis wrote that the Incarnation was "God's own assumption of the suffering nature."[11]

There is simply no way to make the Incarnation a small concept, a mere superstition or mere fraud or mere anything. If the claim that Jesus was God is false, it is nevertheless a large, lofty, and profound claim that is false—a claim that, if true, is the key to the whole cosmic story. A scene in *The Last Battle* communicates the grandeur of the Incarnation:

"It seems, then," said Tirian, smiling himself, "that the Stable seen from within and the Stable seen from without are two different places."

"Yes," said the Lord Digory. "Its inside is bigger than its outside."

"Yes," said Queen Lucy. "In our world too, a Stable once had something inside it that was bigger than our whole world."[12]

An Exalted Concept of Humanity

Discussions of the Incarnation inevitably center on the idea that the infinite God, whose greatness and majesty cannot be contained or surpassed, united with an individual human being, who in comparison is small and humble. Yet the sweep of biblical revelation advances the idea of humanity as a large and compelling idea—a creature conceived and willed by God to bear his image and relate to him in loving fellowship. Folk Christianity too often denigrates humanity in order to emphasize God's greatness, but classical orthodoxy affirms that humanity is in itself a display of God's greatness.

Indeed, an animal creature with rational, moral, and relational powers that mirror in finite ways God's own powers is an amazing idea. Some Narnian creatures questioned the very existence of such a thing. While visiting Mr. Tumnus's cave in Narnia, Lucy surveyed a cozy fire, a picture of an old grey-bearded Faun on the mantle, and a door that probably led to Tumnus's bedroom. Books on his reading shelf included *Nymphs and Their Ways* and *Is Man a Myth?* Ironically, the existence of nymphs is assumed, but the existence of human beings is questioned. Of course, Jadis, the White Witch, fears the ancient prophecy that four humans—two Sons of Adam and two Daughters of Eve—would end not only her reign but her life.[13] Victory in the rescue of Narnia would be Aslan's, but the humans would be important instruments in the grand plan.

The basis for the metaphysics and meaning of human nature is the Christian doctrine of creation. The *Magician's Nephew* contains a creation account, a depiction of how Narnia was born as Aslan walked among the animals he had created: "Narnia, Narnia, Narnia, awake. Love. Think. Speak. Be walking trees. Be talking beasts. Be divine waters."[14] Soon Aslan makes a pronouncement to those he had made special Talking Beasts:

> "Creatures, I give you yourselves," said the strong, happy voice of Aslan. "I give to you forever this land of Narnia. I give you the woods, the fruits, the rivers. I give you the stars and I give you myself. The Dumb Beasts whom I have not chosen are yours also. Treat them gently and cherish them but do not go back to their ways lest you cease to be Talking Beasts. For out of them you were taken and into them you can return. Do not so."[15]

The conferral of selfhood in this fantasy resembles the bestowal of the "image of God" in Genesis upon rational, self-conscious creatures which thereby gives them great value and purpose.

The higher rational and moral consciousness is embedded in an animal body, with physiological form and function, such that together they constitute what Lewis calls our "natural self."[16] Although the passage above warns the higher

animals not to go back to the ways of the other nontalking non-self-conscious beasts, Lewis's Christian view was not that the root of human sin lies in our animality. Commenting on Uncle Screwtape's letter which says that humans are "amphibians"—straddling two worlds, animal and spirit—David Clark forgivably misinterprets Lewis as indirectly warning of the advantages as well as "the dangers arising from sharing the natures of both animals and angels."[17] However, the Christian doctrine of humanity does not teach that a human being shares two natures—an angelic intelligence incarcerated in a physical body. Instead, as Lewis knew, humanity possesses one unique nature with two aspects.

The holistic human creature—pronounced "very good" by God in Genesis—has great value because of our unique *telos*, which is our inherent purpose, end, or destiny. Our *telos* is to become able to love God and others perfectly. However, the human predicament is that our amazing destiny has been impeded by sin: we have become damaged, and we are now powerless to change our condition. Historic Christianity teaches not that the metaphysical constitution of human nature has been altered by "original sin," but that relations between humans and God have been damaged. As Lewis indicated, sin is an "act of self-will on the part of the creature, which constitutes an utter falseness to its true creaturely position."[18]

Understanding that Christianity conceives of "mere humanity," as we might call it, as pure and unadulterated is a needed corrective to both religious and secular distortions of the concept. Commenting on classical theological pronouncements, French philosopher Claude Tresmontant concludes that "in its most profound and essential impulse, the biblical and Christian tradition has had a steadfast tendency to exalt human nature."[19] However, along with naturalism, atheism, and secularism, which mistakenly reduce human nature to a product of the natural world, certain theological perspectives have a low view of humanity as well, often connecting sin to physicality. A high view of humanity—a proper theological anthropology—is essential to a proper Christology, for it was this marvelous kind of creature with which God in Christ became one, intimately and forever.

Myth Became Fact

After Lewis had come to belief in God, he still retained serious intellectual reservations about the Incarnation, about whether Jesus was God, largely because he classified the gospel accounts as mythical. However, his famous late-night talk with Tolkien and Dyson, as discussed in Chapter 1, helped him see that myths are not poetic lies but richly symbolic stories communicating important truths that cannot be conveyed literally. This more profound view

of myth allowed Lewis to combine his commitment to rational evaluation with his lifelong love of imaginative literature: myth can indeed be seen as the conveyer of truth. Tolkien's further argument, which left an indelible impression on Lewis, was that the story of Christ was the True Myth, a myth that works in the same way as the others, but a myth that really happened—a myth that conveys significant truth about the realm of fact. In his essay "On Fairy-Stories," Tolkien explains it by saying, "this story [the Gospel] has entered history."[20]

Recurring patterns in pagan myths had always fascinated Lewis—particularly the pattern of the dying and rising god in ancient polytheisms that connected the gods and the rhythms of nature. He had long thought that the recurring mythic pattern, while not really true, was "profound and suggestive of meanings beyond my grasp even tho' I could not say in cold prose 'what it meant.'"[21] According to Joseph Pearce, Tolkien persuaded Lewis to see that "in the same way that men unraveled the truth through the weaving of story, God revealed the Truth through the weaving of history."[22]

The new perspective was a complete reversal for Lewis as a literary critic because he had embraced the main thesis in *The Golden Bough* by Sir James Frazer that all religions, including Christianity, share the same general patterns and were not significantly different from one another.[23] Joseph Campbell—perhaps the greatest "mythologist" of the twentieth century and a contemporary of Lewis—also maintained that these patterns, while not factually true, provide models for the individual to understand the meaning of his existence in society.[24] Campbell's contributions drew from Sigmund Freud, who reduced religion to neurosis, and Carl Jung, who viewed symbols as metaphors which unleash our psychic powers for entering into mature relationships.[25]

But a profound conception of how truth and meaning, fact and myth, come together was powerfully influential in Lewis's thinking because he had already examined the historicity of the Gospels on the Incarnation and had become "*nearly* certain that it really happened."[26] Joseph Pearce explains Tolkien's impact on Lewis:

He had shown that pagan myths were, in fact, God expressing Himself through the minds of poets, using the images of their "mythopoeia" to reveal fragments of His eternal truth. Yet, most astonishing of all, Tolkien maintained that Christianity was exactly the same except for the enormous difference that the poet who invented it was God Himself, and the images He used were real men and actual history. The death and resurrection of Christ was the old "dying god" myth except that Christ was the real Dying God, with a precise and verifiable

location in history and definite historical consequences. The old myth had become a fact while still retaining the character of a myth.[27]

Lewis echoed this enlarged perspective in a letter to Arthur Greeves:

> Now the story of Christ is simply a true myth: a myth working on us in the same way as the others, but with this tremendous difference that *it really happened*: and one must be content to accept it in the same way, remembering that it is God's myth where the others are men's myths: i.e. the Pagan stories are God expressing Himself through the minds of poets, using such images as He found there, while Christianity is God expressing Himself through what we call "real things." Therefore it is *true*, not in the sense of being a "description" of God (that no finite mind could take in) but in the sense of being the way in which God chooses to (or can) appear to our faculties. The "doctrines" we get *out of* the true myth are of course *less* true: they are translations into our *concepts* and *ideas* of that wh. [which] God has already expressed in a language more adequate, namely the actual incarnation, crucifixion, and resurrection.[28]

In the biblical account of the Incarnation, according to Lewis, myth and history come together.

In pagan religious myths, the crops live and die and rise again—and certain gods do as well. But with Christianity, "[w]e pass from a Balder or an Osiris, dying nobody knows when or where, to a historical Person crucified (it is all in order) under Pontius Pilate."[29] "Descent and reascent" in the fertility myths is "a familiar pattern . . . written all over the world," in both vegetable and animal life.[30] The pattern of myth is cyclical and repetitive, reflecting a vision of a deterministic universe in which the gods, humanity, and nature are intertwined. Religion scholars contend that these fertility myths convey meaning without any factual truth, which means that they are *ahistorical*.

However, Lewis came to see that the Incarnation of Jesus Christ was genuinely *historical*—that he entered the arena of history where finite choices are significant and where God and humanity can interact. In surrendering his stereotype that the Gospels are typical myth, he was able to disclose honestly his appraisal of the Gospels as anything but typical:

> I was by now too experienced in literary criticism to regard the Gospels as myths. They had not the mythical taste. And yet the very matter which they set down in their artless, historical fashion—those in narrow, unattractive Jews, too blind to the mythical wealth of the Pagan world around them—was precisely the matter of the great myths. If ever a myth had become fact, had

been incarnated, it would be just like this. And nothing else in all literature was just like this. Myths were like it in one way. Histories were like it in another. But nothing was simply like it. And no person was like the Person it depicted; as real, as recognizable, through all that depth of time, as Plato's Socrates or Boswell's Johnson Here and here only in all time the myth must have become fact; the Word, flesh; God, Man. This is not "a religion," nor "a philosophy." It is the summing up and actuality of them all.[31]

Lewis the expert literary critic assigned strong factual plausibility to the Gospels because they are "clumsy" and "don't work" as pure legends.[32]

Near the end of *Miracles*, Lewis states the thesis that in the Incarnation our religious aspirations, historical interest, and imaginative longings come together:

Just as God is none the less God by being Man, so the Myth remains Myth even when it becomes Fact. The story of Christ demands from us, and repays, not only a religious and historical but also an imaginative response. It is directed to the child, the poet, and the savage in us as well as to the conscience and to the intellect. One of its functions is to break down dividing walls.[33]

Although Lewis started with essentially the same theory of myth that Frazer and Campbell espoused—believing that Christianity is like all nonhistorical religious myths—his elevated view of myth allowed him to rethink the Christian story as the meeting of ultimate meaning and profound truth.

In *The Chronicles of Narnia*, Lewis creatively translated his understanding of "myth become fact" to an imaginary world. In response to readers and commentators who called this work an allegory, revolving around the comparison of Christ and Aslan, Lewis offered clarification referring to John Bunyan's famous allegory, *The Pilgrim's Progress*:

If Aslan represented the immaterial Deity in the same way in which Giant Despair represents Despair, he would be an allegorical figure. In reality however he is an invention giving an imaginary answer to the question, "What might Christ become like, if there really were a world like Narnia and He chose to be incarnate and die and rise again in that world as He actually has done in ours?"[34]

Lewis's point is that allegory as a literary form provides one-to-one parallels between the tangible and the intangible but that *The Chronicles* instead follows in the tradition of myth in which meaning is created, in this case, in an alternative reality. In any event, Lewis used this insight in various contexts to elucidate how the fact of the Incarnation symbolized higher significance, how in Jesus Christ both truth and meaning converge.

Scripture and the Historical Jesus

As a Christian thinker, Lewis had to address the problem of the historical Jesus—most notably issues regarding our ability to access the historical Jesus of Nazareth with a fair degree of accuracy. Rationalism in the late Enlightenment spawned critical study of the Bible that raised questions about whether the three Synoptics or John's Gospel preserved the most accurate picture of Jesus, but the working assumption was that a biography of Jesus "as he really was" could be reconstructed in spite of the difficulties. Lewis was conversant with and responded to various interpretations of Jesus that had emerged in the late nineteenth and early twentieth centuries.

Many theologians and Bible scholars in the late nineteenth century wrote various "lives of Jesus," which were summarized in Albert Schweitzer's *The Quest of the Historical Jesus*.[35] However, early optimism eventually gave way to pessimism that an accurate biography of Jesus could be constructed, but the thought remained that Jesus was a noble moral teacher. Schweitzer and others denied the supernatural dimension of Jesus, particularly the eschatological end to history that Jesus proclaimed he would bring about. For these thinkers, Jesus's self-perception indicated he was mentally unstable or a lunatic.

Nonhistorical interpretations of Jesus continued well into the twentieth century. Theologian Rudolf Bultmann advocated "demythologizing" the New Testament because the "Jesus of history" is myth, which is not important to the "Christ of faith." He stressed instead the *kerygma* (Greek: essential proclamation), which reflects what the early church thought of Jesus:

> It is impossible to repristinate a past world picture by sheer resolve, especially a *mythical* world picture, now that all of our thinking is irrevocably formed by science. A blind acceptance of New Testament mythology would be simply arbitrariness; to make such acceptance a demand of faith would be to reduce faith to a work.[36]

For Lewis, the separation between the Christ of faith and the Jesus of history is untenable and unpreachable—untenable because of the flawed mythology on which the division is based and unpreachable because of the artificiality of the Christ who is preached.[37]

After Lewis died in the middle of the twentieth century, "the quest" continued as scholars proposed nonhistorical interpretations of Jesus that Lewis would also have opposed. The Jesus Seminar, convened in 1985, brought together twenty scholars to determine what Jesus actually did and said, resulting in two volumes—*The Five Gospels: What Did Jesus Really Say?* and *The Acts of Jesus: What Did Jesus Really Do?*[38] Marcus Borg, arguably the best-known voice

in the seminar, expressed skepticism about the Jesus of orthodoxy and provided a purely naturalistic explanation of how religious experience and tradition have constructed him.[39]

Lewis would have resonated with informed responses to these developments in "the quest" by orthodox Christian scholars—such as C. H. Dodd and N. T. Wright—who point out its various mistakes.[40] Wright and Borg actually coauthored a book discussing their differences, under the title *The Meaning of Jesus: Two Visions*.[41] Like Lewis, who was highly critical of "the quest," Wright identifies the unquestioned questions and naturalist assumptions of modern biblical scholarship, which deny in advance any supernatural aspect to Jesus, leading to the post hoc view that the Gospels are legendary embellishments. Lewis in his day pointed out that naturalist assumptions unfairly place the "burden of proof" on scholars and believers who discern an essential authenticity in gospel reports. Evidence does not matter on naturalistic background beliefs which never allow a supernatural interpretation of who Jesus was. To have a fair and balanced consideration of the evidence for the historical Jesus in the biblical record, there must be a degree of openness to some form of supernaturalism on the part of investigators.

Lewis also pointed out the need for an adequate understanding of the concept of history. The philosopher of history R. G. Collingwood argues that a history is not an exhaustive retelling of events but is instead an account written somewhat selectively from a point of view.[42] Similarly, Lewis wrote that history as a purely neutral listing of facts was "never even envisaged by the Ancients."[43] On the other hand, this does not mean that history is totally subjective; we simply have to understand the kind of objectivity that is possible in any history. When we consider the extraordinary claims and actions of Jesus in the Gospels, we must ask questions about how—emanating from a specific time, era, culture, and set of purposes—they represent historical material regarding the case of Jesus.

In a letter to Corbin Scott Carnell, Lewis wrote that a "sound critical reading" uncovers "different kinds of narrative in the Bible" and that "it would be illogical to suppose that these different kinds should all be read in the same way."[44] Commenting on the peculiar genre of gospel literature, Lewis stated,

> Now, as a literary historian, I am perfectly convinced that whatever else the Gospels are they are not legends. I have read a great deal of legend and I am quite clear that they are not the same sort of thing. They are not artistic enough to be legends. From an imaginative point of view they are clumsy, they don't work up to things properly. Most of the life of Jesus is totally unknown to us, as is the life of anyone else who lived at that time, and no people building up a legend would allow that to be so.[45]

As one piece of evidence for his own view, Lewis cites the story of the woman caught in adultery. Jesus bent down and wrote in the dust with his finger—which is a seemingly irrelevant detail, inexpertly recorded, with no apparent attempt to deceive that no one artfully writing legend would report.

The topic of the historical Jesus of the Gospels also raises questions about the concept of revelation. When Lewis was interacting with the scholarship on this point, he wrote the essay "Modern Theology and Biblical Criticism," which relentlessly critiques Bultmann:

> I have been reading poems, romances, vision-literature, legends, myths all my life. I know what they are like. I know that not one of them is like this. Of this text there are only two possible views. Either this is reportage Or else, some unknown writer in the 2nd century, without known predecessors, or successors, suddenly anticipated the whole technique of modern, novelistic, realistic narrative. If it is untrue, it must be narrative of that kind. The reader who doesn't see this has simply not learned to read.[46]

In *Reflections on the Psalms*, Lewis offers an extensive treatment of the texture of the biblical documents and recommends that we should read them "with the use of such intelligence and learning as we may have," although they do not constitute "an encyclopedia or an encyclical."[47]

As Lewis often affirmed, biblical literature "carries the Word of God" or communicates the Word of God.[48] Because he held a classical prereformationist *sensus plenior* view of scripture—that it has fuller supernatural meaning beyond the natural—Lewis affirmed that Christ is its overall focus and import. He further articulated an *incarnational* and *sacramental* understanding of the nature of the Bible as a whole. First, he did not discount critical study of the Bible but as a good Anglican argued that it could be described in "incarnational" terms— that is, as being fully "human" while still divine. The Athanasian Creed declares that the Incarnation was "not by conversion of the Godhead into flesh: but by the assumption of humanity into God."[49] Analogously, Lewis explains that "the Scriptures proceed not by conversion of God's word into a literature but by taking up of a literature to be the vehicle of God's word."[50] So biblical literature for Lewis is fully human in a way parallel to the way Jesus is fully human—concrete and multitextured—but it is also fully divine, but divine in a way that breaks all stereotypes, as he explained in his introduction to J. B. Phillips's *Letters to Young Churches*:

> The same divine humility which decreed that God should become a baby at a peasant-woman's breast, and later an arrested field-preacher in the hands of the

Roman police, decreed also that He should be preached in a vulgar, prosaic and unliterary language. If you can stomach the one, you can stomach the other.[51]

Lewis's theory of scriptural revelation, then, is that human authors—and even the subsequent redactors and editors—were "guided by God" to produce literature that would fulfill God's purpose.[52]

Of equal importance, second, is Lewis's concept of the "sacramental" nature of scripture. Since a *sacrament* is a tangible and visible sign of an intangible and invisible spiritual grace, ordinary bread and wine, for example, can become avenues for receiving the divine life. So too otherwise ordinary human writings become bearers of divine truth and life. Thus, "the Bible, read in the right spirit and with the guidance of good teachers, will bring us to Him."[53] As Lewis said, just as believers or seekers "receive" the Holy Sacraments, we also sacramentally "receive that word," and we do so "by steeping ourselves in its tone or temper and so learning its overall message."[54]

Behind the incarnational and sacramental view of Scripture that Lewis held lies his *theory of transposition*, which he uses to illuminate the relationship between the supernatural and the natural. His essay "Transposition" contains a sophisticated theory—with ontological, epistemological, and linguistic dimensions—regarding how a richer system (with more elements) can be represented in or mapped onto a poorer system (with fewer elements). Conversely, the lower can be "taken up into" the higher. However, only the person who knows both sides of a transposition can fully understand it: "The brutal man never can by analysis find anything but lust in love; . . . physiology never can find anything in thought except twitchings of the grey matter."[55] He might have said that the naturalist can never find anything in the Gospels but contrivance and legend. Yet the Christian can see the Bible as great literature that conveys higher meaning.

Liar, Lunatic, or Lord?

Lewis thought extensively about the various interpretations (which he considered misinterpretations) of the Jesus of the Gospels that are prevalent in modern biblical scholarship as well as general culture:

1. Legend (or myth)—he never existed or never made the claims ascribed to him
2. The devil—a supernatural being bent on deception, mostly rhetorical in this context
3. Divine in the pantheistic sense—not a unique person because all persons generally are divine

4. Great moral teacher—a sage who taught lofty moral principles
5. Liar—a deceiver and fraud
6. Lunatic—one psychologically unstable and divorced from reality
7. Lord—the Son of God

Lewis was convinced that reasonable evaluation of the various alternative interpretations would lead to the reasonable conclusion that Jesus was God.

For his popular BBC broadcasts which became *Mere Christianity*, Lewis crafted the famous Liar, Lunatic, or Lord trilemma argument, which condenses his reasoning process on the subject to three options regarding the status of Jesus, each of which must be evaluated in terms of probability. In his scholarly writings, he had eliminated the first three interpretations from this list, particularly the idea that the Gospels are pure legend. The starting point of the trilemma, then, is the often encountered fourth interpretation that Jesus was "a great moral teacher" but not God.[56] At the outset, Lewis disqualifies this option as incoherent and therefore impossible because a mere human who identified himself with God would be either a liar, lunatic, or something worse—but he would definitely not be a noble teacher of morality:

> I am trying to prevent anyone from saying the really foolish thing that people often say about Him: "I'm ready to accept Jesus as a great moral teacher, but I don't accept His claim to be God." That is the one thing we must not say. A man who was merely a man and said the sort of things Jesus said would not be a great moral teacher. He would either be a lunatic—on a level with the man who says he is a poached egg—or else he would be the Devil of Hell. You must make your choice. Either this man was, and is, the Son of God: or else a madman or something worse. You can shut Him up for a fool, you can spit at Him and kill Him as a demon; or you can fall at His feet and call Him Lord and God. But let us not come with patronizing nonsense about His being a great human teacher. He has not left that open to us. He did not intend to. . . . We are faced, then, with a frightening alternative. This man we are talking about either was (and is) just what He said or else a lunatic, or something worse. Now it seems to me obvious that He was neither a lunatic nor a fiend: and consequently, however strange or terrifying or unlikely it may seem, I have to accept the view that He was and is God. God has landed on this enemy-occupied world in human form.[57]

Lewis sometimes referred to the deeper roots of the argument—traditionally known as the *aut Deus aut malus homo* dilemma (Latin: either God or a bad man), which reduces the options to two.[58]

Christopher Hitchens calls the argument "pathetic" for simplistically designating too few options.[59] John Beversluis says that Lewis's argument is purely

rhetorical with no logical force because it offers "only three alternatives and *two of them are absurd*"—which for Beversluis provides a reason why "professional philosophers and theologians do not take him seriously."[60] Adam Barkman states that such criticisms are unfair misrepresentations but still appraises the argument as a "false dilemma" (either liar/lunatic or Lord)—which closes off other options.[61] Barkman charges that Lewis assumes without argumentation that Jesus took himself to be God, whereas he thinks that "reasonable doubt can be cast upon the claim that Jesus thought himself to be God."[62] However, since Lewis wrote a considerable amount about the reliability of the Gospels and his opinion that Jesus indeed believed himself to be God, we will not discuss this proposal further.[63]

The general criticism that Barkman and others make is that the trilemma does not exhaust the options for interpreting Jesus and therefore is not sound reasoning. Certainly, the ideal goal of this kind of argument is to work with an exhaustive set of alternatives, but in many of Lewis's brief popular presentations, he simply assumes that some alternatives can be eliminated in order to work with the options typically promoted in academia and broader culture. Admittedly, there is no clear end to proposals of more logically possible options, but the challenge of generating credible options has been difficult for critics to meet. If we see Lewis's fundamental strategy as rationally evaluating and eliminating credible options for a nondivine Jesus, then we may use it as a guide for framing up a more comprehensive project of argumentation that goes beyond Lewis's more basic formulation.

Taking the "great moral teacher" option off the table, we can formulate Lewis's basic argument:

1. Jesus was either a liar, a lunatic, or Lord.
2. Jesus was neither a liar nor a lunatic.
3. Therefore, Jesus was Lord.

Although the argument structure is deductively valid, its overall bearing becomes probabilistic because we judge premise 2 probabilistically. Premise 2 denies both the liar and lunatic alternatives, drawing from subarguments to show that the liar and lunatic theories are improbable. By contrast, the conclusion that Jesus was Lord is more probable than the other alternatives.

Of course, there are subarguments supporting premise 2, such as the following line of reasoning countering the claim that Jesus was a liar (fraud, charlatan, scam artist):

1. Liars do not teach honesty and act honestly in all their dealings.
2. Jesus taught honesty and acted honestly in all his dealings.
3. Therefore, Jesus was not a liar.

The conclusion that Jesus was not a liar is probabilistic, but it is reasonable to think it is very probable or at least more probable than not. Furthermore, other premises can be added to increase the probability of the conclusion—among them, that liars are usually not willing to be tortured and executed for their lies, whereas Jesus chose the path of suffering and death; that liars generally have a sufficient motive for lying, whereas no such motive is apparent for Jesus; and so forth.

A similar subargument could be mounted against the claim that Jesus was clinically mentally ill—whether suffering from extreme narcissism, delusional states, antisocial tendencies, or paranoia. The theory that Jesus was insane has been proposed in various settings, even the Gospels which indicate that some in Jesus's audience, including his brother James, originally thought Jesus was insane—an astoundingly honest statement in these documents.[64] Jim Perry, writing for The Secular Web, compares Jesus to the seriously insane but influential religious leaders Jim Jones and David Koresh.[65] On the other hand, grounds for a subargument to the low probability of the insanity thesis are offered by psychiatrist O. Quentin Hyder, who argues that the Gospels "are sufficient to document that Jesus's patterns of thought, speech, behavior, and interpersonal relationships were not those of known patterns in people who are mentally ill."[66] Hyder explains that "any contention that Jesus was paranoid or delusional simply does not fit in with present day descriptions of such psychiatric disorders."[67] Again, this developing subargument about Jesus's mental condition could be augmented with additional claims: that his brother James changed his assessment of Jesus and became a devoted follower; that the kind of compassionate, winsome, selfless moral teachings of Jesus are not found in the pronouncements of insane, self-proclaimed religious prophets, and so forth.

Christian philosopher Daniel Howard-Snyder has raised two objections to the trilemma. First, he says that the argument is not exhaustive of the possibilities because there is a fourth option—that Jesus was "merely mistaken" about being God without being mentally unstable.[68] Now, Peter Kreeft and Ronald Tacelli have long been on record saying that a mistake of this significance is reducible to the lunatic option.[69] Consequently, Howard-Snyder mounts a sustained argument that the fourth option is both credible and not reducible: "Merely being wrong about something important, even something as important as whether one is divine, neither implies nor makes it likely that one is a lunatic, insane, deranged, or otherwise fit to be institutionalized."[70] To support his view, he imagines *possible* scenarios in which Jesus had credible grounds for believing he was God—among them, perhaps Jesus concluded from study of certain Old Testament texts like Isaiah 9:6 and Psalms 110:1 that he was the messiah and that the messiah must be divine.[71]

Howard-Snyder's second criticism of the argument is that the probability assessments for the non-Lord options do not result in a sufficiently high probability for the opposite conclusion that Jesus was Lord.[72] If we assign moderate probability values to the non-Lord options—particularly if the merely mistaken option is at least as probable as the divine option—then the "dwindling probabilities" for the Lord option create an obstacle to affirming it as more probable than not.[73] Of course, assessing probabilities is a complex matter, involving one's measured judgments about the claims involved and one's background beliefs by which the judgments are generated. Lewis obviously enumerated the credible options—whether stated as a trilemma or quadrilemma or hexalemma—and evaluated them differently, with the result that the Lord option was very probable.

Stephen Davis, also a Christian philosopher, disagrees with Howard-Snyder's overly generous probability values for the non-Lord options, maintaining "that they are highly improbable, somewhere (I would estimate) around 0.1 each."[74] Of course, if all the other options have a 0.1 (10%) probability, then logically there is fairly high probability for the option that Jesus was Lord. Davis critiques the "merely mistaken" option directly:

> It has never been my view that it is impossible to cook up scenarios in which a sane and moral person could mistakenly consider himself divine. But even for someone other than Jesus, it seems to me extremely difficult to make such a scenario plausible. And when we turn to Jesus—a person about whom we know a great deal (surely more than anyone else in the ancient world)—it seems to me that the difficulty increases geometrically.[75]

The debate between Howard-Snyder and Davis shows that the argument, when fairly stated and defended, is not overly simplistic and is capable of sustaining rigorous evaluation.

Although some misinterpretations caricature it as an attempted "proof" of his divinity, the argument is about what it is *rational to believe* about the nature of Jesus. Lewis's strategy for the argument is based on the idea that any serious engagement with the Jesus of the Gospels faces us with a limited number of alternative interpretations. Complex epistemic dynamics will come into play when contemplating the alternatives—including being closed or open to reality beyond the natural world, understanding the system of theological concepts that give meaning to the claims of Jesus, and so forth. Lewis's point was that the reasoning that can be built on the basic argument structure is sufficient to support the rationality of believing that Jesus was God.

Interestingly, Lewis connected his case that Jesus is Lord to one especially striking aspect of how Jesus represented himself as God: he claimed to forgive

sins, any sins whatsoever. In *Mere Christianity*, Lewis prefaces the trilemma argument by describing Jesus as follows:

> He told people that their sins were forgiven, and never waited to consult all the other people whom their sins had undoubtedly injured. He unhesitatingly behaved as if he was the party chiefly concerned, the person chiefly offended in all offences.[76]

Thus, the doctrine of the Incarnation is linked to the doctrine of the Atonement. The distinctively English word "Atonement"—which means "at-one-ment"—signifies reconciliation or peace between parties that were previously alienated. After all, if there is a holy God from whom humanity is alienated and to whom they cannot return on their own power, then the Incarnation portends an occurrence of cosmic significance and certainly "the central event in the history of the earth—the very thing the whole story has been about."[77] The Incarnation and Atonement make forgiveness, transformed life, and resurrection available to humanity.

Therefore, as Lewis explained, if Jesus is truly Lord, there is now a gateway to this new life, which Lewis describes as "the process of surrender" to God. The idea is that we have organized our lives apart from God, made ourselves the center of our own universe, as Lewis continues, and now need to "return" to God to receive "forgiveness."[78] Christians call the movement back to God *repentance*—from the Greek *metanoia*, meaning "change of mind"—which is a reorientation of one's life, a change of heart, a reversal of outlook. In Lewis's own journey, he found that our usual self-protective instincts and egocentric agendas prevent us from giving ourselves to God in this way and receiving the benefits of the Atonement.[79]

Now, repentance—which is a necessary kind of death to self—faces us with a profound paradox: "Only a bad person needs to repent: only a good person can repent perfectly.... The only person who could do it perfectly would be a perfect person—and he would not need it."[80] Through Christ, God can help us to repent:

> [S]upposing God became a man—suppose our human nature which can suffer and die was amalgamated with God's nature in one person—then that person could help us. He could surrender his will, and suffer and die, because he was man; and he could do it perfectly because he was God. You and I can go through this process only if God does it in us; but God can do it only if he becomes man.[81]

Lewis here follows the long-standing axiom of classical Christology well expressed by Gregory of Nazianzus: "that which He has not assumed He has not

healed."[82] In other words, no mediation between God and humanity is possible if the mediator lacks any aspect of God's nature or any aspect of human nature.

Lewis clearly affirms *that* the Atonement is a true doctrine, but he avoids making any pronouncement about *how* the Atonement accomplishes our reconciliation with God: "The central Christian belief is that Christ's death has somehow put us right with God and given us a fresh start. Theories as to how it did this are another matter."[83] While Lewis endorsed no specific theory of Atonement, he did envision its reach beyond *justification*, conceived as coming into right relationship with God, to *sanctification*, conceived by the ancient church as the beginning of a fundamental restoration of human nature. At this point, the fullest human and cosmic significance of the Incarnation and Atonement can be seen only in the larger context of orthodox Trinitarian theology.

7

The Social God and the Relational Creation

The doctrine of the Trinity is at the heart of Christian theology. Jesus's claims to be "one with the Father," to be divine, and to be humanity's access to God can only be fully understood in connection to Trinitarian doctrine. Lewis was deeply Trinitarian in his thinking because he believed that the doctrine has far-reaching ramifications for understanding the nature of Christ and the destiny of humanity and also because he believed it reveals to us the inner life of God. He saw the doctrine of the Trinity as the largest possible framework for the Christian vision of reality—the most fundamental conceptual component in the Christian worldview.

Lewis's understanding of the Trinity is based on the thinking of the ancient church combined with other more modern sources, all of which point to a God who is deeply social and relational in himself and who has social and relational purposes for his creation. Lewis knew that the idea of the eternal God as a being who is a living fellowship of divine persons—Father, Son, and Holy Spirit—is theologically rich and profound. To convey the dynamic of the inner life of God, he artfully employs the image of "the dance," which he then utilizes to speak of God's purposes for humanity. Those purposes, according to Lewis, involve the transformation and fulfillment of finite persons by participation in the divine fellowship.

In Search of Our True Selves

Aristotle asked, "What is it that all persons desire for its own sake?" His answer was that all persons seek *happiness*, which he explained as the fulfillment of our distinctively human *telos*—our inherent purpose, end, or destiny. Of course, he then defined the human good within a secular framework. Although few disagree that happiness is the proper human goal and the deepest human need, the nature of happiness is controversial. Philosophers over the centuries have defined happiness in various ways—as contemplation, virtue, power, and pleasure—and have suggested that it is what we are inevitably seeking in all of our activities. Lewis's own search may be accurately interpreted as a search for happiness that explored inadequate definitions of it.

C. S. Lewis and the Christian Worldview. Michael L. Peterson, Oxford University Press (2020).
© Oxford University Press.
DOI: 10.1093/oso/9780190201111.001.0001

The existential need for fulfillment or happiness drives human life, and yet each worldview purports a different path to that happiness. The "practical naturalism" of secular culture offers fulfillment along materialistic lines, such as wealth, status, power, sex, entertainment, and sports. While these things are not inherently bad, psychiatrist Viktor Frankl argues that they often serve as "existential masks or guises," which cover the loss of human meaning or sense of purpose.[1] Aristotle once remarked that a person may think he is happy when he is merely pleased.[2] True happiness, then, is more than a momentary sense of pleasure; rather, it is a deeper state of being that is properly connected to the purpose of human life.

Noted psychotherapist Paul Tournier distinguishes between "person" and "personage," which is the mask or image that we project when we present ourselves to others.[3] Each person appropriately fills many roles in life and society, but the key is not to hide behind a façade. To Dorothea Conybeare, his long-time correspondent, Lewis wrote that a human "must be speaking with its own voice (not one of its borrowed voices), expressing its actual desires (not what it imagines that it desires), being for good or ill itself, not any mask."[4] Lewis repeatedly states that our deep need is to give up our false selves, which struggle with loves and desires out of harmony with actual human fulfillment, so that we can become "more truly ourselves."

Lewis's *The Screwtape Letters* offers insightful glimpses into the human tendency toward self-absorption, pride, and manipulation, which prevent true happiness. Uncle Wormwood's letters explore the psychology of temptation as he advises his nephew, Screwtape, how to lead his human subject astray—by appealing to self-seeking motives such as envy or pride. Encouraging wrong self-orientation, Wormwood knows, results in the "warping" or the "twisting"—and indeed the "self-entrapment"—of created personality.

In *Till We Have Faces*, Lewis's last novel, he further explores the human tendency toward self-deception and the need for self-understanding. In this rewrite of the story of Cupid and Psyche, Orual, who is ugly, envies her half-sister, Psyche, who is beautiful. Orual accuses the gods of injustice because she has a facial deformity, which she hides, while Psyche is pure, loves life, and comes to be worshipped as a goddess by citizens of the kingdom. Although Orual pursues achievements—becoming a queen, a warrior, and a judge—to cover her loneliness and self-loathing, these roles serve as masks to keep her from facing her twisted inner self, just as she wears a physical mask to hide her deformed face. Orual's physical ugliness is a metaphor for her inward ugliness—we might say relational ugliness—just as Psyche's physical beauty is a metaphor for her relational beauty. Self-honesty about one's real motivations is necessary to becoming an authentic person, as Orual suggests in her question, "How can [the gods] meet

us face to face till we have faces?"[5] Until we are honest about who we are, we have only a personage to present to others, including God.

The search for happiness ultimately turns on what it means to be a human person—recognizing what fosters or impedes the fulfillment of the distinctive human *telos*. Lewis the classicist assumes that human nature is everywhere and at all times the same and thus that the human purpose is universal, while acknowledging the great diversity of personalities, interests, and talents that make for the flavorful differences among persons. His point is that the nature of humanity is the metaphysical foundation of all distinctively human happiness. Furthermore, he believed that experiencing true happiness requires spiritual transformation in which the unhealthy imbalance of desires within the human psyche becomes healthy and balanced—a transformation, as Lewis says, in which we become "our true selves." A fuller understanding of the need for personal transformation involves understanding the nature of sin and its distortion of finite personality.

Sin as Relational Damage

Christianity teaches that human beings are gifted with personhood—and that once one has a self—or, better, *is* a self—he or she is at risk of elevating the self out of proportion to its creaturely status, an error both subtle and grave. As Lewis wrote, "From the moment a creature becomes aware of God as God and of itself as self, the terrible alternative of choosing God or self for the centre is opened to it."[6] Choosing self rather than God "each day of each individual life," he further explained, is "the basic sin behind all particular sins."[7] Theologically, "original sin" is the problematic condition of the human race from its early beginning, such that all persons now operate with a strong gravitational pull toward self, which inevitably disorders our loves and relationships. In this light, Lewis commonly speaks of the present human condition as being "damaged" or "wounded" by sin.

Christian theologians and philosophers carefully reflected on the kind of damage caused by the entry of sin into the human condition. Augustine thought that before the Fall humans were able either to sin or not to sin (Latin: *posse peccare, posse non peccare*) but that, after the Fall, humans were no longer able not to sin (Latin: *non posse non pecare*). Implicitly siding with Augustine on this point, Lewis remarks, "No man knows how bad he is till he has tried very hard to be good."[8] During the Protestant Reformation, however, the theological concept of "total depravity" was articulated: the view that fallen human nature is completely corrupted such that sinful humans cannot do any good on their own. Totally depravity was logically linked to a doctrine of predestination: if

individuals lack any capacity to respond to God, then God must sovereignly choose those who will be saved. However, Lewis the "mere Christian" rejected this view in favor of the historically orthodox view: that while all human beings now have a bent toward sin and are unable to solve their own sin problem without the aid of divine grace, this does not entail that human nature is completely corrupt.

After a lengthy discussion on the negative effects of the Fall in *The Problem of Pain*, Lewis explicitly distances himself from the doctrine of totally depravity: "I disbelieve [the doctrine of total depravity], partly on the logical ground that if our depravity were total we should not know ourselves to be depraved and partly because experience shows us much good in human nature."[9] For Lewis, the claim that we are totally depraved involves a kind of incoherence—because the very claim to know that we are totally depraved involves reasonably reliable cognitive powers, which is a particular kind of good, in which case we are not totally depraved.

Furthermore, argues Lewis, human moral awareness cannot be as depraved as the human ability to follow the moral law:

> If we accept the primary platitudes of practical reason [the moral truths of the natural law] as the unquestioned premises of all action, are we thereby trusting our own reason so far that we ignore the Fall . . . ? As regards the Fall, I submit that the general tenor of scripture does not encourage us to believe that our knowledge of the Law has been depraved in the same degree as our power to fulfill it.[10]

To keep the human choice to sin in focus, Lewis explains that it is our responsibility to live up to the best we know:

> Now Christianity, if I have understood the Pauline epistles, does admit that perfect obedience to the moral law, which we find written on our hearts and perceive to be necessary even on the biological level, is not in fact possible to men. This would raise a real difficulty if perfect obedience had any practical relation at all to the lives of most of us. Some degree of obedience which you and I have failed to attain in the last twenty-four hours is certainly possible. The ultimate problem must not be used as one more means of evasion.[11]

God requires of us the goodness that is within our power, not the kind of goodness that lies beyond our power. By expressing the human problem in this fashion, Lewis eliminates the stereotype that God is an aloof judge who can never be satisfied.

To clarify the essence of sin, Lewis wrote of Adam and Eve,

They wanted, as we say, to "call their souls their own." But that means to live a lie, for our souls are not, in fact, our own. They wanted some corner in the universe of which they could say to God, "This is our business, not yours." But there is no such corner. . . . This act of self-will on the part of the creature, which constitutes an utter falseness to its true creaturely position, is the only sin that can be conceived as the Fall.[12]

Sin is relational damage: human persons are not in right relation to themselves or to God and thus cannot be in right relationship to others or the rest of creation. The proper relations we should have experienced are broken and skewed, making sin in a very real sense a denial of true reality. Our way back to healing and wholeness, then, must somehow be our restoration within the relational reality we inhabit.

Creation and Divine Intentions

To assert that humans are creatures of a perfectly good God, even if they are fallen, raises prior questions about the original divine purposes in creating. The Judeo-Christian creation story, interpreted theologically, affirms that the eternal personal agent at the core of reality willed into existence a creaturely order. This is a radically new worldview; no other ancient creation story conveys such lofty themes. Whether in Babylonian, Mesopotamian, or any other polytheistic culture, the ideas of primeval conflict between cosmic forces and human servitude demanded by the gods abound.[13] Orthodox theology, by contrast, teaches that God brought the universe into being "out of nothing"—no cosmic resistance and no selfish motives are present—and that finite personal beings came forth for God's purpose of loving fellowship. As Lewis emphasized, he who needs nothing chose to bestow the gift of creaturely personal life.[14] H. P. Owen indicates that "the doctrine of the Trinity reconciles the paradoxical affirmations that God is self-sufficient and that he is love," and thus explains why God created not to *get* but to *give*.[15]

What exactly does God want to give in this regard? The *Catechism of the Catholic Church* contains the following magnificent statement: "God, infinitely perfect and blessed in himself, in a plan of sheer goodness freely created man to make him share in his own blessed life."[16] The life of God is characterized by complete blessedness or happiness—and God's offer to humanity is to share in that unending Life of perfect peace, love, and joy. It is our great need—intrinsic to our *telos*—to worship, love, and obey God, the only path to our true fulfillment.

Lewis portrays this theological reality in *The Magician's Nephew*. The creation of Narnia was accomplished by Aslan singing, a motif that connotes joy and

love—and the creatures themselves, even the stars, began singing along with the Singer's song, sharing it, in harmonious joy and love.[17] As the good creatures of Narnia were being instructed to live in peace and harmony, Jadis ran away and plotted to control Narnia and subjugate its creatures, which led to the crusade to save and liberate Narnia. Since Jadis, the evil Queen of Charn, could not create her own world, she attempted to spoil what Aslan had done. This reflects the Augustinian (and Thomistic) idea that good can exist without evil, but that evil can exist only as a distortion of the good or as parasitic upon the good.

Interestingly, Lewis's good friend Tolkien also finds a creative way to depict in his *Silmarillion* the ancient theme that evil is a distortion of the good. The first rational beings, the Ainur, spring from the mind of "Eru," the supreme being. And Eru, who was called Ilúvatar on Earth, propounded to the Ainur themes of music that they were to make by joining their own individual sounds in harmony. Ilúvatar's intention was to bring harmony out of individuality as the Ainur sang the one great song he gave them. Melkor, however, desired more honor than is proper to creatures and sought to alter the music, weaving in elements of his own that made for discord. Since there is no harmonious theme but that given by Ilúvatar, neither Melkor nor any other creature can create a musical theme de novo that is harmonious and beautiful.[18] With such literary images, Tolkien and Lewis portray the truth that God's good creation has been damaged. However, both Tolkien and Lewis also knew that the damage is temporary, that the Incarnation is God's remedy, and that God's original intentions in creation will be fulfilled.

The Trinity and the Great Dance

Orthodox Christianity declares that God created humans so that they could live in harmonious love and joy, purely out of a desire to share his already perfect love and joy, which raises the question: what kind of being could have that particular aim? Lewis answered this question by repeating the familiar Christian line that "God is love" and then providing further analysis: "The words 'God is love' have no real meaning unless God contains at least two persons. Love is something that one person has for another person. If God was a single person, then before the world was made, He was not love."[19] "Love" is a relational and interpersonal concept that can legitimately be applied to God apart from creation only if he is essentially relational and personal in himself. Grasping this truth is preparation for a fuller vision of the classical doctrine of the Trinity: the idea that God is three persons in one being. The idea of God's intrinsic relationality is, in turn, the basis for understanding his relational intentions in creation.

The doctrine of the Trinity was explicitly made creedal at the Council of Constantinople in 381 AD. Although Nicaea had affirmed that the Son was "of the same substance" as (and thus coequal to) the Father, some continued to hold that we can affirm belief in the Holy Spirit without affirming that he too is eternally existing and "of the same substance" with the Father. The Nicene creed was also amended at Constantinople—giving us the Niceno-Constantinopolitan Creed—to include clear affirmation of Christ and the Holy Spirit as God: "We believe . . . in the Holy Spirit, the Lord and the Life-giver, that proceedeth from the Father, who with the Father and the Son is worshiped together and glorified together."[20]

The orthodox doctrine of the Trinity was expressed in terms of three important philosophical concepts—the *being* of God, the *persons* of the Trinity, and the *relations* among the persons. God, or the Godhead, is one self-existent being or substance (Greek: *ousia*) which is eternal and uncreated. Yet God as a unitary being subsists in *three persons*. The classical Greek concept of a *person* was sadly inadequate for a fruitful analysis of the Trinity because Aristotle's most fundamental category of *being* excluded the category of *person*. Hence, Aristotle's absolute being exists on its own and is not a person, and an individual person *has* being but cannot *be* being itself. Life, then, is a *quality added* to being and is lost at death.

The historical Trinitarian discussion significantly advanced and enriched the concept of personhood because it opened up a new way of understanding *being* as consisting in *personhood* and *personhood* as consisting in *relationship* rather than individuality. Particularly in the writings of the Cappadocian Fathers—Basil the Great, Gregory of Nyssa, and Gregory of Nazianzus—the concepts of *being* and *person* are coordinate. The orthodox formula for the Trinity became "Three Persons in one Being"—implicitly affirming that personhood is the most fundamental reality. Book IV of *Mere Christianity* is entitled "Beyond Personality: First Steps in the Doctrine of the Trinity"—making the statement that God is the prototype of all personhood and holds the key to human personality.

The doctrine of the Trinity may appear paradoxical at first glance. The Athanasian Creed of 500 AD contains this line: "We worship one God in Trinity, and Trinity in Unity, neither confounding the persons, nor dividing the Substance [Essence]."[21] Michael Durrant, for example, is one critic who argues that Trinitarian doctrine is logically inconsistent because each of the divine persons is supposed to be God, and yet the persons are distinct from one another such that the Father is not the Son, the Father is not the Holy Spirit, and the Son is not the Holy Spirit. Yet, as Durrant reasons, since there is exactly one God, Christ must be his own father and his own son, which is impossible.[22] Such criticisms fail to understand the underlying metaphysics of the persons/being distinction. The doctrine of the Trinity would involve a contradiction only if it asserted that

God is three persons and not three persons in the same sense of "threeness" or one being and not one being in the same sense of "oneness."

In fact, Lewis probes the idea of the Trinity as a society of "others" in which individual selfhood can be real:

> There is no reason to suppose that self-consciousness, the recognition of a creature by itself as a "self," can exist except in contrast with an "other," a something which is not the self. It is against an environment and preferably a social environment, an environment of other selves, that the awareness of Myself stands out. This would raise a difficulty about the consciousness of God if we were mere theists.[23]

Mono-personal monotheisms simply cannot fully account for the social and relational nature of individual selfhood.

The status of the doctrine of God as a Trinity of Persons is of utmost importance. The great consensual theologians were theological realists: they thought that theological propositions refer to theological or spiritual reality and that the human mind can access these truths about this reality. Modern theology has been pervasively anti-realist, working in the shadow of Kant, Heidegger, Wittgenstein, and other anti-realists, and saying that the Trinity is a human construct which could not be known to be accurate about a God who is Wholly Other. Lewis strongly criticizes liberal theologians who present God as a vague spiritual force or principle about which no descriptive claims can be made.[24] Striking a realist chord, the noted Catholic theologian Karl Rahner declared that "the economic Trinity *is* the immanent Trinity"—that the historic church *experienced* God as Three Persons in the economy of the world *because* he is a Trinity in his own inner nature.[25] As the Greek Orthodox theologian John Zizioulas has stated, "The being of God is a relational being; without the concept of communion it would not be possible to speak of the being of God."[26] The rebirth of theological realism over the past few decades has been encouraging and, in the case of the doctrine of the Trinity, a genuine true ontological insight—that God's being *is* communion.

Lewis was a theological realist in general, and he was certainly a realist about the Trinity, believing that the doctrine is true of the divine nature, and yet, like Augustine, recognizing that the Trinity cannot be fully captured in human thought and language. Lewis argues that Christian religion is God's "statement to us of certain quite unalterable facts about His own nature."[27] The Trinitarian revelation, he believes, tells us that God's inner nature—consisting of Three Divine Persons—is deeply personal, social, and relational. To criticisms that the doctrine of God should be simple and all doctrinal complexity eliminated, Lewis answered,

Besides being complicated, reality, in my experience, is usually odd. It is not neat, not obvious, not what you expect. . . . Reality, in fact, is usually something you could not have guessed. This is one reason I believe Christianity. It is a religion you could not have guessed. If it offered us just the kind of universe we had always expected, I should feel we were making it up. But, in fact, it is not the sort of thing anyone would have made up. It has just that queer twist about it that real things have.[28]

Christian philosopher Peter van Inwagen compares a realist view of theology to a realist view of science, arguing that "creedal descriptions of the Trinity . . . are good, practical descriptions of real things. . . . I am confident that they are at least as good as descriptions of curved space or the wave-particle duality in works of popular science."[29]

If the *relations* among the Persons of the Trinity are intrinsic to God's own inner life, what more can be said about these relations? Lewis elaborated on the claim that "God is love," writing that "[Christians] believe that the living, dynamic activity of love has been going on in God forever and has created everything else."[30] He follows with his most picturesque and powerful image of the Trinity:

In Christianity God is not a static thing—not even a person—but a dynamic, pulsating activity, a life, almost a kind of drama. Almost, if you will not think me irreverent, a kind of dance. The union between the Father and the Son is such a live concrete thing that this union itself is also a Person. I know this is almost inconceivable, but look at it thus. You know that among human beings, when they get together in a family, or a club, or a trade union, people talk about the "spirit" of that family, or club, or trade union. They talk about its "spirit" because the individual members, when they are together, do really develop particular ways of talking and behaving which they would not have if they were apart. It is as if a sort of communal personality came into existence. Of course, it is not a real person: it is only rather like a person. But that is just one of the differences between God and us. What grows out of the joint life of the Father and Son is a real Person, is in fact the Third of the three Persons who are God.[31]

God's active, generative love, says Lewis, is "perhaps the most important difference between Christianity and all other religions."[32]

The imagery of God as a dance—actually, as "the Great Dance"—first appeared in the writings of Gregory of Nazianzus in the fourth century to speak of the relation of the divine and human natures in Christ.[33] Gregory coined the term "perichoresis"—from the Greek *peri*, meaning "around," and *choreo*, meaning "to make space for another"—which suggests the idea of a dance, choreographed

movement of alternatively advancing and deferring. Interpreted in Trinitarian terms, the internal life of God—that is, the community of Father, Son, and Holy Spirit—is an eternal passionate and joyous love exchange, a selfless giving and receiving.[34]

Will Vaus thinks that Lewis borrowed the idea of the dance from Gregory without ever quoting him; Adam Barkman thinks that this is unlikely because Lewis was poorly read in the Greek Fathers.[35] In any event, Lewis the "mere Christian" was familiar with ancient theological discussions defining the ortho-doxy of the Trinity. What is abundantly clear is that the ancient Christian idea of *perichoresis*—imaged as the Great Dance—captivated Lewis and became his most dominant, organizing theme. In the intervening decades, the perichoretic understanding of the Social Trinity has become much more prominent in the-ological discussions.[36] Like Lewis, many theological thinkers are recapturing the ancient vision of the Trinity—the Self-Living, Self-Giving Personal Life at the heart of reality—as essential to any exploration of the purpose of human existence.

Personal Beings in a Relational Universe

In the Christian worldview, the human search for happiness is underway because we are relational beings created by a relational God and set within a relational universe. God, who is the ultimate personal-interpersonal-social reality, placed within human persons the need for proper relationship to himself, which is the human *telos*. It is predictable, then, that creation would bear marks of relationality and interconnectedness, which become pointers to the relational God. Thomists speak of *analogia entis*—the idea that aspects of our finite being (such as ration-ality and morality) are analogous to aspects of God's infinite being. Since social understandings of the Trinity tell us that the very nature of God consists in com-munion or loving fellowship, we may see the relational aspects of our humanity as suggesting the nature of God, making *analogia relationis* a rich insight in-deed.[37] Relational human nature in a relational universe reflects the relational nature of God.

In his essay "Membership," Lewis takes the Pauline line that Christians should consider themselves as parts of one body, as members of differing dignity that are complementary to one another in a single community.[38] In *The Discarded Image*, he borrows from Chalcidius, a fourth-century Christian Platonist, the image of the "celestial dance"—the *caelestis chorea*, which literally means "a dance belonging to heaven." The idea is that all existence is—or ought to be—in a "grand celestial dance" in which each creature finds its proper place in harmo-nious relation to all others. Lewis wrote,

Thus, for Chalcidius, the geocentric universe is not in the least anthropocentric. If we ask why, nevertheless, the Earth is central, he has a very unexpected answer. It is so placed in order that the celestial dance may have a centre to revolve about.[39]

Lewis knew that the medieval image of the cosmos was much less about the relative position of Earth and Sun and much more about a framework for communicating truths about the relational God creating a relational reality. Lewis makes the same point in his *Spenser's Image of Life*: "For the universe, as they conceived it, is a great dance or ceremony or society."[40] The imagery suggests that the dance intrinsic to the life of God is to be played out in the movements and rhythms of the universe.

Lewis develops his understanding of the dance in *Perelandra* when Ransom and King Tor discuss whether there is a meaning or plan to reality and how their worlds fit into it. Tor replies that everything is for "the Great Dance." Different *eldila* (rational creatures) then speak in turn about Maleldil and the Great Dance. The first voice says,

"The Great Dance does not wait to be perfect until the peoples of the Low Worlds are gathered into it. We speak not of when it will begin. It has begun from before always. . . . Blessed be He!"[41]

Maleldil *is* the Great Dance—and all creatures are to be included in it and find their source and meaning in Maleldil, who is perfect righteousness, justice, and love. Concerning the relation of Maleldil to his creatures, one voice says,

"All which is not itself the Great Dance was made in order that He might come down into it. In the Fallen World He prepared for Himself a body and was united with the Dust and made it glorious for ever. . . . Blessed be He!"[42]

And Maleldil is somehow the "center" of everything:

"Where Maleldil is, there is the center. He is in every place. Not some of Him in one place and some in another, but in each place the whole Maleldil, even in the smallness beyond thought. . . . Blessed be He!"[43]

It is worth noting that Jaime Vidal believes that Lewis borrowed the idea of the "ubiquitous center" from St. Bonaventure.[44]

In the litany of speeches, a voice extols the self-giving love of Maleldil:

"Each thing was made for Him. He is the center. Because we are with Him, each of us is at the center. It is not as in a city of the Darkened World where they say

that each must live for all. In His city all things are made for each. When He died in the Wounded World He died not for me, but for each man. If each man had been the only man made, he would have done no less. Each thing, from the single grain of Dust to the strongest *eldil*, is the end and the final cause of all creation and the mirror in which the beam of His brightness comes to rest and so returns to Him. Blessed be He!"[45]

The voice continues:

"In the plan of the Great Dance plans without number interlock, and each movement becomes in its season the breaking into flower of the whole design to which all else had been directed. Thus each is equally at the center and none are there by being equals, but some by giving place and some by receiving it, the small things by their smallness and the great by their greatness, and all the patterns linked and looped together by the unions of a kneeling with a sceptered love. Blessed be He!"[46]

Upon listening to the voices, Ransom has a vision of the Great Dance—composed of innumerable intertwining cords of light, containing smaller points representing creatures, like flowers and insects, as well as larger streams representing personal beings and universal truths, all displaying the vastness, complexity, and perpetuity of the Great Dance.[47]

The Great Dance of *Perelandra* occasions several observations. First, the idea that each creature is equally at the center is almost certainly derived from Charles Williams, who wrote, "Hierarchic, republican, the glory of Logres." Lewis interpreted this to have the following meaning: "As willed necessity is freedom, so willed hierarchy becomes equality."[48] Second, there is a clear reversal of the Platonic view of the cosmos in which the passionless Form of the Good is the ultimate object of desire (*eros*) around which the cosmos revolves because Maleldil passionately loves his creatures and puts in their hearts the desire to love him. Third, the medieval term "cosmos," according to Charles Taylor, connotes the idea of the totality of existence involved in a meaningfully ordered whole, whereas the term "universe" suggests the modern secular view of physical order without regard to meaning or value.

Free will is necessary for creaturely participation in the Great Dance. Maleldil, who is the very center of the Great Dance, is equally available to each created being as long as it chooses to remain at the center. "There is no way out of the center," says an eldil voice, "save into the Bent Will which casts itself into the Nowhere."[49] Free will, as Lewis explains, is the key to connecting to the source of all existence and goodness:

God created things which had free will. That means creatures which can go ei-
ther wrong or right. Some people think they can imagine a creature which was
free but had no possibility of going wrong; I cannot. If a thing is free to be good
it is also free to be bad. And free will is what has made evil possible.[50]

Free will puts good and evil under the control of creatures. As Lewis further
argues, the risk that creatures might choose wrongly and do horrible things and
reject God is worth it because free choice is the only way creatures can connect to
the goodness, love, and other values in a relational universe.

To develop this point, Lewis compares relation to God to earthly romantic love:

The happiness which God designs for His higher creatures is the happiness of
being freely, voluntarily united to Him and to each other in an ecstasy of love
and delight compared with which the most rapturous love between a man and
a woman on this earth is mere milk and water. And for that they must be free.[51]

Just as control and power destroy relationship in earthly matters, divine control
prevents intimate self-giving union between God and creatures. For the sake of
achieving this union, God gave creatures free will and thus opened himself to the
contingent outcomes of their choices.

Alvin Plantinga provides a careful definition of this robust kind of free will as
incompatible with any sort of determinism, divine or physical:

If a person is free with respect to a given action, then he is free to perform that
action and free to refrain from performing it; no antecedent conditions and/
or causal laws determine that he will perform the action, or that he won't. It
is within his power, at the time in question, to take or perform the action and
within his power to refrain from it.[52]

If a creature has incompatibilist freedom—sometimes called "libertarian"
freedom—then no circumstances can tip the scales of choice and get a certain
outcome. Lewis affirmed incompatibilist free will:

God has made it a rule for Himself that He won't alter people's character by
force. He can and will alter them—but only if the people will let him. In that way
he has really and truly limited His power. Sometimes we wonder why he has
done so, or even wish that He hadn't. But apparently he thinks it worth doing.
He would rather have a world of free beings, with all its risks, than a world of
people who did right like machines because they couldn't do anything else. The
more we succeed in imagining what a world of perfect automatic beings would
be like, the more, I think, we shall see His wisdom.[53]

Free choice to participate or not in the Great Dance suggests that the unfolding future of the world is not a predetermined script but more like an improvisation between God and creatures. The pattern of the Great Dance does not change, for it is eternal, but God's ways of drawing creatures into the dance are infinitely creative. In wooing and inviting creaturely response, God is adding to the Dance, building a great fellowship, a loving community—indeed, a family.

8

Pain, Suffering, and Death

The philosophical "problem of evil" is the most formidable objection to theistic and Christian belief, providing a reason for nonbelievers to reject faith and for believers to doubt their faith. If God is both infinitely powerful and infinitely loving, why does he allow evil and suffering in his world? For the intellectual representation of Christianity, Lewis knew that a reasonable response to the problem was required, for any rational presentation of the faith would be incomplete if it contained only positive arguments and lacked an insightful response to the problem of evil. At another level, the problem is also deeply emotional because of the personal hurt involved and deeply existential because it concerns how we orient ourselves in a world that includes pain and suffering. When Lewis lost his wife, Helen Joy Davidman, to cancer, he too was faced with the emotional and existential aspects of the problem. In the following discussion we first work through Lewis's thinking about the philosophical problem and then explore how his ideas of God affected his reaction to Joy's suffering and death.

The Problem of Evil

The problem of evil coming to us from Epicurus through Hume is that theistic claims about God and evil appear to generate a logical contradiction. Epicurus's old questions are blunt: "Is he willing to prevent evil, but not able? then he is impotent. Is he able, but not willing? then is he malevolent. Is he both able and willing? whence then is evil?"[1] In the first half of the twentieth century, philosophers commonly framed the problem as an argument demonstrating a contradiction in theistic belief. In 1955, atheist philosopher J. L. Mackie provided the standard statement:

> In its simplest form the problem is this: God is omnipotent; God is wholly good; yet evil exists. There seems to be some contradiction between these three propositions, so that if any two of them were true the third would be false. But at the same time all three are essential parts of most theological positions; the theologian, it seems, at once must adhere and *cannot consistently* adhere to all three.[2]

C. S. Lewis and the Christian Worldview. Michael L. Peterson, Oxford University Press (2020).
© Oxford University Press.
DOI: 10.1093/oso/9780190201111.001.0001

In his extensive treatment of the problem, Mackie defined God's "omnipotence" as the power to bring about any logically possible state of affairs and God's "perfect goodness" as the desire to eliminate all evil insofar as possible. Given these definitions, if evil is not logically necessary, then the claim that God exists clearly entails that no evil exists. Yet the theist also affirms that evil exists. Hence, as Mackie charges, theism is inconsistent and cannot be rationally accepted.

Although Lewis treated the problem of evil as an apparent contradiction in *The Problem of Pain*, published in 1940, it is unlikely that Mackie as a technical philosopher would have known about Lewis's more popular treatment. Lewis's approach particularly focuses on the phenomenon of pain as a key element of the evidence for evil, although evil may be defined broadly as all of the negatives or minuses of life. He articulates the problem, "in its simplest form," thus: "If God were good, He would wish to make His creatures perfectly happy, and if God were almighty He would be able to do what He wished. But the creatures are not happy. Therefore God lacks either goodness, or power, or both."[3] Christianity claims, of course, that God is both good and all-powerful. This apparent contradiction, he continues, can only be resolved by "showing that the terms 'good' and 'almighty,' and perhaps also the term 'happy,' are equivocal: for it must be admitted from the outset that if the popular meanings attached to these words are the best, or the only possible, meanings, then the argument is unanswerable."[4] For Lewis, answering the problem of evil, then, involves correcting, at a minimum, misunderstandings of three key concepts—"divine power," "divine goodness," and "human happiness."

Lewis's definition of "omnipotence" highlights that God's power does not control his rational creatures in any way that would violate the free will he has given them. Lewis's concept of divine "goodness" is that God's lofty goal for creatures is their true good, which makes their comfort a secondary matter. These moves actually anticipate Alvin Plantinga's reply to Mackie, which was developed through the early 1970s and became known as the "free will defense."[5] In essence, Plantinga argued that if it is *possible* that an *omnipotent, wholly good* God might create persons with free will, and if it is *also possible* that those free persons go wrong, then it obviously *is possible* that the claims that God exists and that evil exists are both true. Therefore, Plantinga concluded, Mackie was mistaken that those two claims are inconsistent and cannot possibly be simultaneously true.

Philosophers of all stripes eventually agreed that the "logical problem of evil" was never a good formulation of the difficulty evil poses for theism and moved on to a more accurate formulation of the challenge from evil. In the late 1970s, atheist philosopher William Rowe offered a statement of the challenge that became known as the "evidential problem of evil."[6] A skeletal version of the argument is as follows:

1. There exist evils which are not necessary to any greater good.

 (Factual Premise)

2. An omnipotent, wholly good God would allow evil only if it is necessary to some greater good.

 (Theological Premise)

Therefore,

3. An omnipotent, omniscient, wholly good God does not exist.

 (Conclusion)

The evidential argument has generated much discussion and debate and remains the paradigmatic form of the problem in professional philosophy.

Since the evidential argument is logically valid, if there are rational grounds to believe its premises, then there are rational grounds to believe its atheistic conclusion. Most theistic responses attack premise 1, which makes the factual claim that there are evils that are not necessary to any greater good. Philosophers have coined the term *gratuitous evil* to speak of this particular class of evil; conversely, they say that an evil is *nongratuitous* or has a point if and only if there is some good that could not be achieved without the evil occurring. What is at issue regarding the factual premise is whether it is more reasonable than not to believe that there are gratuitous evils.

The technically correct response to the logical problem is *defense*, showing that theism is not inconsistent; but the traditional type of response to the evidential argument is *theodicy*, an explanation for why God allows evil by connecting it to a greater good. A traditional "greater-good type theodicy" in effect argues that the factual premise is false because evils are necessary to some proposed greater good. Lewis, of course, was unaware of the sharp distinctions philosophers would later make between the logical and evidential problems and between defense and theodicy. But his explicit response to the logical problem in *Pain* actually provides a theodicy for pain in light of certain goods. Our task now is to translate Lewis's response using more contemporary categories and evaluate its effectiveness.

Does Evil Serve a Greater Good?

We can make real progress on the problem of evil generally or on the problem of pain specifically, according to Lewis, only if we start with correct understandings of the concepts of divine power, divine goodness, and human happiness. Many renditions of the problem interpret these concepts, taken together, to imply

that God can and would want to eliminate all evils. The factual premise of the argument—that there are evils which are not necessary to any greater goods—gets part of its force from the presumption that an omnipotent goodness would attain its aims without either natural or moral evils. Natural evils are painful or tragic results of the workings of nature, while moral evils are the wrong actions of free personal creatures.

First, Lewis clarifies the meaning of omnipotence. The popular definition of "omnipotence" asserts that it is "having all power," which leads people to think that it is possible for God to do anything whatsoever, including to eliminate all evils. However, Lewis points out that omnipotence must be understood in relation to the logical law of noncontradiction. He quotes Aquinas, who speaks for the mainstream of theistic and Christian thought on the point: "Nothing which implies a contradiction falls under the omnipotence of God."[7] Lewis distinguishes between states of affairs that are described without contradiction, and thus are "intrinsically possible," and states involving a contradiction, which thus are "intrinsically impossible." For example, the state of affairs described as *John's being married* is possible because the proposition "John is married" is not self-contradictory. However, the state of affairs consisting in *John's being a married bachelor* is impossible because being *married* and *not married* simultaneously is contradictory.

What is intrinsically impossible, Lewis explains, "is impossible under all conditions and in all worlds and for all agents." He continued, "[God's] omnipotence means power to do all that is intrinsically possible, not to do the intrinsically impossible. You may attribute miracles to Him, but not nonsense."[8] Physical laws, which God could suspend or violate to perform a miracle, must not be confused with logical laws, which rest on the law of noncontradiction, a necessary truth that cannot be suspended. In terms of physical laws, God could change something that is water at one moment into wine the next moment, but in terms of logical laws, he cannot make a substance be water and not water at the same moment.

Lewis then parlays the classical concept of omnipotence into an understanding of why God cannot so easily eliminate natural and moral evils. Lewis begins his explanation of natural evils by first linking them to God's plan to create beings with free will: "not even omnipotence could create a society of free souls without at the same time creating a relatively independent and 'inexorable Nature.'"[9] This is because a society of interacting personal beings cannot exist without a "neutral field" or common medium that allows them to acquire self-consciousness in contrast to "others" and serves as a context for free choice in common life.[10] However, if there must be a relatively independent Nature, with its own laws that operate independently human agendas or interests, then it may sometimes bring pain and suffering. Fire may comfort us at a distance but may also harm us if

we get too close because Nature has its own determinate character. As long as God wills that free beings exist, he must generally allow Nature its own law-like activity. The insistence that omnipotence could avoid pain for personal beings either by creating a different natural system or by frequently intervening in the present system is unwittingly a demand for no natural system at all. Thus, the possibility of natural evil is inherent in a natural system, which is necessary for free will.

The logical parameters for divine power also carry over to considerations of moral evil that results from free will: "the free will of rational creatures, by its very nature, included the possibility of evil."[11] One of Mackie's mistaken assumptions was that an omnipotent being could control free will and thus prevent evil.[12] Plantinga countered that theists are not necessarily committed to a compatibilist view of free will—that is, the idea that free will is compatible with being determined. Thus, both Plantinga and Lewis based their responses on the idea that God gave human beings incompatibilist free will. Plantinga explicitly amends Aquinas's classic principle—that omnipotence cannot bring about states of affairs that are intrinsically impossible—by adding that neither can God bring about states of affairs that are intrinsically possible but are *impossible for God to bring about*.[13] For example, Stephanie's free choice to repent is intrinsically possible because its description is not logically self-contradictory; but it is self-contradictory to say that God brought it about that Stephanie freely repents. As Lewis argued, the possibility of humans making evil choices that God cannot control is inherent in the gift of free will.

Second, Lewis explores the concept of divine goodness in relation to evil, primarily along two major lines—how we humans can make judgments about divine goodness and what positive meaning we assign to it. To begin, he removes two religiously oriented attempts to block the moral objection to God expressed in the problem of evil. For one thing, he refutes the idea that human finitude prevents our moral judgments from applying to God. The finitude objection, as Lewis explained, entails that all human ascriptions of goodness to God are meaningless, which would eliminate all moral grounds for worshiping or obeying him. Second, he shows that the appeal to human sinfulness also fails to render our moral judgments unreliable.[14] As a theistic moral realist, Lewis argues that "the Divine 'goodness' differs from ours, but it is not sheerly different: it differs from ours not as white from black but as a perfect circle from a child's first attempt to draw a wheel."[15] Continuity between divine and human goodness is supported by the doctrine of the *imago Dei*, which entails that God has given humanity reasonably reliable powers of moral judgment such that neither finitude nor sinfulness can nullify them. But this means that the pervasive human judgment that many evils are unnecessary or pointless has initial traction.

Although we humans have the ability to make meaningful moral ascriptions to God, Lewis warns that people still often adopt a mistaken view of divine goodness:

> By the goodness of God we mean nowadays almost exclusively His lovingness; and in this we may be right. And by Love, in this context, most of us mean kindness—the desire to see others than the self happy; not happy in this way or in that, but just happy.[16]

Although God is surely love, our understanding of love must be greatly refined, for according to Lewis, equating love with sentimental kindness trivializes God's goodness. Kindness can consent to the removal of its object—as in euthanizing a pet to prevent its pain. However, that sort of "kindness, merely as such, cares not whether its object becomes good or bad, provided only that it escapes suffering."[17] In contrast, Lewis asserts, "love may forgive all infirmities and love still in spite of them: but love cannot cease to will their removal."[18] In this sense, God's love may not feel at all kind, just as a child may cry when a parent removes a splinter.

Genuine love does not accept the object on its own terms but wills the object's true good. Lewis puts it this way: "I do not think I should value much the love of a friend who cared only for my happiness and did not object to my becoming dishonest."[19] God is our true good—the fulfillment of all human longing—and is thus the ground of authentic human happiness. God's love cannot do otherwise than to give us not what we think we *want* but what we most deeply *need*—he intends to give us himself.[20] Thus, Lewis writes, "When we want to be something other than the thing God wants us to be, we must be wanting what, in fact, will not make us happy."[21] There can be no happiness apart from our true source:

> God gives what He has, not what He has not: He gives the happiness that there is, not the happiness that is not. To be God—to be like God and to share His goodness in creaturely response—to be miserable—these are the only three alternatives. If we will not learn to eat the only food that the universe grows—the only food that any possible universe ever can grow—then we must starve eternally.[22]

If we live under the illusion that we are happy with lesser things, then it is absolutely essential to our true happiness to shed this illusion, however painful it may be for us.

God seeks to dispel the illusions that keep us from true happiness, but the divine overtures toward humanity face us with a choice:

From the moment a creature becomes aware of God as God and of itself as self, the terrible alternative of choosing God or self for the center is opened to it. This sin is committed daily by young children and ignorant peasants as well as by sophisticated persons, by solitaries no less than by those who live in society: it is the fall in every individual life, and in each day of each individual life, the basic sin behind all particular sins: at this very moment you and I are either committing it, or about to commit it, or repenting it.[23]

For the creature to choose self, "which constitutes an utter falseness to its true creaturely position, is the only sin that can be conceived as the Fall."[24] Since our ultimate happiness depends on our moral and spiritual condition, God takes seriously our need for transformation, which is a love that far surpasses mere kindness.

Lewis's treatment of the concepts of divine power and goodness as well as the concept of happiness provides the beginnings of a response to the overall problem of evil and the more specific problem of pain. In essence, since God willed into existence personal free beings that have the potential for the great goods of significant moral and spiritual development and for true happiness in union with God, God must allow the conditions for those goods to be realized. However, those same conditions of natural law and free will allow the possibility of natural and moral evil, including the pain such evil may involve. Hence, the *possibility* of evil is necessary if we are to have the *possibility* of the great goods that God wills. However, this does *not* mean that the *actuality* of various evils is necessary to the great goods envisioned—that is, that every actual evil X is necessary to a great good. Logically, the goods remain just as possible without the occurrence of the evils.

From these subtle but enlightening considerations, a Lewisian response to the factual premise can be extrapolated. Upon reflection, the factual premise, stating that there is gratuitous evil, can be seen to entail the claim that the world would be better on the whole without many of the evils it contains. Given Lewis's moral realism, which endorses the general validity of our moral evaluations, the widespread assessment of many evils as gratuitous is reasonable to believe. Besides, it staggers the imagination to think that every evil in the history of the world had to happen or else some greater good would not be obtained. So, from a Lewisian perspective, the claim that there is gratuitous evil is reasonable to believe. However, if the factual premise has traction and cannot readily be discounted, then answering the argument will depend on finding fault with its theological premise. It is to Lewis's thoughts on this matter that we now turn.

Risk and the Relational Universe

Although many theists and nontheists alike think that the evidential argument's theological claim—that God would not allow gratuitous evil—is unassailable, major concepts in Lewis suggest that this claim should be rejected. This second premise is equivalent to the claim that an omnipotent and perfectly good God would guarantee that every evil is necessary to a greater good, but this claim is in turn tantamount to the claim that God takes no risks in creating the world. However, the whole tone and tenor of Lewis's thinking on this matter is that God is relational and created us for the ultimate purpose of relation to him. Natural laws and libertarian free will are, then, necessary conditions for a variety of valuable relational possibilities with other personal beings, including relation to God. This means that the pursuit of God's lofty relational goals involves risk, a risk that some evil may occur.

Having established a world framework with possibilities for evil as well as good, Lewis then focuses on the specific question of pain. Having clarified that distinctively human happiness is fulfillment in relation to God, he argued that whatever increases the likelihood of the great good of the creature coming into proper relationship to God is instrumentally good. In this light, pain can be instrumentally valuable because when we humans are self-satisfied we often ignore our need for God. He quotes a line attributed to Augustine: "God wants to give us something, but cannot, because our hands are full—there's nowhere for him to put it."[25] If this is so, then our best interests are served if our self-obsession, what Lewis called "the journey homeward toward habitual self," can be interrupted—even if it is interrupted by pain.[26]

Lewis's oft-quoted line that "pain is God's megaphone to rouse a deaf world" emphasizes pain's capacity to shatter our illusions of self-sufficiency.[27] For unbelievers, "pain plants the flag of truth within the fortress of a rebel soul" by signaling their frailty and need to turn to God.[28] For believers who mistakenly take prosperity as constituting their blessedness, there is "an insufficiency that one day they will have to discover."[29] Although pain, which is not good in itself, can be instrumentally valuable in moving us toward God, Lewis was not formulaic about this point because pain only sometimes shatters our false sense of self-sufficiency and at other times drives us farther from God, depending on our response.[30] Lewis holds the general Aristotelian view that virtue is pleasant, but he makes a particularly Kantian point in observing that the initial act of self-surrender, which contains all other virtues, is itself unpleasant.[31]

Lewis does not make sweeping generalizations about the purpose of all pains, although some interpreters mistakenly represent him as doing so. He does not address evils such as natural catastrophes that wipe out hundreds

of people without giving them a chance to reorient toward God; neither does he engage human wrongful acts like the torture and murder of children who cannot respond productively to the pain. While Lewis asserted no tidy theory that each person experiences the exact amount of pain needed for positive spiritual results, he did argue that God can work redemptively with pain when it does occur. Using John Keats's term, Lewis calls the world a "vale of soul making"—that is, a context that includes pain and is conducive to moral and spiritual growth. Philosopher John Hick built his theodicy around this theme, but he was more hesitant than Lewis to credit this world with great success in accomplishing the purpose of developing mature souls.[32] There simply is no guarantee that all persons, even when pain exposes their insufficiency, will choose relationship with God.

This is part of the risk God decided to take in creating a relational world, one in which we must choose between ourselves and God as our center. Lewis explains, "Since I am I, I must make an act of self-surrender, however small or however easy, in living to God rather than to myself. This is, if you like, the 'weak spot' in the very nature of creation, the risk which God apparently thinks worth taking."[33] By accepting the risk necessary to relationship, God set for himself "the problem of expressing His goodness through the total drama of a world containing free agents, in spite of, and by means of, their rebellion against Him."[34]

As Lewis explained, the personal creature's initial surrender to God must be followed by continual surrender as the qualities of God's own life take root and grow in our lives as love, joy, and peace.[35] This process of sanctification will sometimes involve acting "contrary to our inclinations," which, again, is a kind of pain.[36] Yet surrender is the only way to true happiness:

> Now the proper good of a creature is to surrender itself to its Creator—to enact intellectually, volitionally, and emotionally, that relationship which is given in the mere fact of its being a creature. When it does so, it is good and happy.[37]

Even the giving of one's complete self to God is due to God's initiative in assisting us. "The world exists," Lewis states, "not chiefly that we may love God but that God may love us."[38] In defining the essence of love, Lewis in effect takes the Thomistic line that love always includes two desires: for the good of the beloved and for union with the beloved.[39] Our highest good is to be united with God, and God cannot do otherwise than to seek us and perfect us. "If you let me," God says, "I will make you perfect"—and pain and suffering *may* serve as a means to that end.[40] For God, the possibility of achieving this great relational good is worth the risk.

Suffering Comes to Joy

Lewis's theory of pain as a piece of rational theodicy was put under extreme pressure when he lost his wife to cancer. In *A Grief Observed*, he records his turbulent thoughts and feelings during his crisis of faith and his struggle to regain equilibrium. The book was originally published under the pseudonym "N. W. Clerk"—the N. W. was derived from an Anglo-Saxon phrase meaning "I know not whom," and "clerk" meant simply one able to read and write. After Lewis's death, later editions were published under his name, leading to differing assessments of the lasting impact of Joy's suffering and death on Lewis's faith.

Helen Joy Gresham was an awarded poet, a Jewish Communist from the Bronx, who began reading Lewis and corresponding with him during her failing first marriage. She soon converted to Christianity, divorced her husband, and moved to England in 1954 with her two sons. Joy developed such a close friendship with Lewis that he married her in a civil ceremony in 1956 to secure her legal residency in England. Their friendship blossomed into romantic love, and when Joy's cancer was diagnosed in 1957, Lewis insisted that they be married in a religious ceremony in her hospital room. Unexpectedly, Joy's cancer went into remission, allowing them four happy years together. Lewis wrote that he and Joy feasted on love—every mode of love, whether solemn or merry, romantic or realistic.[41] Lewis remarked to Nevill Coghill, "I never expected to have in my sixties, the happiness that passed me by in my twenties."[42]

In 1960, Joy—or "H." as Lewis called her in *Grief*—died a painful death at the age of forty-five, leaving an aching void in Lewis's life. Joy's zest for life, penetrating mind, and bold honesty had changed Lewis, the aging bachelor and lifelong academic, for the better. "H. was a splendid thing; a soul straight, bright, and tempered like a sword," wrote Lewis. She was that one person, who, though very different, completed him. He spoke of their marriage using the biblical imagery of "one flesh"—a spiritual and physical amalgamation of two complementary persons. Reflecting on the many roles Joy played in his life, Lewis wrote,

> A good wife contains so many persons in herself. What was H. not to me? She was my daughter and my mother, my pupil and my teacher, my subject and my sovereign; and always, holding all these in solution, my trusty comrade, friend, shipmate, fellow-soldier. My mistress; but at the same time all that any man friend (and I have good ones) has ever been to me. Perhaps more.[43]

Like Solomon in the love poetry of the Song of Songs, Lewis called his bride his "sister," accenting the closeness of a faithful, intimate partner.

Following Joy's death, Lewis felt incomplete in every situation: "The act of living is different all through. Her absence is like the sky, spread over

everything."[44] In similar fashion, philosopher Nicholas Wolterstorff described the palpable absence of his son, Eric, who died in a mountain climbing accident: "There's a hole in the world now. In the place where he was, there's now just nothing."[45] Caught in a vortex of emotions, Lewis experienced fear and self-pity intermingled with fond memories of Joy and desperate hopes to see her again. Early in his grief, he also expressed the feeling—not uncommon among those who suffer loss—that God seems unavailable:

> Meanwhile, where is God? . . . [G]o to Him when your need is desperate, when all other help is vain, and what do you find? A door slammed in your face, and a sound of bolting and double bolting on the inside. After that, silence. . . . Why is He so present a commander in our time of prosperity and so very absent a help in time of trouble?[46]

The pain of seeking God and, apparently, finding oneself alone is a hard one to justify as a means of pointing us to God.

In his grief, doubts about some of his most established beliefs plagued Lewis, leading some commentators to say that the fragility of his intellectual perspective was finally exposed. When friends told him that Joy was now "in God's hands," Lewis questioned the metaphysical status of persons. Taking no comfort in the trite "consolations of religion," he asked, "Where is she now?" Since Joy is no longer in space and time, what in her personhood, if anything, persists? He raised the haunting prospect that materialism may be true: "If H. 'is not,' then she never was. I mistook a cloud of atoms for a person. There aren't, and never were, any people. Death only reveals the vacuity that was always there."[47] Now, if Joy was actually a *person* and had a *mind*, then materialism is false. Besides, Lewis reasoned, it is "nonsense" to think that one cloud of atoms could have mistaken beliefs about another cloud of atoms—for only persons with minds have beliefs. Against this emotional doubt, he intellectually reaffirms his argument against materialism and his realism about personhood and mind.

After dismissing materialism as a serious intellectual threat, Lewis then questioned whether God is good. After all, if there are persons in the realist sense, and if God is directly involved with them, then Joy's suffering seems to be an evil done to her by God. Lewis had long defended the theory that God's goodness could allow pain for spiritual benefit, but in reflecting on Joy's horrible suffering and death, he angrily proposed the Cosmic Sadist hypothesis—the idea that God is evil:

> What reason have we, except our own desperate wishes, to believe that God is, by any standard we can conceive, "good"? Doesn't all the *prima facie* evidence suggest exactly the opposite? What have we to set against it?[48]

Critic John Beversluis argues that Lewis's faith in a God who is objectively good according to natural law was shattered but that he avoided the Cosmic Sadist conclusion only by embracing theological voluntarism, which was famously championed by William of Ockham:

> The shift from the hypothesis of Cosmic Sadist to the Great Iconoclast is a shift from the qualified Platonist view that God says certain things are good because his nature requires him to do so to the Ockhamist view that things are good simply and solely because God says so.[49]

If God's will decides what is good, then at least we cannot call him an evil Sadist by realist standards.

Beversluis designates Lewis's hesitation to affirm the objective goodness of God as an ontological move about who God is, but Lewis also toyed with the epistemological notion that our depravity prevents us from knowing true goodness, which would at least block the charge that Joy's suffering is counterevidence to God's goodness. Either way, the result is discontinuity between human and divine concepts of goodness: "the word good applied to [God] becomes meaningless."[50] For Beversluis, this constitutes a defeat of Lewis's Christian intellectual position, which depends crucially on commitment to God's objective goodness.[51]

Beversluis further contends that in surrendering moral realism Lewis was shifting the blame from God to himself. At a low moment, Lewis wrote, "If my house has collapsed at one blow, that is because it was a house of cards."[52] "When the stakes were raised horribly high," he found that his faith was "imaginary" and would not support him.[53] Lewis called God the Great Iconoclast who shattered his faith: "My idea of God is not a divine idea. It has to be shattered time after time. He shatters it Himself."[54] But what exactly was shattered in Lewis's faith? According to Beversluis, the rational basis of Lewis's Christian faith was destroyed, and a new faith was rebuilt on a completely different foundation akin to fideism, or faith embraced apart from rational considerations.[55]

However, Lewis himself explains that the Cosmic Sadist thesis was intellectual "nonsense" from the beginning, not based on philosophical grounds but on "feelings, and feelings, and feelings."[56] For all those who suffer, Lewis modeled that they too may experience seemingly uncontrollable emotions that make them want to doubt and accuse God. Although he was justly famous for his contribution in *Pain* to the philosophical problem of evil, he perhaps makes a greater contribution by sharing in *Grief* how he dealt in an agonizingly personal way with what we might call the emotional problem of evil. We note that he expressed the emotional problem faced by all who grieve suffering and loss in highly intellectual terms which are not characteristic of many other expressions of grief.

Nonetheless, as his emotion subsides in *Grief*, he confesses that his skeptical remarks were actually forms of "yelling" and "kicking" at God rather than outright denials of basic theistic and Christian claims about God.

Through his grieving process, Lewis realized not that his idea of God was obliterated but that it was subject to ongoing refinement and revision.[57] Lewis's theory of suffering was not totally unchanged between *Pain* and *Grief*, as Michael Ward argues; neither was it completely demolished, as Beversluis maintains.[58] Lewis simply came to recognize that all reality is iconoclastic, sometimes deconstructing false ideas and sometimes reminding us that ideas only partially capture their objects and must not be mistaken for their objects.[59] He wrote that the true objects of his love were "Not my idea of God, but God. Not my idea of H., but H. Yes, and also not my idea of my neighbor, but my neighbor."[60] In a relational universe, we must love the person and not our mental image of the person; we must worship God rather than the activities of worshiping God. This recognition led to Lewis to more intimate faith and trust in God.

When Lewis eventually focused on deeper relationship with God as key, he stopped trying to find a rational explanation for Joy's suffering and instead began expressing thankfulness to God for giving Joy to him in the first place. To acknowledge her as a great gift was to reframe his grief. The 1993 Hollywood film *Shadowlands*, starring Anthony Hopkins and Debra Winger, depicts Lewis asking, "Why love if losing hurts so much?" He reasons that choosing safety forecloses the possibility of love but that choosing to love is equivalent to choosing suffering, for one partner will eventually go on living without the other. For all pairs of lovers, he wrote, "bereavement is a universal and integral part of our experience of love."[61] In *The Four Loves*, Lewis explains,

> To love at all is to be vulnerable. Love anything, and your heart will certainly be wrung and possibly be broken. If you want to make sure of keeping it intact, you must give your heart to no one, not even to an animal. Wrap it carefully round with hobbies and little luxuries; avoid all entanglements; lock it up safe in the casket or coffin of your selfishness. But in that casket—safe, dark, motionless, airless—it will change. It will not be broken; it will become unbreakable, impenetrable, irredeemable.[62]

As *Shadowlands* draws to a close, Anthony Hopkins delivers a line which is characteristically Lewisian: "The pain now is part of the happiness then." Because we live in a fallen world in which physical death is inevitable, the future happiness we anticipate with another mortal person includes suffering that is redeemed and reframed in the presence of God.

At the end of the grieving process, Lewis's intellectual beliefs were deepened and his personal faith strengthened as he learned to trust God like never before.

On the last page of *Grief*, Lewis affirms that the best is yet to come and commits Joy to a perfectly good God with the words, *Poi si tornò all' eterna Fontana*—which is Italian (from Dante's release of Beatrice to the Divine Presence in Paradise) meaning, "Then to the eternal fountain she turned."[63] Looking forward to future resurrection, Lewis wrote a poem for Joy and had it inscribed on a plaque at Headington Crematorium:

> Here the whole world (stars, water, air
> And field, and forest, as they were
> Reflected in a single mind)
> Like cast off clothes left behind
> In ashes, yet with hope that she,
> Re-born from holy poverty,
> In lenten lands, hereafter may
> Resume them on her Easter Day.[64]

Evil and Worldview Comparison

Critics and commentators who believe that Lewis abandoned his philosophical Christian worldview in light of suffering when it became terribly personal commit the category mistake of interpreting emotional catharsis as philosophical reversal. Furthermore, they simply fail to note his simultaneous rejection of any other worldview alternatives as having even minimum rational credibility compared to the Christian worldview. For example, in *Grief*, when Lewis flirts with the possibility of a materialist view of persons as well as the possibility of an evil god, he immediately refers to the inadequacy of these other positions in explaining a number of important interconnected phenomena. A Cosmic Sadist, as Lewis says, might hurt us, but he could not do positive things such as invent or create or govern a universe. To hurt us, the Cosmic Sadist might bait traps, "but he'd never have thought of baits like love, or laughter, or daffodils, or a frosty sunset. *He* make a universe? He couldn't make a joke, or a bow, or an apology, or a friend."[65] Here Lewis retains solidarity with the classical idea that goodness is original and fundamental and that evil is derivative and parasitic. We might call this "the problem of good," indicting all views that cannot affirm a perfectly good and loving being at the heart of reality. Lewis, whose long-standing approach was to seek worldview engagement, remained confident that the Christian worldview explains evil and suffering better than other worldviews explain it.

While granting that acute emotional distress led Lewis to concoct the Cosmic Sadist hypothesis, it only superficially seemed more reasonable to him than Christian theism. As Lewis knew well, all evil occurs within a total world context

that includes other important phenomena that cannot be adequately explained by an evil source. Evil occurs in a world containing objective morality, mind, personhood, and relationality—which are best explained by Christian theism and are problematic in the extreme for other worldviews to explain. Indeed, the problem of evil itself, as Lewis indicated, can be credibly formulated only if these other realities are assumed; but these are all realities that fit best within a Christian theistic universe. Thus, although he did it only implicitly in *Grief*, Lewis maintained that the Christian explanation of all key phenomena of life and the world is better than the explanations of other worldview alternatives.

In the final analysis, the loss of Joy did not alter the broad intellectual contours of Lewis's Christian worldview, but it did modify certain theories he had associated with his Christian perspective. His theory that pain is a catalyst for spiritual reorientation—a belief that he articulated frequently and that many readers took as categorical—encountered the hard fact that sometimes we just have to endure pain that serves no particular purpose.[66] In fact, when Lewis eventually accepted that there is no "specific answer" to the puzzle of God's goodness, Joy's suffering, and his sorrow, he made progress toward emotional healing. The emotional changes—or, we might say, personal changes—in Lewis's faith included simply realizing that a devastating loss feels different "when it happens to oneself, not to others, and in reality, not in imagination."[67] When theory met practice, he found that his ideas about faith had not been put under the pressure of real life—but more to the point, his personal ability to trust God had never been really tested.[68]

In a letter penned barely a month before his own death, Lewis revealed his capacity to empathize with another person who had lost a loved one. Professor Thomas Van Osdall wrote to Lewis about the tragic loss of his teenage son, his only child, in a car accident. Lewis replied,

> Thank you for your letter. You tell a most moving story. I too have lost what I most loved. Indeed unless we die young ourselves, we mostly do. We must die before them or see them die before us. And when we wish—and how agonizingly we do o how perpetually!—it is entirely for ourselves for our sakes not theirs.[69]

Lewis had just previously written to Van Osdall about his own serious physical decline: "Since I wrote to you my life has undergone a great change. I nearly died in July and I have now resigned all my appointments and live on one floor of this house as an invalid."[70] Nevertheless, upon learning of Van Osdall's tragic loss, Lewis found the strength to engage in pastoral care guided by his more mature Christian understanding.

In sharing with us how he worked through the grieving process to a stronger faith, Lewis offers an invaluable piece of pastoral theology. He helps us realize

that the sufferer's experience of grief does not change the evidential situation with respect to God's existence or goodness, which is questioned in the rational problem. He also awakens us to the fact that we do no service to those who suffer to offer rational explanations in the midst of their suffering, when their pressing need is to have emotional and practical support. Even Jesus struggled with feelings of abandonment and confusion, as indicated by his cry of dereliction on the cross: "Why hast Thou forsaken me?" Such seems to be every person's cry when overwhelming pain and loss make God seem distant. Yet the better part of wisdom is to allow persons who are suffering pain or loss to process their feelings and to regain their emotional balance. Wisdom also counsels, on the rational side of the process, to allow a perfectly good God to bring some good out of any unfortunate event or tragedy—to reframe and redeem it in this life and strengthen hope in the next.

9

Science, Scientism, and Evolution

Although Lewis was a scholar in medieval literature and lover of the humanities, he wrote a surprising amount of material on science and its relation to both Christian faith and general culture. He did not address any scientific findings in empirical detail but rather demonstrated remarkably good insights about the legitimate nature of science and critiqued distortions of science that serve a secular philosophical vision. He understood that the challenges to religion generated by science readily move the discussion to the level of worldview engagement and particularly involve the clash between Christian theism and all forms of naturalism. To borrow words from historian of science Richard Olsen, Lewis steered a middle course between "science defied" and "science deified."[1]

Does Science Discredit Religion?

As a child Lewis was disappointed with God for failing to answer his prayers to heal his dying mother, and as a teenager he moved further away from God under the tutelage of William T. Kirkpatrick, who was a staunch rationalist and atheist.[2] As Lewis's intellectual life developed, he gave voice to atheism, exclaiming to a religious friend, "You can't start with God. *I don't accept God.*"[3] David C. Downing explains that the young Lewis included science in his atheistic outlook:

> [Lewis's] adolescent atheism was further reinforced by his reading of the natural and social sciences. From the former he gained a sense that life on earth was just a random occurrence in a vast, empty universe, that all of human history is no more than a teardrop on the vast ocean of eternity. From the latter he concluded that all the world's religions, including Christianity, could be best explained not as claims to truth, but as expressions of psychological needs and cultural values.[4]

With atheism and science as pillars of his worldview, Lewis believed that all religions are mythologies that have "absolutely no proof."[5]

As we know, when Lewis entered Oxford in 1919, he adopted his "New Look"—a doctrinaire combination of atheism, materialism, and science drawn from the writings of Lucretius, James Frazer, David Hume, Bertrand Russell,

C. S. Lewis and the Christian Worldview. Michael L. Peterson, Oxford University Press (2020). © Oxford University Press.
DOI: 10.1093/oso/9780190201111.001.0001

H. G. Wells, and others.[6] He thought meaning in religion was generated by primitive human drives, and he nihilistically accepted the Russellian universe as "a meaningless dance of atoms."[7] By 1920, however, Lewis was moving away from materialism toward idealism and allowing that religion has some contact with the divine. Later, as a Christian, Lewis stated that religious myth is an authentic but "unfocused gleam of divine truth falling on human imagination" and that in Christianity "Myth had become Fact" in the Incarnation.[8] Thus, science and the world of facts could not exclude religion.

In representing Christianity intellectually, Lewis realized that "we have to answer the current scientific attitude towards Christianity"—not because he viewed the human enterprise of science as a problem but because a fashionable cultural opinion held that science creates insurmountable obstacles to Christian faith, foreshadowing similar arguments today. Such scientific arguments against religion, which Lewis once accepted and later rebutted, are of two broad types: direct and indirect.

Direct arguments hold that the scientific facts rebut and replace the claims of religion, as truth replaces falsity. Lewis recalled that early readings of science "had lodged very firmly in [his] imagination the vastness and cold of space, the littleness of man," making it perfectly understandable that he "should feel the universe to be a menacing and unfriendly place."[9] He embraced the familiar secularist fallacy employed since the Copernican revolution in astronomy: the logical non sequitur of inferring from the earth's physically small size and remote position that we humans are of little worth. Physics researcher Francisco Diego is one of many contemporary thinkers who commit this reductionistic fallacy: "We are not so special because our own bodies, our own chemistry, our blood, our bones, our skin, are made of hydrogen, nitrogen, oxygen, sodium, and so forth."[10]

In *The Discarded Image: An Introduction to Medieval and Renaissance Literature*, Lewis exposed the roots of the fallacy, correcting the stereotype that the rise of science in modernity refuted the Christian understanding of the world and humanity. It is commonly thought that the medieval world picture—or "medieval synthesis"—was superseded by the rise of science. However, Lewis shows that the "medieval synthesis" was a systematization of theology, science, and history into a total view of reality; he went on to explain that it served as a backdrop, a cultural narrative, that did not claim literal accuracy but projected the meaning and value of life in a divinely created cosmos.

"Every model," wrote Lewis, "is a construct of answered questions" which were largely about the nature of the divine and the status of humanity.[11] There was "no direct conflict between religion and science" like that which arose in modernity because the questions were different. Even Ptolemy acknowledged that "the earth has no appreciable size."[12] And Chalcidius knew the exact order of the planets was open to dispute. Medieval thinkers also believed that humans

were akin to animals, affirming our composite status as rational soul and animal body.

The Medieval Model lost ground to the Modern Model, as Lewis explained, not because of an onslaught of new facts, but because the questions changed. As modernity became more interested in "how" than "why," Lewis contended, a more economical Model emerged that embraced the new science as a better conceptual tool for studying the detailed workings of empirical reality:

> People usually think the problem is how to reconcile what we now know about the size of the universe with our traditional ideas of religion. That turns out not to be the problem at all. The real problem is this. The enormous size of the universe and the insignificance of the earth were known for centuries, and no one ever dreamed that they had any bearing on the religious question. Then, less than a hundred years ago, they are suddenly trotted out as an argument against Christianity.[13]

Clearly, he argued, "we can no longer dismiss the change of Models as a simple progress from error to truth."[14] The Modern Model, then, is not based on science per se but on a secular *interpretation* of science which is hostile to the theological truths of the old Model. Media and academia have created what Lewis called "a popular scientism," which is "a caricature of the true sciences" that rejects religion and exaggerates the role and reach of science.[15] What Lewis has offered here is a case study of how direct arguments rely on a philosophical construal of science, not science itself, in seeking to rebut religion in general and Christianity in particular.

Indirect arguments seek not to rebut or replace religious claims with scientific knowledge but rather to characterize religion as a natural phenomenon completely explicable by science and thereby undercut its capacity for truth. As part of his "New Look," Lewis deployed ideas from both the social and natural sciences in his rejection of religion. From the social sciences, he adopted Sigmund Freud's psychoanalytical theory of religion as an illusion motivated by hidden inner impulses, such as wish fulfillment.[16] Interestingly, John of Puritania in *Pilgrim's Regress* is sentenced to prison by the Spirit of the Age, where young Mr. Enlightenment, named Sigismund, professes that all arguments are actually projections of subliminal desires. But John is rescued by Lady Reason, who refutes this attempt to debunk reason:

> "You must ask them whether any reasoning is valid or not. If they say no, then their own doctrines, being reached by reasoning, fall to the ground. If they say yes, then they will have to examine your arguments and refute them on their

merits: for if some reasoning is valid, for all they know, your bit of reasoning may be one of the valid bits."[17]

Subjecting the psychoanalytic criticism to its own critique exposes the general mistake of indirect arguments that want to exempt themselves from their own analysis and accents the need to engage religion, and particularly Christianity, on intellectual terms.

During the period of his New Look, Lewis also accepted an indirect argument against religion made from the natural sciences—the evolutionary explanation that religion is shaped purely by adaptive forces:

> Primitive man found himself surrounded by all sorts of terrible things he didn't understand—thunder, pestilence, snakes etc: what more natural than to suppose that these were animated by evil spirits trying to torture him. These he kept off by cringing to them, singing songs and making sacrifices etc. Gradually from being mere nature-spirits these supposed beings were elevated into more elaborate ideas, such as the old gods: and when man became more refined he pretended that these spirits were good as well as powerful.[18]

The explanation that religion originated in primitive, superstitious human instincts supposedly supports the conclusion that religion is not about anything transcendent.

Philosopher Daniel Dennett, one of the famous "New Atheists," offers precisely this kind of explanation, arguing that evolutionary biology and cultural anthropology reveal that religion is purely a natural phenomenon. According to Dennett, humans share with all animals a vital defense mechanism—"the intentional stance"—which is the tendency to attribute mental content like thoughts and motivations to moving bodies. Successful animals employed this mechanism to survive dangerous predators, but it sometimes generated "false positives"—as when a dog thinks a falling tree branch is the action of an agent of some sort. Likewise, early humans were sometimes frightened and puzzled by their environment—lightning and thunder, the change of seasons, and so forth—but mistakenly attributed agency to such phenomena. According to Dennett, these "false alarms generated by our overactive disposition to look for agents wherever the action is are the irritants around which the pearls of religion grow."[19] From the simple supposition that nymphs and spirits exist to beliefs about the more complex deities of organized religions, supernatural ideas that met deep psychological and physical needs prospered over time. When it is understood, so the argument goes, that religious beliefs are purely the remains of humanity's evolutionary past, there will be no need to take them seriously as truth claims.

In his Christian writings, Lewis does not avoid evolutionary themes in describing the history of religion. For example, *Mere Christianity* and *The Problem of Pain* indicate that early humans had a sense of the numinous, developed conscience, and eventually connected them to a divine moral goodness. But Lewis also explains that the fact that religion went through natural developmental stages does not imply that it is not about truth. It is very Lewisian to argue that, if humans are biological and cultural beings, then we would expect biology, cultural anthropology, and other relevant disciplines to provide insights into religion and into other important human activities as well. In the last analysis, Lewis the Christian thinker consistently pointed out that neither direct nor indirect pseudo-scientific arguments were effective against a theistic and Christian worldview.

Science and Human Knowledge

In analyzing the relationship between science and religion, one key is to understand correctly the activity of science. Lewis tried to describe the essence of scientific practice—or, "mere science," pure and unadulterated by philosophical bias:

> Science works by experiments. It watches how things behave. Every scientific statement in the long run, however complicated it looks, really means something like, "I pointed the telescope to such and such a part of the sky at 2:20 am on January 15th and saw so-and-so."[20]

Although the business of science is much more complicated than simply gathering and reporting data, we may sympathetically interpret Lewis to be indicating that science is both a method of seeking knowledge about empirical reality and an accumulated body of such knowledge. In his own way, Lewis tried to locate science on the larger intellectual landscape as a discipline that seeks natural explanations for natural phenomena, a description which today is labeled *methodological naturalism*.

Each intellectual discipline has its distinctive subject matter and method— and, for science, the subject matter is the natural world and the methods are geared for empirical investigation, which entails that science cannot inquire into ultimates or what is beyond nature. Hence, science cannot discredit religion because methodological naturalism is completely neutral on ultimate questions pertaining to whether God exists or life has meaning. For this reason, science, as Lewis pointed out, is "neither an enemy nor a friend" to religion.[21]

Addressing ultimate questions is the province of metaphysics and theology, which employ their own methods to inquire into a very different subject matter

and thus occupy different areas on the intellectual map. In a sense, science answers "how" questions about natural phenomena, whereas metaphysics and theology answer "why" questions regarding the ultimate origin and meaning of everything, questions that science, Lewis argues, could never answer:

> But why anything comes to be there at all, and whether there is anything behind the things science observes—something of a different kind—this is not a scientific question. If there is "Something Behind," then either it will have to remain altogether unknown to men or else make itself known in some different way. The statement that there is any such thing, and the statement that there is no such thing, are neither of them statements that science can make. And real scientists do not usually make them. It is usually the journalists and popular novelists who have picked up a few odds and ends of half-baked science from textbooks who go in for them. After all, it really is a matter of common sense. Supposing science ever became complete so that it knew every single thing in the whole universe. Is it not plain that the questions, "Why is there a universe?" "Why does it go on as it does?" "Has it any meaning?" would remain just as they were?[22]

While science continues to offer important information in answer to factual questions about the physical world, it cannot address questions about God or ultimate meaning. Indeed, at the metaphysical and theological level, the Christian worldview explains God and meaning, and thus explains the very existence of the physical world and the human rational capacities that make science possible.

Where the Conflict Really Lies

In showing that there is no inherent conflict between science and theology, Lewis helped clarify the deep, irreconcilable conflict that does involve science and theology—the *worldview conflict* between naturalism and theism. Philosophical naturalism, which implies atheism, seeks to co-opt science to claim that all forms of religion are false. Science is elevated as the paragon of knowledge, which rules out metaphysical and theological knowledge. Astronomer Owen Gingerich says that this is not science but "scientism"—a "dogmatic philosophy that can develop from [scientific observation], saying that since this is the only way we can find out about nature, that is all there is."[23] Lewis did some of his best work exposing the fatal flaws of "scientism," which he linked directly to atheistic naturalism as a philosophical precommitment imposed on science rather than a conclusion generated by science. Clearly, the sciences in modernity eventually replaced theological (or purposive) explanations of physical phenomena with mechanical explanations developed by methodological naturalism. The motions of the planets, for example,

were no longer ascribed to supernatural beings but to Newtonian physical forces. Mechanical explanations have been key to much of the success of science, but they have also been improperly enlisted in the service of "scientism" to reduce or deny all phenomena that are not subject to mechanical explanation.

Well into the nineteenth century, organic complexity was the one remaining natural phenomenon that was still scientifically explained in terms of design and purposes. When Darwin published his evolutionary theory, premised on natural selection, a mechanical, nonpurposive explanation of the physical world became available. For evolutionary science, organic complexity is simply the result of a de facto process whereby the members of a species that survive due to slightly greater fitness relative to a certain environment reproduce at a differentially higher rate. But biologist Richard Dawkins, along with all the New Atheists, sees Darwinian natural selection as completing the scientific picture of the world with which naturalism combines. In *The Blind Watchmaker*, Dawkins writes, "[A]lthough atheism might have been logically tenable before Darwin, Darwin made it possible to be an intellectually fulfilled atheist."[24] In other words, atheistic naturalism has always assumed in principle that no divine being guides nature and that mechanistic explanation could explain everything, and now it finally has a detailed mechanistic explanation of biological organization without reference to purpose or design.

Once the alleged science-religion conflict is seen as a conflict between naturalism and theism, then all of Lewis's arguments against naturalism recur. For instance, the argument from reason could be recast in the following way:

> If the solar system was brought about by an accidental collision, then the appearance of organic life on this planet was also an accident, and the whole evolution of Man was an accident too. If so, then all our present thoughts are mere accidents—the accidental by-product of the movement of atoms. And this holds for the thoughts of the materialists and astronomers as well as for anyone else's. But if *their* thoughts—i.e. of materialism and astronomy—are merely accidental by-products, why should we believe them to be true?[25]

Unless reason is valid, there can be no real science and certainly no metaphysical inflations of science by naturalists that can be rationally believed.

The conflict between worldviews comes to a head in regard to science because science, which requires rational thinking, makes better sense on theism than on naturalism. Putting the comparison probabilistically, where S is science, T is theism, and N is naturalism,

$$P(S/T) > P(S/N).$$

Evolution and Evolutionism

Evolutionary science—just like science in general—can be elevated to the status of worldview. Much of Lewis's devastating critique of scientism applied to evolutionism as well, and Lewis added several specific criticisms of evolutionism. Just as Lewis was careful to distinguish between science and the philosophical interpretation of science within a naturalist framework, so he was also careful to distinguish evolution from evolution interpreted by naturalism.

In Darwin's day, Herbert Spencer elevated evolution to the status of a principle that guided cosmic and human history, asserting that "this law of organic progress is the law of all progress" driving everything toward improvement, including organic life, society, government, literature, and art.[26] "Social Darwinism," as it was called, reflected the great secular optimism of the day about the inevitable progress of the human species but also inspired the pernicious doctrine of a "superior race," which justified the Nazi eugenics project and other evils. Darwin always distanced himself from Spencer's work as nonscientific.[27] Lewis similarly reacted against Spencer in his critiques of the "Great Myth of Evolutionism" or "Developmentalism," as he called it.[28]

In the twentieth century, the developmental scenario for humanity was pictured as a brief interlude within the larger sweep of a meaningless universe. The popular writer H. G. Wells articulated a nihilistic evolutionary narrative: an accidental universe gives rise, by pure chance, to life on a small planet, and life struggles mightily through long ages to improve its position, up from the intertidal slime, toward "freedom, power, and consciousness."[29] Yet, as life becomes Man, at the threshold of triumph, tragedy strikes as inevitable physical forces destroy the universe. Calling this thinking "Wellsianity," Lewis sarcastically describes the nihilistic last act of the cosmic drama: "The sun will cool—all suns cool—the whole universe will run down.... All ends in nothingness."[30]

Of course, quasi-religious versions of the Great Myth of Evolutionism also became targets for Lewis. Henri Bergson, the French naturalist who discovered quantum mechanics, rejected natural selection and posited the *élan vital* ("life force") as the innate purposive tendency driving adaptive change. Lewis derided Bergson's "creative evolution" as presenting "a tame God" who offers "all the thrills of religion and none of the cost."[31] Although Bergson's philosophy is sometimes mistakenly termed "theistic evolution," it does not affirm the theistic God but instead holds that humans project an idea of god for meditation. Lewis himself embraced a more standard form of theistic evolution, or we might say, Christian theistic evolution. Today, Francis Collins, former director of the Human Genome Project and current director of the NIH (National Institutes of Health), is perhaps the best known representative of this general view.[32]

The fundamental issue is the *philosophical interpretation* of evolutionary science and what it reveals about the development of organic life. Lewis accepted evolution as a "genuine scientific hypothesis" or "purely biological theorem" that "makes no cosmic statements, no metaphysical statements, no eschatological statements."[33] He indicated that he could not help thinking that there was good factual evidence for evolution as science, but he pointed out that "universal evolutionism" is actually a philosophical position that is imposed on the facts, not inferred from them.[34] Nevertheless, as Lewis acknowledged, evolutionism or developmentalism as a secular alternative to theism strongly appeals to some scientists and to the popular imagination of society.

Lewis appreciated the integrity of all disciplines, including the mainstream sciences, although he sometimes had questions about new discoveries. In his published works, he even used evolution for illustrative purposes, as he did at the end of *Mere Christianity*. His pertinent writings carefully distinguish between *evolution* and *evolutionism*, and thus avoid creating confusion in readers' minds about the focus of his criticisms—something that both opponents and advocates of Christianity often fail to do. When his friend Captain Bernard Acworth invited him to join his crusade against evolution by writing a preface to Acworth's little book "The Lie of Evolution," Lewis politely declined, explaining that biological evolution as a factual claim does not contradict "the Creed."[35]

Acworth persisted, but Lewis continued to demur, mentioning that a few points in "The Lie of Evolution" were interesting to him—such as the apparent need for the simultaneous existence of a great many species. However, Lewis humbly stressed that "neither" of them knew enough science to sort through the relevant issues. He also agreed with Acworth that the exposure of Piltdown Man—presented as the "missing link" between ape and man by amateur archaeologist Charles Dawson in 1912—as a hoax was a good thing, not because it particularly damaged evolutionary claims but because exposing any fraud whatsoever is always a good thing. He even reminded Acworth that many more Christian miracle hoaxes have been exposed by scientists but that Christianity is not thereby refuted. It is important to note that just months before Lewis died, he wrote to scientist Thomas Van Osdall, who had read many of Lewis's books and wanted to solicit Lewis's advice on his own book project treating the influence of science on culture, a topic that would clearly involve evolutionary science. However, while Lewis discussed in his reply various aspects of science in culture, he never mentioned evolution to Van Osdall or warned him that evolutionary science should be rejected.[36]

Without quarreling with evolutionary science, Lewis maintained his general theological commitment that God created the physical world and willed that special creatures that bear his image eventually come forth:

[T]hat man is physically descended from animals, I have no objection. . . . For long centuries God perfected the animal form which was to become the vehicle of humanity and the image of Himself. . . . The creature may have existed for ages in this state before it became man [I]n the fullness of time, God caused to descend upon this organism . . . a new kind of consciousness which could say "I" and "me," . . . which knew God . . . [and] could make judgments of truth, beauty, and goodness.[37]

While the term "long centuries" naively understates the facts, and the idea of "perfecting" the animal form is unwittingly misleading, Lewis was trying to say that it was a long process for God to guide the primate form to a sufficient degree of complexity, particularly in the brain and nervous system, so that it could support higher intellectual and emotional processes.[38] Lewis once said that this evolutionary life in which we participate has been "dropped" here by "the real Originator of the natural order."[39] Interpreted theologically, evolutionary processes *mediate* but do not *create* rationality, morality, and higher aspects of our personhood.

Since Lewis accepted the creation account in Genesis as myth in the highest sense, conveying lofty truths via rich symbolic images, he felt no compulsion to defend it as literal. In *Pain*, he articulated the theological truths embedded in the creation story—that God willed everything into existence, including humanity, and that the essence of the human fall is the rational creature's disobedience of living for itself rather than for God, not the eating of forbidden fruit. Of course, genuine science, Lewis observed, "has nothing to say for or against the doctrine of the fall" because science does not deal with the theological or metaphysical.[40]

Despite his acceptance of evolutionary biology as mainline science, Lewis despised evolutionism, with its empty promise of continuous improvement, as a kind of secular creed or religion substitute. In a letter to Dorothy Sayers on March 4, 1954, he penned a satirical poem entitled "Evolutionary Hymn."[41] The opening stanza is particularly biting:

> Lead us, Evolution, lead us
> Up the future's endless stair:
> Chop us, change us, prod us, weed us
> For stagnation is despair:
> Groping, guessing, yet progressing,
> Lead us nobody knows where.

Lewis was a persistent critic of the idea that a mindless, subpersonal force driving all existence toward an unknown future could explain the personal dignity and meaning of humanity.

The Future of Humanity

The glory and dignity of humanity is a pervasive theme in Lewis, supported both by his classical background, which affirmed the uniqueness of the rational animal, and his Christian background, which affirmed the value of humanity created in God's image. Nowhere is Lewis more protective of the dignity of human nature than in defending it against the overblown use of science. Scientism—that is, science allied with philosophical naturalism and extreme empiricism—always tends toward the metaphysical and epistemological reduction of important aspects of our humanity.

Chad Walsh recalls that Lewis once commented that the more closely a science approaches human affairs, the more dehumanizing it is—meaning that, wrongly interpreted, the social sciences have greater dehumanizing potential than the natural sciences have.[42] Hingest, the curmudgeon chemist in *That Hideous Strength*, undoubtedly speaks for Lewis when he states, "There are no sciences like sociology. . . . I happen to believe that you can't study men, you can only get to know them, which is quite a different thing."[43] But the natural sciences are also used in a dehumanizing way when they reductionistically take human persons to be "nothing but" the assemblage of their physical parts. Lewis's rich classical and Christian metaphysics would affirm that even nonhuman objects cannot be totally reduced to collections of their parts. When, in *Voyage of the Dawn Treader*, Eustace says that "in our world, a star is a huge ball of flaming gas," Ramandu, a retired star, identifies the mistake: "Even in your world, my son, that is not what a star is but only what it is made of."[44] Here we see Lewis's Romanticism serving as an ally in defense of the full nature of reality which can be accessed at various levels, the imaginative as well as the empirical.

Scientific reductionism rests on the false dichotomies which emerged in modernity—objective/subjective, fact/value, quantity/quality, body/mind, material/spiritual—and which favor the empirical and dismiss or distort the nonempirical. In "The Empty Universe," Lewis addresses the cultural shift from the medieval world picture to the modern world picture that was so dangerous to our humanity:

> At the outset the universe appears packed with will, intelligence, life, and positive qualities; every tree is a nymph and every planet a god. Man himself is akin to the gods. The advance gradually empties this rich and genial universe, first of its gods, then of its colors, smells, sounds and tastes, finally of solidity itself as solidity was originally imagined. As these items are taken from the world, they are transferred to the subjective side of the account: classified as our sensations, thoughts, images or emotions. The Subject becomes gorged, inflated, at the expense of the Object. But the matter does not rest there. The same method

which has emptied the world now proceeds to empty ourselves. The masters of the method soon announce that we were just mistaken (and mistaken in much the same way) when we attributed "souls" or "selves" or "minds" to human organisms, as when we attributed Dryads to the trees.[45]

Objective values were reduced to the subjective, all qualities reduced to the quantitative, in preparation for the final devastation: "We, who have personified all other things, turn out to be ourselves mere personifications."[46]

In *The Discarded Image*, Lewis ponders the future of a humanity stripped of special dignity and transcendence: "Having eaten up everything else, he eats himself up too. And where we 'go from that' is a dark question."[47] This "dark question" is addressed at length in *The Abolition of Man*, first given as the Riddell Memorial Lectures in 1943, which envisions a dystopian society shaped by the rejection of objective value, the *Tao*, the structure of reality that makes some things really right and some things really wrong. In Chapter 5, we discussed Lewis's philosophical critique of the denial of objective value, but here we consider his ominous forecast of disastrous practical consequences for human existence apart from the *Tao*.

As Lewis argued, a society with no objective moral guidance will be run by "conditioners" or "planners" that represent the alliance of scientific technology and political power. Since the planners have stepped outside the framework of objective value, they may act for ostensibly noble ends but without moral limitations on the means. Without the moral law orchestrating their choices, practices such as eugenics, prenatal conditioning, and other technologies have no controls.

The technological reshaping of humanity in service of the totalitarian state was all too real in Lewis's day. Huxley's *Brave New World* and Orwell's *1984* projected an amoral society that "conditioned" and "controlled" humans through surveillance, propaganda, and selective breeding. "Subhumanity," as Lewis called it, was "imagined by Mr. Aldous Huxley and George Orwell and partially realized in Hitler's Germany."[48] He further warns, "It is in Man's power to treat himself as a mere 'natural object' and his own judgments of value as raw material for scientific manipulation to alter at will."[49] Ironically, outside the *Tao*, which adjudicates among our impulses and drives, humanity's "conquest of nature" turns out to be, in the end, nature's conquest over humanity itself.[50]

In 1971, Harvard behaviorist psychologist B. F. Skinner directly attacked Lewis's position in *Beyond Freedom and Dignity*:

C. S. Lewis put it quite bluntly: Man is being abolished. . . . [W]hat is being threatened is "man *qua* man," or "man in his humanity," or "man as Thou not It," or "man as a person not a thing." . . . What is being abolished is autonomous

man—the inner man, the homunculus . . . the man defended by the literatures of freedom and dignity.

His abolition has long been overdue. . . . Science does not dehumanize man, it de-homunculizes him . . . to prevent the abolition of the human species. To man *qua* man we readily say good riddance. Only by dispossessing him can we turn to the real causes of human behavior. Only then can we turn from the inferred to the observed, from the miraculous to the natural, from the inaccessible to the manipulable.[51]

Regrettably, Skinner simply ignored rather than refuted Lewis's argument that the human being, sharing physical and animal commonalities with the rest of nature, also transcends nature with its rational and moral capacities.

Technology, which can do much good under moral guidance, can also threaten to destroy our humanity when pursued without reference to moral law. The 1997 film *Gattica* portrays a futuristic society in which children are technologically conceived through genetic manipulation. The 2003 successful completion of the Human Genome Project made such a biotechnological nightmare all the more possible. According to futurist Ray Kurzweil, Google's director of engineering, "transhumanism" is a realistic goal—that is, the enhancement of human intellectual and physical capacities with "artificial intelligence," which includes uploading our entire minds to computers by 2045.[52] As Lewis argued, the only protection against the abolition of humanity by the technological totalitarian state is the recognition of universal moral values:

Either we are rational spirit obliged for ever to obey the absolute values of the *Tao*, or else we are mere nature to be kneaded and cut into new shapes for the pleasures of masters who must, by hypothesis, have no motive but their own "natural" impulses. Only the *Tao* provides a common human law of action which can over-arch rulers and ruled alike. A dogmatic belief in objective value is necessary to the very idea of a rule which is not tyranny or an obedience which is not slavery.[53]

Since the universal moral law applies to universal human nature, nothing less than human nature itself is at stake if the moral law is rejected.

As Lewis saw Western culture increasingly coming under the spell of scientism, he took his mission to be the articulation of a profound concept of human dignity that is entailed by the principles and values of the moral law. Science appropriately studies various aspects of our total humanity, but scientism reduces humanity merely to the categories of science—to "nothing but" atoms, neuroses, or social roles. Evolutionary biology in our day has particularly been co-opted in

service of a naturalist worldview, becoming one more form of the evolutionary reductionism that Lewis addressed in many venues.

In fact, in *The Descent of Man*, Darwin suggested that biology as a science recognizes "no fundamental difference between humans and the higher mammals in their mental facilities."[54] He also opposed ranking species in the chain of development, once commenting, "Never use the word higher & lower—use more complicated."[55] For Darwin, as for any scientist operating legitimately by methodological naturalism, *quantitative* judgments about differences between humanity and the rest of nature are the rule, but the value judgment that humanity is *qualitatively* distinct from all other animals is not available. The philosophical error lies in interpreting the scientific observation that human beings can only be measured as differing in degree from other animals to support the metaphysical naturalist's claim that the only difference between them is one of degree.

Since Lewis particularly identified human specialness with our rational and moral capacities, he took exception with Darwinism when understood as a form of naturalist philosophy. Although Lewis noted that some religious advocates invoked special creation to defend human exceptionalism, he indicated that he had no fundamental problem with the evolutionary history of humanity as revealed by science. In terms of our animality, he admitted that humans differ in *degree* from other animals, but in terms of our rational and moral capacities, he maintained that we differ radically in *kind* because in us a transcendent element is united to animality. The fact that human rational and moral functions have precursor structures and behaviors in the higher primates simply accents the dual aspects of our humanity: rational-moral-soulish life is dependent upon, but not reducible to, an animal organism. As a Christian thinker, Lewis consistently rejected scientism, including evolutionism, on the grounds that it distorts science to support a naturalistic worldview and argued that real science is harmonious with a Christian worldview.

10

Salvation and Persons Outside the Faith

Religious diversity poses an important challenge to the idea that there is one true religion that teaches the definitive understanding of human destiny and way of salvation. Many great religions have many devout followers who live decent and even exemplary lives, and a number of these religions insist that they are the only way to salvation, liberation, or enlightenment. For Lewis, the basic problem concerns how "mere Christianity," or orthodoxy, makes sense of the perplexing facts of religious diversity. The problem for Christianity involves not simply accounting for the historical development of religions in God's creation but reconciling the dual claims that God desires to save all persons and that God sent his Son into the world as the only savior.[1]

Problems of Truth and Knowledge in Religion

Two interrelated issues pertain to the problem of Christian salvation and the world religions. The first is an ontological problem that arises because of the vastly different truth claims across the world's religions about the nature of the divine. In classical realist terms, a proposition is true if, and only if, it corresponds to the facts, to the way things are. According to scientific realism, physical reality is a unified, knowable whole; our claims about it can be more or less accurate; incompatible claims about it cannot all be true. Big bang theory, for example, was eventually accepted over steady-state theory as a more accurate description of reality. Physical reality itself makes a scientific claim true or false; even though we may not always have the tools to accurately assess physical reality, that reality exists as a hypothetically knowable fact. But what is it for a religious claim or doctrine to *be* true? Is there a determinate religious reality about which religious claims can be more or less accurate? Because our tools for assessing religious reality are so limited, ontological anti-realism about religion is quite common and simply denies that there is any ultimate religious reality that would make its claims objectively true independent of religious narratives, cultural constructs, or doctrines.

In this vein, religion scholar Joseph Campbell solved the "incompatibility problem" of divergent religious claims by asserting that religions are mistaken when they embrace "the interpretation of mythic metaphors as references to

C. S. Lewis and the Christian Worldview. Michael L. Peterson, Oxford University Press (2020).
© Oxford University Press.
DOI: 10.1093/oso/9780190201111.001.0001

hard fact."[2] Contemporary sociological and anthropological approaches to religion also deny that there are religious facts. Postmodernism in our day takes a similarly relativistic line—insisting that each cultural group has its own "truth" emerging out if its own narrative, but that no group may treat its outlook as a Grand Narrative or "final truth" about reality that can judge other narratives as less true.

As an atheist, Lewis was anti-realist about religion, writing to Greeves in 1916 that religions are "mythologies" with "no proof" bolstered by intellectual arrogance: "In every age the educated and thinking [people] have stood outside [religion]."[3] As Lewis's thinking shifted toward idealism, he wrote to Greeves that he did not believe in a God but did believe in a "universal spirit."[4] When he was on the verge of embracing theism, he wrote to Greeves in 1929 that he thought there was a real Being to whom we must respond: "I . . . am still finding more and more the element of truth in the old beliefs [that] I feel I cannot dismiss. . . . There must be something in it: only what?"[5] About his conversion to theism later in 1930, he wrote, "I gave in, and admitted that God was God."[6] In coming to theism, Lewis made an essentially realist move—admitting that the ultimate religious reality exists independently of human thought and that our task is to align our thoughts and our lives with it. Although he knew nothing at this time about the Incarnation, he had come to believe that religious claims and doctrines are about an objective religious reality and can be more or less accurate to that reality—and thus rejected "the nonsensical idea that mutually exclusive propositions about God can both be true."[7]

After he became a Christian, his religious realism was reflected in his emphasis on believing in Christianity because it is true:

> One of the great difficulties is to keep before the audience's mind the question of Truth. They always think you are recommending Christianity not because it is *true* but because it is *good*. . . . You have to keep forcing them back, and again back, to the real point.[8]

Persons considering Christianity sometimes react against the Crusades or hypocritical believers and forget that the question of truth is paramount, even if there are cases where Christians did not live up to their own teachings about the truth. If Christianity is in fact true, then it gives us amazing information about the nature of God and invites all persons to turn to God, in whom they will find their ultimate fulfillment.

The second problem generated by religious diversity is epistemological: how can one rationally believe the claims of any particular religion in light of the differing claims among religions? If one is aware of religious disagreement, under what conditions would she be rational or within her epistemic rights in

affirming one of the mutually exclusive doctrinal systems? Even if ontological religious realism is the case and there is a determinate divine reality, in light of differing religious claims, how is a person epistemically warranted in embracing her own religious position as true? Might the proper intellectual posture in the face of religious diversity be agnosticism or skepticism? Because of these kinds of questions about the diversity of religious truth claims, many cite the epistemological problem—or what Lewis calls the "anthropological argument"—as a reason for not accepting Christianity as true.

However, for Lewis, the epistemic dynamics generated by awareness of disagreement among religious belief systems did not lead to agnosticism or, indeed, present an insurmountable problem:

> To me, who first approached Christianity from a delighted interest in, and reverence for, the best pagan imagination, who loved Balder before Christ and Plato before St. Augustine, the anthropological argument against Christianity has never been formidable.[9]

This is because it is a false dichotomy, he cautioned, to say that Christianity is completely true and other religions are completely in error. "I could not believe Christianity," he wrote, "if I were forced to say that there were a thousand religions in the world of which 999 were pure nonsense and the thousandth (fortunately) true."[10] He meant not that we should see classical orthodoxy as containing some error but that we should recognize that other religions contain some truth.

Furthermore, Lewis conceived a way of construing the relationship of Christianity to the other religions such that it is entirely reasonable to embrace Christianity as true:

> If my religion is erroneous then occurrences of similar motifs in pagan stories are, of course, instances of the same, or a similar error. But if my religion is true, then these stories may well be a *preparatio evangelica*, a divine hinting in poetic and ritual form at the same central truth which was later focused and (so to speak) historicized in the Incarnation.[11]

Glimpses of truth in other religions become clarified, contextualized, and even concretized in Christianity on Lewis's view.

Lewis goes on to explain that his own conversion was not based on rejection of other religions—and particularly not rejection of the great pagan myths he dearly loved—but rather on seeing Christianity as the fulfillment of the deepest longings in other religions: "My conversion, very largely, depended on recognizing Christianity as the completion, the actualization, the entelechy, of something that had never been wholly absent from the mind of man."[12] By

emphasizing their commonalities, Lewis was able to maintain epistemic magnanimity in the face of religious diversity while still claiming the objective, realist truth of Christianity, arguing that "in Christ whatever is true in all religions is consummated and perfected."[13]

Moral and Soteriological Problems

Around the turn of the twentieth century, religion scholar Ernst Troeltsch called for a theology of the history of the world's great religions, pointing out a serious gap in Christian theology.[14] To write a *history* of religions is to produce an account of the development of all of humanity's religious belief systems in their social and cultural contexts, but to offer a *theology* of that history is to grapple with the historical relativism of religious differences in relation to Christian claims to truth. Theologian Wolfhart Pannenberg develops Troeltsch's concern as a moral problem regarding why the Christian God would create a world with an unfolding history resulting in great differences among religions systems regarding salvation or liberation.[15] Clearly, this problem of religious diversity is a subset of the problem of evil: if God is all-powerful, all-knowing, and perfectly good, then why would he allow such confusion among religions and yet require that all persons find the true way?

The problem of religious diversity in regard to salvation particularly strikes against God's goodness. Surely, if God were perfectly good, he would have wanted a history of religion that is fair and equitable to all, not one where religious affiliation is largely a function of birth and culture and in which the true way is difficult to discover. If God is not fair, then he is not just; and if he is not just, then he cannot be perfectly morally good. But if God is not perfectly good, then he is not worthy of worship; and if he is not worthy of worship, then Christianity is false. Lewis gave honest voice to the moral unfairness problem: "Is it not frightfully unfair that this new life should be confined to people who have heard of Christ and been able to believe in Him?"[16]

The moral problem of religious diversity segues into the soteriological problem of religious diversity, which is the difficulty of explaining how God gives equal opportunity to all persons and makes no person's ultimate destiny unfairly hang on circumstances beyond his or her control. Just as Aristotle recognized that contingencies beyond our control play into moral life, philosopher Linda Zagzebski points out that contingencies beyond our control play into religious life as well.[17] "Religious luck" parallels "moral luck" in being rooted in the innumerable circumstances of birth, culture, temperament, and opportunity for each individual to know the way of salvation. Some persons, through no choice or fault of their own, simply have the advantage of favorable circumstances for

learning the way of salvation. A satisfactory answer to this soteriological problem must successfully navigate the moral problem as well—that is, an adequate solution must show how in the matter of human salvation God is not unfair, unjust, or less than perfectly good, and that his loving nature has somehow made salvation available fairly to all.

The typical comparative religions approach takes the issue of God's justice and fairness off the table by dismissing the ontological reality of God as essential to religion and reducing all religions to social constructions. By contrast, some approaches that defend Christianity as the definitive religion hold up God's requirement that all must know Christ as the only measure of God's justice. However, Lewis was a natural law theorist who believed that what is fair, just, and good is objective and universal, independent of the divine will. He further believed that theology must articulate the implications of its essential principles for life's big questions—including the questions surrounding religious diversity—thereby projecting a coherent worldview. Without claiming to have a detailed answer to the question of exactly how God's justice applies to persons outside the gospel due to factors beyond their control, Lewis carefully drew out some general implications of orthodoxy for the combined moral and soteriological problems. Although persons in other religions are in focus here, the same problems occur regarding other persons who cannot properly process the gospel but fall into other problem categories—infants who die young, the mentally challenged, and even Old Testament saints. Whatever broad orthodox Christian principles Lewis applies to the religious diversity case should apply to the other cases as well.

Models of Salvation

Four major Christian accounts of salvation for persons in other religions have been advanced to address the soteriological problem related to the unevangelized. These different accounts or "models" involve distinctive interpretations of religious truth as well as divine justice and love. In order to locate Lewis accurately in this important discussion, we must first define and discuss the four models.

Universalism is the well-known view that all persons will find salvation or liberation, regardless of their religious affiliation or beliefs. Various religious organizations and traditions are inherently universalist, such as the Unitarian Universalist Church and neo-Vedantic Hinduism. Distinctively *Christian* universalism is the view that all persons will ultimately be restored to a right relationship with the Christian God through the work of Christ. Often postulated to avoid difficult problems with the concept of eternal hell, this view holds that all

persons, regardless of their circumstances, character, and deeds, will be saved, which implies that even the nonreligious and the tyrants will be saved.[18]

Pluralism, which is often conflated with universalism, is the doctrine that salvation may be found in any of the world's religions. Many forms of pluralism generally follow philosopher John Hick in affirming ontologically the existence of some ultimate religious Reality but recognizing that all religions are equally valid ways for connecting with it. Since historical religions provide different cultural categories for persons to think about the Ultimate, pluralism asserts that epistemological matters of truth and knowledge cannot be necessary for salvation or liberation. As Hick argues, salvation in a given religion is found by participating in its ways of effecting "the transformation of human existence from self-centeredness to Reality-centeredness."[19]

Exclusivism is the position that there is only one objectively true religion through which salvation must be found and that other religions are false or mostly false. Exclusivists reject universalism and pluralism because they minimize objective truth in religion and ignore the salvific requirements of the one true religion. Although there are forms of exclusivism in other religions, Christian exclusivism insists that salvation can be found only through conscious, voluntary acceptance of Christ as defined by correct doctrines. Acceptance of Christ must occur in earthly life and possibly be accompanied by membership in a specific Christian denomination, an emphasis often cited to motivate missionary and evangelistic efforts.[20]

Inclusivism, which is often considered a middle way between pluralism and exclusivism, holds that one religion contains the most complete set of truths about divine reality but also affirms that many persons in other religions are sincerely seeking the divine reality. Christian inclusivists agree with exclusivists that salvation is only through Christ but disagree that this salvation can be confined to correctness of belief or overt affiliation with Christianity, and they agree with pluralists that sincere persons in other religions, who perhaps have never heard Christian teachings, are nevertheless encountering religious reality at some level and that this Reality is the Christian God. Christian inclusivism does not claim that other religions have salvific power, even though other religions can be credited, in varying degrees, with containing fragments of truth, recommending moral living, and helping the individual self to become more open to the transcendent. However, if sincere seekers in these other religions receive salvation, it is because Christ's Atonement is applied to them.

For the Christian inclusivist, while Christianity contains accurate knowledge of salvation, people are not denied salvation if they lack this knowledge but are living up to the best they know. The Catholic theologian Karl Rahner, who was so influential at Vatican II, calls such persons "anonymous Christians":

The "anonymous Christian" in our sense of the term is the pagan after the beginning of the Christian mission, who lives in the state of Christ's grace through faith, hope, and love, yet who has no explicit knowledge of the fact that his life is orientated in grace-given salvation to Jesus Christ.[21]

Although the notion of "anonymous Christians" is controversial, it reflects, on the one hand, a deep appreciation for the classical orthodox Christian concept of universal prevenient grace, which is the grace that seeks to draw all people to God, and, on the other hand, a Christian theological solution to the problem of salvation in light of religious diversity.

Reflection on these four models of salvation enables us to distinguish accurately among positions that are often conflated with one another. For example, the term "universalism"—the position that all persons will find salvation or liberation—has been used to denote pluralism and inclusivism, but we now see that these are three different positions. Christian inclusivism, which is sometimes mistakenly accused of being a version of pluralism, actually entails that Christianity is the true religion and that the intellectual content of Christianity implies that God in his grace seeks all persons, even those outside the faith, and in his justice will not hold people accountable for detailed knowledge which is not within their power to acquire.

Identifying Lewis's Position

We now face the question of locating Lewis's position on the soteriological problem generated by religious diversity. *The Last Battle* contains the most widely discussed passage on the topic—a scene in which the followers of Tash gather outside the Stable discussing what god is in the Stable and declaring that Aslan and Tash are one and the same. Emeth, a young but courageous and upright Calormene soldier, accepts the cynical challenge from Shift the Ape to go through the Stable Door, declaring, "I would die a thousand deaths if I might look once upon the face of Tash."[22] As King Tirian, Jewel, Jill, and other Narnians watch Emeth boldly approach the Stable, the unicorn Jewel whispers to Tirian, "By the Lion's Mane, I almost love this young warrior, Calormene though he be. He is worthy of a better god than Tash."[23]

Later in the story, the kings and queens of Narnia enter Aslan's country and meet a bewildered Emeth, who is still pondering his amazing experience inside the Stable, when, attempting to enter Tash's domain, he encountered the great Lion, Aslan. Emeth describes the meeting as follows:

"Then I fell at his feet and thought, Surely this is the hour of death, for the Lion (who is worthy of all honor) will know that I have served Tash all my days and not him. . . . But the Glorious One bent down his golden head and touched my forehead with his tongue and said, 'Son, thou art welcome.' But I said, 'Alas, Lord, I am no son of Thine but the servant of Tash.' He answered, 'Child, all the service thou has done to Tash, I account as service done to me.' . . . I overcame my fear and questioned the Glorious One and said, 'Lord, is it then true, as the Ape said, that thou and Tash are one?' The Lion growled so that the earth shook . . . and said, 'It is false. Not because he and I are one, but because we are opposites—I take to me the services which thou hast done to him. For I and he are of such different kinds that no service which is vile can be done to me, and none which is not vile can be done to him.' . . . But I said . . . , 'Yet I have been seeking Tash all my days.' 'Beloved,' said the Glorious One, 'unless thy desire had been for me thou wouldst not have sought so long and so truly. For all find what they truly seek.' "[24]

No doubt, Lewis chose the names "Emeth," which is the transliteration of the Hebrew word for "truth," and "Aslan," which is the Turkish word for "lion," for their symbolic value. But now let us include this episode in our continuing probe of Lewis's position on salvation for persons outside the faith.

It is puzzling that this passage in Lewis is frequently cited to show he was a universalist while, in context, it is clear that Lewis is not promoting universalism because many who battle against Narnia, including Shift the Ape, do not pass into Aslan's country. We even learn that Queen Susan "is no longer a friend of Narnia."[25] Furthermore, the whole body of Lewis's philosophical writings provides no assurance that no one will be lost. In *Pain*, he wrote that "Divine labor to redeem the world cannot be certain of succeeding as regards every individual soul" and that "some will not be redeemed."[26] The risk of loss is due to the gift of finite free will that gives the creature the choice of whether or not to enter the life of God: "If the happiness of a creature lies in self-surrender, no one can make that surrender but himself."[27] Therefore, according to Lewis, a universalist claim would be incompatible with free will.

If the Emeth episode does not imply universalism, does it imply pluralism? Is Lewis suggesting that there are different ways to salvation? Is Emeth's worship of Tash salvifically on par with the Narnians' adoration of Aslan? Unfortunately, the pluralist interpretation of the passage cannot account for Aslan's vehement denial that he and Tash are the same: "I and he are of such different kinds that no service which is vile can be done to me, and none which is not vile can be done to him."[28] Philosopher James Sennett explains that "Aslan isn't saying that Emeth's service to Tash is just as worthy as service to Aslan. Rather, he's saying that what Emeth *thought* was service to Tash was *really* service to Aslan."[29] Sennett

concludes, "So Lewis clearly isn't a religious pluralist. He doesn't believe that all religions are basically the same, or that all of them are equally viable means to salvation."[30] Lewis is a universalist only in the sense that he affirms that the *opportunity* for salvation must be universally available; he is a pluralist only in the sense that he believes that other religions can contain fragments of spiritual truth and support moral life.

It is also clear that Lewis rejected religious exclusivism because it makes God unfair and unjust and instead pursued a more positive understanding: "Of course it should be pointed out that, though all salvation is through Jesus, we need not conclude that He cannot save those who have not explicitly accepted Him in this life."[31] Extending the same point, Lewis stated, "God has not told us what his arrangements about the other people are. We do know that no man can be saved except through Christ; we do not know that only those who know Him can be saved through Him."[32]

Lewis affirmed that relation to Christ is necessary for salvation, but he also goes on to advise Christians not to divide the world neatly into two camps, Christian and non-Christian. He ventured to claim that there are "people in other religions who are slowly becoming Christians though they do not yet call themselves so" and that such people "are being led by God's secret influence to concentrate on those parts of their religion which are in agreement with Christianity, and who thus belong to Christ without knowing it."[33] Such statements make Lewis an inclusivist—and Lewis's inclusivism could not be more orthodox. Similarly, reflecting orthodox thinking, John Wesley, the eighteenth-century Anglican priest and founder of Methodism, rejected the view that doctrinally correct ideas are necessary in order to benefit from the Atonement. Endorsing an inclusivist view, Wesley wrote, "The merciful God regards the lives and tempers of men more than their ideas. I believe he respects the goodness of the heart rather than the clearness of the head."[34] Orthodox Christian inclusivism represents the New Testament teaching that the genuine seeker may not know Christ but that God knows the true seeker.[35]

Lewis expressed Christian inclusivism in many of his philosophical and nonfiction writings. A clear statement from his *Letters* is illustrative: "I think that every prayer which is sincerely made even to a false god or to a very imperfectly conceived true God, is accepted by the true God and that Christ saves many who do not think they know Him."[36] Lewis also weaves his orthodox inclusivism into his fantasy and fiction. For example, in *Dawn Treader*, the travelers meet a lamb frying fish for breakfast on the seashore—and the lamb tells them that they can find their way into Aslan's country from their own world:

"What!" said Edmund. "Is there a way into Aslan's country from our world, too?"
"There is a way into my country from all worlds," said the lamb.[37]

When the lamb reveals himself as Aslan, he tells the travelers that they must know him by "another name" in their world. Other Narnian stories—such as Jill Pole's encounter with the Lion and Shasta's journey being secretly guided by Aslan—reflect a consistent inclusivist theme in Lewis.

Putting a finer point on the inclusivism of the Emeth passage, we must ask on what grounds Emeth was accepted by Aslan. Inclusivism does not entail that Emeth's worship of Tash is just as legitimate as the Narnians' worship of Aslan. What Aslan communicates in this passage is that Emeth was actually searching for him and serving him without realizing it. Although Aslan uses the language of "service" or deeds, Emeth was not accepted by Aslan because of his works; rather, Aslan makes it clear that Emeth's service was in fact honorable and driven by the intention to do good. When Emeth is puzzled by this pronouncement because he had been "seeking Tash all his days," Aslan replies that he knew the purity of Emeth's desire and that "all find what they truly seek." Lewis himself was likewise driven by desire, adopting and then abandoning various mistaken philosophical perspectives until the true object of his search presented itself.

Perfect Wisdom, Justice, and Love

Lewis's thinking on the subject of Christianity and religious diversity comprehensively addressed the crucial four problems set forth at the beginning of this chapter. He addressed the ontological problem as a religious realist, asserting that God exists and has a determinate character described by Christian doctrine, which implies that there are bona fide truths about God even though contingencies of culture and circumstance do not always allow these truths full exposure. He engaged the epistemological problem with his realist epistemology, which holds that we can know truths about the Christian God, but added the important proviso that vague or inaccurate intellectual understanding of God does not necessarily indicate lack of contact with God.

Lewis's response to the moral problem of whether God is perfectly good was that all persons must have equal opportunity to learn the truth about God and the way of salvation. Based on orthodox understanding, he concluded that God extends salvation to earnest seekers who, due to no fault of their own, do not explicitly and consciously know him. This position clearly supports justice and love as two important aspects of God's goodness. The justice of God is supported because God is not unjust toward people whose circumstances do not allow clear knowledge of Christ. God's love is supported because he seeks all persons and invites all to himself.

The soteriological problem is addressed in Lewis's account of how God seeks to save all persons who respond to him to the best of their knowledge

and ability, regardless of their grasp of correct doctrine. As Lewis explained in *Mere Christianity*, "doctrines are not God: they are only a kind of map."[38] As we know, a person can study a map and not use it well, and a person without the map may still find the final destination. Some people in other religions do not know of Christ—that is, they do not have the complete map—due to a variety of circumstances. Yet Lewis was unequivocal in affirming that God is not limited in giving salvation to those who respond to him—that is, to those without the map who are still moving toward the correct destination. Lewis commentator Kathryn Lindskoog indicates that "Lewis expressed hope that many true seekers like Akhenaton and Plato, who never had a chance to find Christ in this life, will find Him in the next one."[39]

The principles of God's infinite justice and infinite love apply equally to those outside any religion whatsoever. In *That Hideous Strength*, Jane Studdock, who is a professed nonbeliever, is asked by Ransom the Pendragon whether she will place herself in obedience to Maleldil:

> "Sir," said Jane, "I know nothing of Maleldil. But I place myself in obedience to you."
>
> "It is enough for the present," said the Director. "This is the courtesy of Deep Heaven: that when you mean well, He always takes you to have meant better than you knew. It will not be enough for always. He is very jealous. He will have you for no one but Himself in the end. But for tonight, it is enough."[40]

Once again we see in Lewis that intention, desire, and purity of heart are more important to God than correct doctrine—for "all find what they truly seek" even if they have inaccurate ideas about the true object of their search.

What emerges from an inclusivist position anchored in orthodox Christian theology is a picture of God who is infinitely just and infinitely loving, rejecting no person for lack of knowledge and desiring to give his own divine life to as many persons as possible. However, since there is no human formula for discerning matters of the heart, it is up to God's infinite wisdom alone to sort out the human situation. It is philosophically necessary, and it is theologically assured, that God's dealing with the trajectory of each life will be perfect: perfect wisdom, perfect justice, and perfect love shall coalesce. Returning to the language of the unicorn Jewel, this is the far, far better God of whom young Emeth was worthy.

11

Prayer and Providence

Although C. S. Lewis was typically shy about his inner life, he wrote a significant amount of material on prayer, revealing some of his personal struggles with prayer and offering important insights into the role of prayer in Christian life. *Letters to Malcolm: Chiefly on Prayer*, published posthumously, as well as three earlier essays focus directly on various theological, spiritual, and practical questions about prayer. With its genius epistolary format, *Malcolm* allowed Lewis the freedom of a conversational style that recorded his side of the correspondence with a fictional friend. Additional comments about prayer appear in other writings, including a technical theory of prayer and providence in "Appendix B" of *Miracles*. Although Lewis tried writing a systematic book on prayer, various conceptual obstacles—ambiguities and seemingly unresolvable paradoxes regarding petitionary prayer—discouraged him from finishing it. Such a book "was clearly not for me," he admitted in a letter to Sister Penelope.[1] A forty-eight-page manuscript fragment has survived, but its contents are consistent with his thoughts in *Malcolm*, which exhibits greater development and depth of insight.[2] In all, Lewis has provided a thorough, but not systematic, contribution to the theology of prayer that is logically connected to certain interpretations of God's knowledge and power as well as to God's relational purposes for Christian life.

Prayer and Christian Life

Lewis was orthodox not only in his Christian beliefs but also in his Christian practices, such as attending church and reading the Bible.[3] The practice of prayer for Lewis was something earthy and realistic—the honest, unpretentious expression of the heart which should not seek to impress God or other persons. In fact, Lewis says in *Malcolm* that praying with mental concentration is a "golden moment," which we do not often achieve because of our tendency toward disordered and distracted thinking.[4]

Since the different ways we can relate to God in prayer constitute another subject, Lewis concerned himself with what prayer *is*: open communication with God. Anglican priest and theologian Joseph Cassidy compares Lewis's approach to that of St. Ignatius of Loyola in his focus on the deep relation of the self to God.[5] For both Ignatius and Lewis, there must be an "unveiling" of the self to

C. S. Lewis and the Christian Worldview. Michael L. Peterson, Oxford University Press (2020).
© Oxford University Press.
DOI: 10.1093/oso/9780190201111.001.0001

God and no attempt at self-concealment, but this is not because God does not already know us, as Lewis clarifies:

> We are always completely, and therefore equally, known to God. That is our destiny whether we like it or not. But though this knowledge never varies, the quality of our being known can. . . . Ordinarily, to be known by God is to be, for this purpose, in the category of things. We are, like earthworms, cabbages, and nebulae, objects of Divine knowledge. But when we (a) become aware of this fact—the present fact, not the generalization—and (b) assent with all our will to be known, then we treat ourselves, in relation to God, not as things but as persons. We have unveiled. Not that any veil could have baffled his sight. The change is in us. The passive changes to the active. Instead of merely being known, we show, we tell, we offer ourselves to view.[6]

In intimate personal relationship with God, we are transformed—or, in Lewis's words, we become our "true selves." We ought not "shrink from too naked a contact" and should offer even our doubts and fears to God, our prayers of lament and questioning.[7]

Of course, in our present imperfect state, Lewis stated, prayer is a duty. However, the duty of prayer—like moral duty—exists to be transcended, one day to be done joyfully and spontaneously out of love: "I must say my prayers today whether I feel devout or not; but that is only as I must learn my grammar if I am ever to read the poets."[8] Prayer is, for Lewis, an essential part of the turning toward God that constitutes our proper response to his overtures toward us.

Aspects of Prayer

Lewis sees honest, authentic relationship as the foundation—and the chief goal—of prayer. To emphasize this aim, Lewis suggests a preamble before all other prayers: "May it be the real I who speaks. May it be the real Thou that I speak to."[9] Lewis further advises that we must not be "too high-minded" or assume an artificial dignity when we pray.[10] Self-deceit, he asserts, must be overcome: "It is no use to ask God with factitious earnestness for A when our whole mind is in reality filled with the desire for B. We must lay before Him what is in us, not what ought to be in us."[11]

Nevertheless, the various aspects of prayer or ways of relating to God in prayer—such as gratitude, adoration, confession, petition—are important and can assist our disordered souls to communicate more clearly with God. One aspect of prayer is the expression of gratitude to God for one's blessings. Adoration

in prayer, then, follows and says, "What must be the quality of that Being whose far-off and momentary coruscations are like this!"[12]

Adoration in prayer leads naturally, Lewis indicated, to repentance, to a confession of our sins and tendencies not to live as we should. However, repentance is not, in his estimation, one step in a formula for receiving absolution. Rather, as Lewis wrote in one letter, repentance is most importantly about restoring personal relationship:

> At the highest level, . . . the attempt is . . . to restore an infinitely valued and vulnerable personal relation which has been shattered by an action of one's own, and if forgiveness, in the "crude" sense of remission of penalty, comes in, this is valued chiefly as a symptom or seal or even by-product of the reconciliation.[13]

The relational breach is the primary problem that repentance seeks to address, and the goal is reconciliation. Lewis introduced the image of friends and lovers, who may quarrel intensely yet simultaneously maintain their love for one another:

> Anger—no peevish fit of temper, but just, generous, scalding indignation— passes (not necessarily at once) into embracing, exultant, re-welcoming love. That is how friends and lovers are truly reconciled. Hot wrath, hot love. Such anger is the fluid that love bleeds when you cut it.[14]

As Lewis noted, the most enlightening images for our interactions with God are always drawn from "deeply personal relationships."

While he stressed often that prayers must be from the heart, Lewis also endorsed using preformed prayers, such as The Lord's Prayer, which is the model prayer for Christians that includes all important aspects, such as adoration and supplication. He also used the Anglican *Book of Common Prayer* as an aid, which he indicates to Malcolm:

> First, it keeps me in touch with "sound doctrine." Left to oneself, one could easily slide away from "the faith once given" into a phantom called "my religion." Secondly, it reminds me "what things I ought to ask" (perhaps especially when I am praying for other people). . . . Finally, [it provides] an element of the ceremonial. On your view, that is just what we don't want. On mine, it is part of what we want.[15]

The ceremonial type of prayer here is not nominal or artificial but is instead the earnest adoption of a common structure for prayer that one does not create, which serves as a balance against self-absorption in prayer. "Infinitely various,"

observed Lewis, "are the levels from which we pray," but emotional intensity, as Lewis learned in childhood, is not an indication of spiritual depth.[16]

Puzzles of Petitionary Prayer

Lewis had previously made significant forays into problems of petitionary prayer in three earlier essays, which are, in chronological order, "Work and Prayer," "Petitionary Prayer," and "The Efficacy of Prayer." In this section, we look closely at the first two essays, and we cover the third essay in the next.

Appearing in 1945, "Work and Prayer" answers two common objections to prayer. It begins with a statement of the critic's "case against prayer," the objection that petitionary prayer can be eliminated as presumptuous because it instructs the omniscient God about things he already knows as he governs the world:

> Even if I . . . admit that answers to prayer are theoretically possible, I shall still think they are infinitely improbable. I don't think it at all likely that God requires the ill-informed (and contradictory) advice of us humans as to how to run the world. If He is all-wise, . . . doesn't He know already what is best? And if He is all-good, won't He do it whether we pray or not?[17]

Lewis takes this challenge seriously, and his response rejects the typical defense that the challenge only strikes at "the lowest sort of prayer," which "asks for things to happen" whereas "higher" forms of prayer enter "communion" with God without asking anything.[18] The Christian tradition, he argued, has never considered petition a lower type of prayer. After all, the Lord's Prayer, with its petitions, is the way Jesus himself taught believers to pray.

The second objection is that petition is pointless because it seeks to influence God's providential activity to do something he would not otherwise have done in governing the world. However, Lewis counters this objection by arguing that God's perfect wisdom and goodness in guiding events would, by the same logic, undermine the need for any human action whatsoever. Lewis writes,

> In every action, just as in every prayer, you are trying to bring about a certain result; and this result must be good or bad. Why, then, do we not argue as the opponents of prayer argue, and say that if the intended result is good God will bring it to pass without your interference, and that if it is bad He will prevent it happening whatever you do?[19]

"In that case," Lewis asks rhetorically, "why do anything?" We know instinctively that we can act and that our actions produce results, which leads Lewis to argue

that prayer is no different from overt action in seeking results. To Pascal's statement that God "instituted prayer in order to allow his creatures the dignity of causality," he added that God gave us "physical action for that purpose" as well.[20] Lewis concluded, "Everyone who believes in God must therefore admit (quite apart from the question of prayer) that God has not chosen to write the whole of history with His own hand."[21] The way the world turns out, then, represents a combination of divine and human actions:

> It is like a play in which the scene and the general outline of the story is fixed by the author, but certain minor details are left for the actors to improvise. It may be a mystery why He should have allowed us to cause real events at all; but it is no odder that He should allow us to cause them by praying than by any other method.[22]

By both prayer and action, rational creatures are able to contribute to the course of history, which Lewis notes "admits a certain amount of free play and can be modified in response to our prayers."[23]

In addressing the problem of petitionary prayer, contemporary Christian philosopher Eleonore Stump quotes Aquinas: "we pray not in order to change the divine disposition but for the sake of acquiring by petitionary prayer what God has disposed to be achieved by prayer."[24] Stump argues that God has chosen to work through the intermediary of prayer for the sake of relationship:

> [Prayer safeguards] the weaker member of the relation from the overwhelming domination and overwhelming spoiling, it helps to preserve a close relationship between an omniscient, omnipotent, perfectly good person and a fallible, finite, imperfect person.[25]

Lewis also argues Thomistically that it is a false dichotomy to assume that divine and human actions are mutually exclusive.[26]

In "Petitionary Prayer: A Problem Without an Answer," which was originally a talk delivered at the Oxford Clerical Society in 1953, Lewis wrestles with the two seemingly contradictory models of prayer that are presented in the New Testament.[27] What he calls "A Pattern" prayer is exemplified by the Lord's Prayer, which makes requests conditional—"Thy will be done"—and does not reflect unhesitating certainty that the thing requested will be given. Jesus in Gethsemene passionately prayed this kind of prayer—hoping to avoid his impending death—and the request was not granted. However, what Lewis calls "B Pattern" prayer, also involves a conditional request but proceeds from a strong faith that can "move mountains,"[28] which many interpret to be an absolute confidence that what is being requested will be delivered. Although moving mountains is

obviously hyperbole, the idea of doing mighty works via B Pattern prayer is clear. For example, John 14:13 indicates that whatever a believer asks "in the name of Jesus" will be done.

The two patterns, both strongly encouraged in the New Testament, appear to be mutually exclusive. Well before Lewis delivered "Petitionary Prayer" as a talk to the Clerical Society, he wrote a letter on January 14, 1953, to his friend Don Giovanni Calabria, an Italian priest, to seek advice:

> How is it possible for a man, at one and the same moment of time, both to believe most fully that he will receive and to submit himself to the will of God—who is perhaps refusing him? How is it possible to say simultaneously, "I firmly believe that Thou wilt give me this," *and*, "If Thou shalt deny me it, Thy will be done"? How can one mental act both exclude possible refusal and consider it?[29]

We do not know how Don Giovanni responded to this question, but we do know that Lewis continued to struggle with it, writing to his friend again on March 17, 1953, that he was "asking all theologians: so far in vain."[30] In fact, he abandoned his systematic book on prayer because he had encountered this problem which he could not solve.

In addition to attempting to reconcile A and B Pattern prayers, Lewis tried but could not square B Pattern prayers with the facts that many go unanswered. For all the biblical assurances, many confident petitions are not granted. During the twentieth century, as he reminds the reader, the Christian church world-wide prayed for peace during two World Wars and no peace was given. Although some defenders have dodged the point by saying that unwavering faith is a general faith in the character of Christ but not faith that a particular event will occur, Lewis pointed out instances in which "the faith seems to be very definitely attached to the particular gift"—such as the healing of the blind man in Matthew 9:28.[31] Lewis admitted that the theoretical problem is frighteningly practical because we need guidance in order to know how to pray.

Lewis never arrived at a satisfactory answer: "I have no answer to my problem, though I have taken it to about every Christian I know, learned or simple, lay or clerical, within my own Communion or without."[32] But whatever else B Pattern faith may mean, he insisted to the ministers that "it does not mean any state of psychological certitude" but is rather a gift from God, without which such faith is impossible.[33] In the end, Lewis took a practical posture about prayer:

> [C]an I ease my problem by saying until God gives me such a faith I have no practical decision to make; I must pray after the A Pattern because, in fact, I cannot pray after the B Pattern? If, on the other hand, God even gave me

such a faith, then again I should have no decision to make; I should find myself praying in the B Pattern.[34]

He closes by humbly asking the reverend Fathers, "How am I to pray this very night?"

Does Prayer Work?

Perhaps the question about prayer that is asked most frequently is, does it work? Marjorie Lamp Mead, a Lewis commentator, unpacks the question: "When we pray to God and make a request, how do we know that our prayer achieved the result? In other words, is answered prayer simply a fortunate coincidence that would have occurred whether or not we had asked for it?"[35] In his 1959 piece "The Efficacy of Prayer," Lewis wrestles with the central question, what is the relationship of prayer and outcome?

He particularly focuses on his experience with prayer for his beloved Joy in her struggle with cancer. On March 21, 1957, the Reverend Peter Bide, a friend and former student of Lewis, performed a Christian wedding for the couple in Joy's hospital room and then administered the sacraments and prayed for Joy's healing. A few days later, the physicians released her to live out her last days at the Kilns. Her condition soon unexpectedly improved, giving the couple great hope and enabling them to take a honeymoon to Ireland and Wales and later a trip to Greece. Lewis wrote,

> I have stood by the bedside of a woman whose thighbone was eaten through with cancer and who had thriving colonies of the disease in many other bones as well. . . . A good man laid his hands on her and prayed. A year later the patient was walking (uphill, too, through rough woodland) and the man who took the last X-ray photos was saying, "These bones are as solid as rock. It's miraculous."[36]

Even for this dramatic example, Lewis admitted that there is "no rigorous proof" of "a causal connection between the prayers and the recovery."[37]

Then he posed the follow-up question: "What sort of evidence *would* prove the efficacy of prayer?" Supposing that the outcome were somehow indisputably miraculous, "it would not follow that the miracle had occurred because of your prayers," for such reasoning would commit the post hoc fallacy of thinking that correlation was causation.[38] For this reason, Lewis argues, no form of empirical proof—"unbroken uniformity" or "experiment"—can show that a given event occurred because of prayer. Furthermore, even "invariable 'success' in prayer

would not prove the Christian doctrine at all" but something very different—like magic or manipulation.[39] Besides, the most telling counterexample to anything like a guarantee of answered prayer is found in Jesus facing his own impending death: "In Gethsemane the holiest of all petitioners prayed three times that a certain cup might pass from Him. It did not. After that the idea that prayer is recommended to us as a sort of infallible gimmick may be dismissed."[40]

For another thing, no reliable experiment can be constructed to test the efficacy of prayer. For Lewis, the structure of the experiment would be something like the following: "a team of people—the more the better—should agree to pray as hard as they knew how, over a period of six weeks, for all the patients in Hospital A and none of those in Hospital B."[41] Results would be tallied to see if A had more cures and fewer deaths. In reality, studies very much like this have been conducted—for example, the intercessory prayer experiment of Victorian scientist Francis Galton and the Templeton Foundation Prayer Study.[42] Unfortunately, such experiments violate the nature of prayer itself because they are generated out of curiosity rather than heartfelt need: "The real purpose and the nominal purpose of your prayers are at variance. In other words, whatever your tongue and teeth and knees may do, you are not praying. The experiment demands an impossibility."[43] After analyzing many scientific studies of prayer, Richard Sloan, professor of behavioral medicine at Columbia University, reached a similar conclusion: that studying religion scientifically is reductionistic toward religion and demeaning of science by pretending it can test and study something that cannot be measured.[44]

Lewis concluded that the question "Does prayer work?" must itself be questioned because it invites wrongheaded notions of what it means for prayer to "work" so that testing it might seem feasible. Lewis, however, placed emphasis on his persistent theme that prayer is personal communion between the believer and God:

> Prayer is either a sheer illusion or a personal contact between embryonic, incomplete persons (ourselves) and the utterly concrete Person. (Prayer in the sense of petition, asking for things, is a small part of it; confession and penitence are its threshold, adoration its sanctuary, the presence and vision and enjoyment of God its bread and wine.) In it God shows Himself to us. That He answers prayers is a corollary—not necessarily the most important one—from that revelation. What He does is learned from what He is.[45]

Prayer "works" if it enables us to know God better; whether God gives us what we request is irrelevant to its efficacy. Nonetheless, as Lewis indicated, Jesus both allowed and specifically commanded petitionary prayer—"Give us this day our daily bread"—and it must be offered as humble request.

In this light, the question "Does prayer work?" should be reinterpreted as asking whether God ever modifies his actions in response to human prayers.[46] Assurance that prayer is effective, he explained, is not empirical knowledge but interpersonal knowledge, which is based on the character of God, much like our personal knowledge of friends or spouses of whom we also make requests and who sometimes act because we asked.[47] But God, like our friends, sometimes grants and sometimes declines our requests, a realization that became very personal to Lewis as he grieved the loss of Joy. For two years after Bide's prayer for Joy, he had considered her healed, until she was again diagnosed with cancer in the fall of 1959, shaking his confidence in prayer:

> What chokes every prayer and every hope is the memory of all the prayers H. and I offered and all the false hopes we had. Not hopes raised merely by our own wishful thinking, hopes encouraged, even forced upon us, by false diagnoses, by X-ray photographs, by strange remissions, by one temporary recovery that might have ranked as a miracle.[48]

In his grief, Lewis lost sight of God's character and the nature of prayer, but as he worked through his grief, he returned to the most central truth about prayer as communion between friends.

Prayer and God's Providential Activity

Our thinking about prayer inevitably rests on philosophical assumptions about God's attributes and purposes in relation to human choice and action. These assumptions shape our theories, for example, about how God's providence can respond to any and all prayers in the unfolding history of the world or about how divine providence and human free will can be reconciled. Lewis expressed definite views on these matters, which we must now briefly explore and assess in terms of his overall worldview commitments.

To explain how God responds to petitionary prayers, Lewis relied on a view of divine timelessness: "if our prayers are granted at all they are granted from the foundation of the world."[49] In short, "God and his acts are not in time"—instead God timelessly takes all prayers into account and timelessly decides on the whole course of events:

> Intercourse between God and man occurs at particular moments for the man, but not for God. If there is—as the very concept of prayer presupposes—an adaptation between the free actions of men in prayer and the course of events, this adaptation is from the beginning inherent in the great single creative act.[50]

Although humans experience time as a flow—as a succession of past, present, and future moments—God's experience is "an infinite present, where nothing has yet passed away and nothing is still to come."[51] Boethius, whom Lewis loved, famously defended the view that God experiences an Eternal Now—which is "the whole of everlasting life in one simultaneous present."[52]

God's timeless apprehension of creaturely events, then, informs his providential guidance of the world, as his infinite wisdom takes into account all prayers and actions of free creatures in ordering the course of events. "God's creative act," Lewis wrote, "is timeless and timelessly adapted to the 'free' elements within it." From the creaturely side, "this timeless adaptation meets our consciousness as a sequence of prayer and answer."[53] Thus, both prayer and all our other acts contribute to the "cosmic shape" that God timelessly constructs according to his good purposes.

It does not appear that Lewis considered the concept of divine timelessness problematic for creaturely libertarian free will, possibly as raising problems of determinism or fatalism. As he explained, if God were within time foreseeing our choices and acts, it would be hard to understand how we could be free not to do them. But since God is outside of time, "what we call 'tomorrow' is visible to Him in just that same way as what we call 'today.' . . . He does not 'foresee' you doing things tomorrow; he simply sees you doing them."[54] In philosophical terms, Lewis most obviously took timelessness to entail *simple foreknowledge*, as did Augustine and Boethius, which is the idea that God timelessly knows what is the actual future for us, that is, what finite persons *will* do.[55]

Yet some Lewis passages suggest that his view of timelessness leads to the stronger position of *middle knowledge*, which asserts that God timelessly knows what personal creatures *would* do in all possible circumstances. This theory was first proposed by Luis de Molina, a sixteenth-century Jesuit thinker who posited a state of divine knowledge "between" God's knowledge of all necessary truths and his knowledge of all contingent truths about the actual world, including truths about free creaturely actions.[56] Lewis sometimes sounds like he accepts divine middle knowledge that knows what a free creature would do if certain circumstances occurred. Lewis stated that God knew that Abraham "would obey" if tested and nevertheless tested his faith anyway by commanding him to sacrifice Isaac.[57] In *The Magician's Nephew*, Aslan tells Digory that if he would have stolen the magic apple to heal his mother, it would not have brought him joy.[58]

Now, although Lewis officially gave allegiance to the concept of timelessness as making sense of divine knowledge in relation to prayer, it is far from obvious that timelessness fits coherently with other key elements of Lewis's overall vision of reality. It could be argued that timelessness—including timeless knowledge—is incompatible with other key elements in Lewis's worldview, such as authentic

divine–human relationship, the Trinitarian Life, and even God's actions in history, including the Incarnation. Christian philosopher William Hasker argues that divine timelessness cannot make sense of personal relationship between God and creatures:

> [I]n responding to another it is of the essence that one first acts, then waits for the other to react, then acts responsively, and so on. There seems to be no way this sequence could be collapsed, as it were, into a single timeless moment.[59]

The same point applies to Lewis's social Trinitarian thinking. Lewis's central image of God as the Great Dance—a dynamic, never-ending Life of mutual giving and receiving among the divine persons—becomes incomprehensible given timelessness. Joseph Cassidy extends the point further to the fact that the Second Person of the Trinity, God the Son, became forever bonded with a historical person, Jesus of Nazareth. A timeless God "cannot easily be reconciled with Chalcedon or later ecumenical councils," he argues, because "the Incarnation clearly implies that God acts in time."[60]

For such reasons, we can critically but sympathetically recommend that divine timelessness in Lewis (and all its Platonic baggage such as divine impassibility) must be rejected to preserve his central commitments to a created universe of genuinely interpersonal relationships, the inner nature of the Trinitarian Life, and God's actions in history. We can appreciate that Lewis thought that timelessness, as a theory of divine eternity, offered a way of distinguishing the qualitatively different kind of existence God possesses from the kind of existence possessed by all temporal creatures. However, he did not detect that the apparent benefits of timelessness for his views on prayer and providence are more than offset by its liabilities for absolutely essential ideas in his Christian worldview. Partly, we are encountering here the fact that Lewis was not always systematic in constructing his worldview, leaving us to organize and prioritize its various elements. But his unsystematic approach does not cancel the need to identify the central elements of his worldview and present them as a coherent whole, a presentation that will fail with timelessness in the mix.

Of course, some theory of divine eternity besides timelessness must make better sense of Lewis's central ideas. In recent decades, the theory of everlastingness, for example, has been articulated by Christian philosophers seeking to avoid the static and nonrelational implications of timelessness.[61] Christian philosopher Nicholas Wolterstorff argues that the theory of everlastingness—that God has no beginning or end and yet acts in time—is a better interpretation of the biblical picture of God as agent and redeemer.[62] Although further exploration of the theory of everlastingness lies beyond the present discussion, everlastingness promises to be much more compatible with the nonnegotiable

commitments in Lewis's overall vision of reality. Interestingly, Lewis himself actually opened the way for considering alternatives to timelessness when he wrote that "[timelessness] is not in the Bible or any of the creeds. You can be a perfectly good Christian without accepting it, or indeed without thinking of the matter at all."[63] In other words, we can know *that* God providentially responds to prayer without knowing precisely *how* God is related to time such that prayer is warranted in God's economy. Furthermore, the issues surrounding prayer and providence in Lewis simply highlight how important it was for him that God's goal of relationship with created persons be seen in all its significance, a goal we explore more fully in the next chapter.

12

Heaven, Hell, and the Trajectory
of Finite Personality

In his philosophical and fantasy writings, Lewis stressed the importance of free choice, especially the choice between good and evil, which—consciously or unconsciously—is fundamentally the choice between accepting or rejecting God. Our choices, he argued, move us toward our ultimate destiny, heaven or hell. In *The Great Divorce*, Lewis's book-length allegory which serves as the basis for our discussion, he weaves together the major themes of his thinking on the subject—such as the deeper meaning of heaven and hell, the nature of divine grace and judgment, and the spiritual struggles of the human heart.

Lewis positions himself in the book as both the narrator and the main character in a dream he is retelling. The dream begins when, after walking for hours one evening along the streets of a dreary town, he finds himself joining a busy bus queue of dead people who are taking an excursion to visit heaven—an idea Lewis developed from the ancient Catholic notion of the *Refrigerium*, or the "holiday of the damned."[1] During this excursion, they are presented with the choice of staying in heaven or returning to hell, which proves remarkably difficult for many.

Lewis originally titled the book *Who Goes Home?*, but the publisher suggested a name change before the book was released in 1945. The final title—*The Great Divorce*—was a response to Romantic poet William Blake's *The Marriage of Heaven and Hell*, symbolizing for Lewis the perennial but misguided attempt to combine heaven and hell, to find a way of retaining attitudes and habits characteristic of hell while still attaining heaven. Popular images depict heaven and hell as "places"—heaven is "up" and contains eternal rewards for the saved, while hell is "down" and contains everlasting punishments for the damned. However, the emerging theme of Lewis's allegory is that heaven and hell are, rather than specific locations, fundamentally different life orientations toward God.

Spiritual Geography

In the opening scene of *The Great Divorce*, the main character (Lewis) finds himself at a bus stop in a grey, depressing town with dingy and deserted residences

C. S. Lewis and the Christian Worldview. Michael L. Peterson, Oxford University Press (2020).
© Oxford University Press.
DOI: 10.1093/oso/9780190201111.001.0001

and little shops selling inferior merchandise. The residents have no needs because they can get anything they want simply by imagining it, yet they cannot get along, arguing and bickering constantly.[2] As the crowd waits for the bus, heated arguments break out, and even a physical fight, all rooted in selfishness and anger. Lewis reports that quite a few persons leave the queue because of a quarrel—a married couple gets into a spat and leaves the line, a Short Man limps away after being hit by a Big Man for insulting him, and so on.

After the remaining passengers board, the bus elevates and begins to fly, allowing the passengers time for conversation, in which they continue to display their narcissism and feelings of superiority. One in a long series of egocentric characters, for example, is the "tousle-headed" youth who fancies himself a poet. He compulsively blurts out that in life he felt unappreciated for his poetic gifts and so committed suicide out of a sense of futility. All of the other characters in the grey town, in turn, reveal their self-seeking "psychology."

New Testament scholar David Clark explains that the "geography" encountered in *The Great Divorce* is indicative of its underlying "sociology"—the dysfunctional relations among the people.[3] "Grey" is an appropriate adjective for the town because it is joyless and because it neither gets fully light nor completely dark. Yet the most obvious meaning of "grey" applied to the town is that its inhabitants have not made settled choices (at least not consciously and deliberately) for heaven or hell. Although readers often take the grey town as a symbol of hell, it is more accurately understood as a broader symbol of the state of being dead for those who continue to avoid God and yet still have the opportunity, if they will take it, to change their fate. That this state is both miserable and self-inflicted reflects Lewis's view of the nature of sin.

As they begin to land, Lewis as narrator reports the sense of being in a larger sort of space that "made the Solar System itself seem an indoor affair," illuminated by a "bright blueness that stung the eyes."[4] In the spiritual geography of the book, they arrive at the "low country," the outskirts of heaven, which the visitors find difficult to navigate because it is somehow more "real" than they. The grass hurts their feet as the light hurts their eyes, for they are insubstantial against the landscape, translucent and frail. They then realize, painfully, that they are Ghosts and not fully real. By contrast, what is eternal—including finite personal beings united to the eternal—is real and, thus, is substantial and solid. In the imagery of the book, of course, becoming "solid" means to become "real" in relationship with God.

The visiting Ghosts are allowed to survey heaven from the outskirts and may choose to stay and travel into the high mountains, called "Deep Heaven," where the presence of God fully resides. This invitation is the opportunity for them to become "solid people," permanent residents of heaven. In their present condition, the Ghosts are not suitable for the new environment; to be suitable, they

must change, or, more precisely, they must *be* changed because no person has the power to change himself. The wrong attitudes, ambitions, and aims that these persons adopted on earth were without reference to God and now prevent them from being comfortable in heaven. Each person must be transformed and reoriented, but change cannot occur to the unwilling.

Soon, a great multitude of solid people come down from the distant mountains, the earth shaking under their feet, each one sent to engage some particular Ghost.[5] The guides—permanent residents who already know the way to Deep Heaven and who knew the Ghosts in life—are tasked with convincing the visitors to give up their selfish orientations and choose life with God, symbolizing that, in a relational universe, other persons are important to our relation to God.

For Lewis, the opportunity for any person to redirect his or her life toward God is open, not closed, but even when the choice and its consequences are completely clear (as in the book's imaginary postmortem state), many people will resist choosing heaven. He presents this decision about destiny as an accumulation of little choices over a long period of time, such that the Ghosts often feel unable to take an alternate path—but free choice is central nonetheless.

The centrality of choice is clarified further when Lewis as narrator meets George MacDonald—the nineteenth-century Scottish author whose writings greatly influenced Lewis—and learns that MacDonald is his assigned guide, much as Beatrice was Dante's guide.[6] Trusting MacDonald completely, Lewis implores him to answer his questions: "Is judgment not final? Is there really a way out of Hell into Heaven?" MacDonald's reply is lengthy but profound:

> "It depends on the way ye're using the words. If they leave that grey town behind it will not have been Hell. To any that leaves it, it is Purgatory. And perhaps ye had better not call this country Heaven. Not Deep Heaven, ye understand." (Here he smiled at me.) "Ye can call it the Valley of the Shadow of Life. And yet to those who stay here it will have been Heaven from the first. And ye can call those sad streets in the town yonder the Valley of the Shadow of Death: but to those who remain there they will have been Hell even from the beginning."[7]

MacDonald is saying that what we earlier called "spiritual geography" is not fixed independently of human choice. As Lewis clarified in *God in the Dock*, "It's not a question of God 'sending' us to Hell. In each of us there is something growing up which will of itself be Hell unless it is nipped in the bud."[8]

A person's choice, MacDonald continues, makes his life history *retrospective*— that is, any segment of creaturely existence can be included in alternative eternal futures, depending on the choice made.[9] Pleasures, hardships, and even sufferings can be included in a life lived with God—who redeems all—or in a life lived without reference to God, in which all experiences are ultimately

contaminated and spoiled. Lewis clarifies the retrospective interpretation of one's life choices in his preface:

> Earth, I think, will not be found by anyone to be in the end a very distinct place. I think earth, if chosen instead of Heaven, will turn out to have been, all along, only a region in Hell: and earth, if put second to Heaven, to have been from the beginning a part of Heaven itself.[10]

Thus, the overarching theme of *The Great Divorce* is that the choice of our ultimate destination is entirely ours and ever before us but that there can be no compromise, no "dual citizenship."

Legitimate and Illegitimate Dualisms

Although many commentators state that most of Lewis's works of fantasy are based on Platonic ideas and use Platonic techniques, this is not completely accurate. Granted, Lewis sometimes employed Platonic literary images, such as the idea that virtues manifested in earthly life are glimmers or "flashes" of higher, eternal qualities, but he rejected many elements of Platonic philosophy. For example, in works like *The Great Divorce* and *The Screwtape Letters*, Lewis profoundly disregards the Platonic view that dramatic works should always present truth and virtue and never portray false opinions or vice because the audience might "imitate" those negative elements.[11] To the contrary, the positive impact of these works is found precisely in their insightful investigation of destructive attitudes and behaviors.

For the purpose of this discussion, Lewis's most important departure from Platonic philosophy is his rejection of Plato's central motif of dualism between the realm of ideas and the material world. For Plato, matter is less real than ideas and is the root of evil. Thus, earthly life is a hindrance, and the body is a prison of the soul. There is no hint of such thinking in Lewis, for whom matter is the creation of a good God, the human body essential to our humanity, and earthly life the opportunity for good. Orthodox Christianity contains dualisms, to be sure, but they are not Platonic dualisms, which means that we must carefully navigate dualistic imagery in *The Great Divorce* in order to discern the orthodox Christian message.

For example, the familiar dualism between spirit and matter suggests that spirit is a higher, ethereal reality whereas matter is lower but more substantial. However, Lewis's ingenious reversal of portraying heaven as more substantial or solid does not imply that spirit is solid and matter insubstantial—that the Ghosts are insubstantial because they are dead people and therefore lack material bodies.

Rather, the Ghosts are insubstantial because they are *temporal*; heaven and those who become residents there are substantial by contrast because they are *eternal*. In Christian terms, it is illegitimate and misleading to make the material and the spiritual antithetical, and Lewis artfully avoids and subtly refutes this erroneous dualism.

The most fundamental—and legitimate—dualism of the book is the "divorce" between heaven and hell, and it is "great" because that dualism is absolute and unbridgeable. As MacDonald tells Lewis, "Heaven is reality itself."[12] Equating heaven with Reality leads to the further identification of Reality with the Trinitarian God—and intrinsic to the Trinitarian Self-living Life are the eternal qualities of love and joy. The following equation expresses the point:

$$\text{Heaven} = \text{Reality} = \text{The Trinitarian God} = \text{Joy}.$$

To be "in" heaven, then, means to accept reality fully, which means to come into relation with the Trinitarian God, through whom human persons experience their *telos* and, by extension, joy.

Hell is not actually an alternative reality to heaven; it is instead "unreality" because it is outside of God. Conceiving of hell as unreality sets up an opposite equation:

$$\text{Hell} = \text{Unreality} = \text{Rejection of God} = \text{No Joy}.$$

People in the grey town get everything they want, but everything is of low quality and only leaves them wanting more, which suggests an unreality that affords no true satisfaction. Disconnected from the source of Joy, Lewis implies, our desires become disordered and undisciplined, creating an unreal world devoid of joy.

The palpable quality of joy is offered to convince the Ghosts to stay in heaven, but they continue to struggle against it, refusing to surrender. To characterize the driving motivation of people who insist on maintaining control of their own lives, MacDonald quotes Satan's famous line from John Milton's *Paradise Lost*: "Better to reign in Hell than serve in Heaven." MacDonald explains, "There is always something they insist on keeping even at the price of misery. There is always something they prefer to joy—that is, to reality."[13]

Lewis's *A Preface to Paradise Lost* further reveals his thoughts on this dualism. It is unsurprising to Lewis that in Milton's epic poem God laughs at Satan for continuing to "rant and posture through the whole universe" about his "injured merit" because Christ is named Head of Angels instead of him.[14] Critics opine that God's laughter is the unfeeling and unseemly ridicule of a loser by the winner of a contest, but Lewis offers a more insightful interpretation in his *Preface*: "Milton cannot exclude all absurdity from Satan" because Satan is at war

with the very structure of reality.[15] Satan's perverse war with God—his demand to be recognized as superior to God himself—cannot be a genuine contest since it is the futile opposition of a creature to its Creator, the attempt to change what cannot be changed. Satan's feeble attempts to destabilize God cannot appear other than ridiculous and cannot be immune from the divine laughter:

> The whole nature of reality would have to be altered in order to give him such immunity, and it is not alterable. At that precise point where Satan [meets] something real, laughter *must* arise, just as steam must when water meets fire.[16]

No private agenda—which is always a form of unreality—can ignore, reverse, or overturn Reality itself. The only other option is to live in a willful state of "unreality," which we may call hell.

The irreconcilability of heaven and hell implies the unavoidable binary choice between them, presented powerfully in *The Great Divorce*. Lewis as narrator observes many Ghosts struggling to retain their own preferences and yet stay in heaven—by striking a compromise, as it were. However, any attempted "marriage" of heaven and hell reflects the mistaken belief that "reality never presents us with an absolutely unavoidable 'either-or' choice," as Lewis clarifies in his preface. Rationalizations abound, based on the conviction that, with enough time and ingenuity, "some way of embracing both alternatives can always be found," or perhaps evil can be refined and turned into good and not require the rejection of anything we want. Lewis calls this line of thinking "a disastrous error," and writes, "If we insist on keeping Hell (or even Earth) we shall not see Heaven: if we accept Heaven we shall not be able to retain even the smallest and most intimate souvenirs of Hell."[17]

Lewis holds that enjoying the earthly pleasures is not bad in itself and is in fact a great good—that these earthly joys point us toward the great Joy—but he maintains that if we choose earthly pleasures without also choosing heaven (that is, relationship with God) and placing it first in our order of loves, then we will have disordered loves and will miss our true fulfillment, making the pursuit of earthly loves an experience of hell all along. However, "any man who reaches Heaven will find that what he abandoned . . . was precisely nothing: that the kernel of what he was really seeking even in his most depraved wishes will be there, beyond expectation, waiting for him in 'the High Countries.'"[18]

Lewis's most quoted biblical statement—"he who loses his life will find it"[19]—affirms the paradox that surrendering to God our lives and the belief that we have constructed them allows him to transform and reorder our lives, keeping what is really good, which gives us genuine happiness. Even things that seem so important to us that we think we cannot live without them, when they are loved and sought in the wrong way, warp us and entrap us. Yet, when we give them up,

nothing that is good or truly good for us will be lost; instead, it will be healed, redeemed, and given back to us "beyond expectation."

Heaven, thus, is best understood as unending, abundant, and full life in God. The various terms Lewis uses for "heavenly desire," then, are best understood as referring to the desire for God in whom alone our fulfillment can be found. To have any hope beyond physical death, finite persons must be connected to the infinite and eternal Reality—God—who is himself heaven.

For Lewis, the common idea that heaven is a state of mind offers no basis for hope of life beyond the grave.[20] By contrast, as MacDonald says, "Hell is a state of mind," a fiction, and "every state of mind, left to itself, every shutting up of the creature within the dungeon of its own mind—is, in the end, Hell."[21] To reject God is to live in a self-created fantasy world that separates one from reality, from the source of all true Joy. "But Heaven," Lewis continues, "is not a state of mind. Heaven is reality itself. All that is fully real is Heavenly. For all that can be shaken will be shaken and only the unshakeable remains."[22]

Lewis offers another analogy in *The Last Battle*. The Dwarfs in Narnia shut themselves in an imaginary stable, smelly and dark, refusing to come out, although daylight and lush trees are all around them. When Lucy asks Aslan if he can help the dwarfs, he explains that he cannot reverse their free choice: "Their prison is only in their own minds, yet they are in that prison; and so afraid of being taken in that they cannot be taken out."[23] Their hearts are so set against being duped or "taken in" by the "fantasy" of Aslan that they choose to stay in a prison of their own making—a kind of hell that is real to them but entirely out of alignment with True Reality. As long as we cling to our illusions—and reject Reality—we can never enter heaven.

The Attraction of False Infinites

Lewis called the seductive lure of earthly things "the sweet poison of the false infinite."[24] Avoiding the enticement of the false infinite requires not ascetic renunciation of finite things but rather grateful affirmation of all good things in creation as gifts of God. This is why the devil Screwtape cautions Wormwood to be careful in using pleasures as a source of temptation: "Never forget that when we are dealing with any pleasure in its healthy and normal and satisfying form, we are, in a sense, on the Enemy's ground."[25] Yet, trying to satisfy ultimate longing with any object given in experience—as Lewis knew well from his search for Joy—is futile and inevitably spoils the actual good as well as our capacity for its proper enjoyment.

Being fully human in a relational universe involves having a proper relationship to everything in the universe—to God, to others, to the other goods of

creation, and even to oneself. Although true fulfillment involves a balance of all of these relationships, the seductive lure is to get them out of balance, to desire them to be other than they truly are. All unhealthy, imbalanced loves represent the quest to grasp, retain, and control, which is a way of creating one's own universe, and which is in turn the reflection of improper self-love, another "false infinite."

The theme of the healthy personality being in proper relation to everything else and the unhealthy personality being self-absorbed runs through Lewis's writings. In *Preface to Paradise Lost*, his comparison of unfallen Adam with Satan is instructive:

Adam talks about God, the Forbidden Tree, sleep, the difference between beast and man, his plans for the morrow, the stars and the angels. He discusses dreams and clouds, the sun, the moon, and the planets, the winds and the birds. He relates his own creation and celebrates the beauty and majesty of Eve. . . . Adam, though locally confined to a small park on a small planet, has interests that embrace "all the choir of heaven and all the furniture of earth." Satan has been in the Heaven of Heavens and in the abyss of Hell, and surveyed all that lies between them, and in that whole immensity has found only one thing that interests Satan. . . . Satan's monomaniac concern with himself and his supposed rights and wrongs is a necessity of the Satanic predicament. . . . He has wished to "be himself," and to be in himself and for himself, and his wish has been granted.[26]

In sharp contrast to Adam, Satan speechifies incessantly about his "injured merit" and his "right to leadership." The differences between Adam and Satan result from their choices—Adam accepts his role as creature and chooses to relate properly to a wider, richer world, whereas Satan rejects his role as creature and chooses to live in a constricted world of lies, propaganda, wishful thinking, and incessant autobiography.

The spiritual dysfunction of imbalanced relationships is also a common theme for the Ghosts in *The Great Divorce*—from the Big Man who is preoccupied with getting just what he deserves to Pam who disguises her possessive control of her son as maternal love. In earthly life, these people chose to fixate on certain things that eventually became their gods, "false infinites." Their momentous postmortem decision, then, can be seen as being about whether they will accept the divine remedy for their spiritual sickness.

In *The Lion, the Witch, and the Wardrobe*, Lewis presents another version of a "false infinite" through Edmund's inordinate love for Turkish Delight, which leads to much sorrow—the betrayal of his siblings and, eventually, Aslan's death. When the White Witch (posing as Queen of Narnia) magically provides a large

box of Turkish Delight at his request, he eats insatiably and becomes susceptible to the Queen's questions about Peter, Susan, and Lucy: "the more he ate the more he wanted to eat, and he never asked himself why the Queen should be so inquisitive."[27] After being served a delicious meal at the home of Mr. and Mrs. Beaver, we learn that Edmund "hadn't really enjoyed it because he was thinking all the time about Turkish Delight—and there's nothing that spoils the taste of good ordinary food half so much as the memory of bad magic food."[28] What began as a seemingly unimportant craving for Turkish Delight became an obsession that made Edmund a traitor, who was subject to death according to "the Deep Magic from the Dawn of Time." He was saved only because Aslan took Edmund's place and died on the Stone Table. Turkish Delight became a "false infinite" that led him away from all real Joy, making him sick, both physically and spiritually.

The hopelessness of pursuing a false infinite is seen clearly in *The Great Divorce* in the conversation between Pam the Ghost and a Bright Spirit named Reginald who had been her brother. Pam expected to meet her son, Michael, in heaven, but her brother explains that while Michael, who died prematurely, is in heaven, he cannot even "see" her in her ghostly condition. Pam will first need to be "thickened up a bit," which is the spiritual corrective of beginning to love God in order to relinquish her fixation on Michael—dominating him while he was alive, memorializing her grief after his death, and making her husband and daughter miserable. When Pam answers that she could love God if that meant she could see Michael, Reginald replies that she is treating God like a means to an end, which is not to want "God for his own sake."[29] Loving God, Reginald continues, is the key to having balanced loves for every other person, but natural loves "all go bad when they set up on their own and make themselves into false gods."[30] When Lewis opines to MacDonald that an "excess of love" is the mother's problem, MacDonald retorts that it is not excess but defect, because if she had loved Michael more, the problem would not have developed.[31] Of course, there was also excess of love, in a sense: it was an excess of self-love by which Pam promoted herself to the role of God in the life of her family. Until she abandons this "false infinite," she has no ability to embrace the true Infinite, which is God himself.

Created Selves Encounter Reality

A person's only hope for escaping the prison of self-choice is to face the truth about himself and begin moving toward God. Since heaven is Reality itself, there can be nothing deceptive or illusory about it. Since truth corresponds to reality, the most fundamental truth about human persons is that our highest good and proper fulfillment is life in God. In these terms, the essence of sin is the

self-deception that we can define our own good; the consequence of this deception is a warping of created personality. Lewis writes, "there are no real personalities anywhere else [apart from God]. Until you have given up your self to Him you will not have a real self."[32]

Milton's Satan could not change the structure of reality, including the reality of his own nature. As a created self—a finite personal being possessing intelligence, will, and agency—Satan's true good would have been realized by accepting his place in creation, which he refused to do. We human persons are also created selves who must either accept our nature and ultimate destiny in God or craft for ourselves a destiny apart from God, which Lewis sees as a free choice. Subtly, gradually, life orientation is shaped by a series of accumulative moral choices in which "good and evil both increase at compound interest."[33] David Clark explains Lewis's view that "these [moral] choices affect the soul, and over time a person becomes more and more shaped by them."[34] Left unchecked, bad temper, jealousy, narcissism, and other spiritual defects gradually get exponentially worse and become hell when projected out over an eternal future.[35] Past a certain point, we may no longer see these choices as such—we may feel unable to redirect the ship, as it were—but the decision was nonetheless our own. Indeed, this blindness is itself a symptom of the spiritual sickness from which we suffer.

Finding our true selves, then, is a matter of letting God heal and transform us spiritually. But God will not force himself upon us: "He will not ravish, he can only woo."[36] As perfect love, God can do nothing less than will our true good, which, as Lewis writes, is for us to be in full, surrendered relationship with him: "He cannot bless us unless He has us. When we try to keep within us an area that is our own, we try to keep an area of death. Therefore, in love, He claims all."[37] In essence, Lewis argues that any piece of our self that we attempt to keep for our own and under our own control is in fact "unreal" or illusory, for our "self" was created to live in God.

The idea of a "false self" is found throughout Lewis's writings, along with its corollary: that we must die to our false self in order to truly live. But dying to the false self is not easy, as we see in the characters in *The Great Divorce* who learn the frightening ultimate outcomes that will result and yet cannot submit their false selves to spiritual death. One salient example is when Frank the Ghost meets his wife, Sarah Smith of Golders Green, who is known in heaven for her great love, and who implores Frank to choose eternal joy as she has done. As an observer, Lewis sees that Frank the Ghost is actually a Dwarf who leads a tall Ghost—a Tragedian actor—around on a chain. The reader learns that Frank made others miserable by overly dramatizing everything out of the need to be pitied, or we might say, the need to be needed.

Frank uses emotional blackmail to try to disturb Sarah's happiness because of need for him, but Sarah replies, "I am full now, not empty. I am in Love Himself,

not lonely. . . . You shall be the same. Come and see."[38] Through Sarah's gracious overtures, some light reaches Frank against his will, and he almost glimpses the absurdity of his false persona, but in the end he will not relinquish his false self. Sarah continues pleading as Frank begins shrinking, continuing to cling to the chain until he disappears, leaving only the facade. Lewis reports that he had never witnessed "anything more terrible than the struggle of that Dwarf Ghost against joy."[39] In clinging to his *idea* of himself, his fantasy self—and thereby rejecting Reality—he loses his true self, consigning himself to misery and loneliness.

Temporal Choice and Eternal Destiny

Freedom of choice, Lewis wrote, is like a compass needle inside each of us that decides our spiritual trajectory. That needle *can* point us to our "true north" (God) but does not necessarily do so. The fundamental question in regard to any person, then, is whether the needle will "swing round, and settle, and point to God."[40] Hence, one's eternal destiny is not about one's present state of character but about one's direction, where one is headed. Although bad life choices may have taken a person in a wrong direction, the key for him or her is turning around and heading "north." In Lewis's writings, as in many other Christian writings, the image of the journey is common because it compares our decisions to steps in a certain direction and leaves room for changing course or backtracking. Lewis employs this imagery allegorically in *The Pilgrim's Regress* and more simply in his preface to *The Great Divorce*:

> I do not think that all who choose wrong roads perish; but their rescue consists in being put back on the right road. A sum can be put right: but only by going back till you find the error and working it afresh from that point, never by simply going on. Evil can be undone, but it cannot "develop" into good. Time does not heal it. The spell must be unwound, bit by bit, "with backward mutters of dissevering power"—or else not.[41]

When we stray down the wrong path, God offers help, nudging us in the right direction, but each of us must freely choose to accept God's help: he does not force us, which would destroy free will, but rather works with us to give opportunity for our free choice.

Accepting grace and turning toward God is necessary for each person, but entering into a process of subsequent sanctification is also necessary. Sanctification means to change in order to come into alignment with Reality, to become "fit" for heaven, to use Lewis's imagery. Put negatively, sanctification involves leaving sin behind, which leads to the idea of "purification" or purgatory:

Our souls demand Purgatory, don't they? Would it not break the heart if God said to us, "It is true, my son, that your breath smells and your rags drip with mud and slime, but we are charitable here and no one will upbraid you with these things, nor draw away from you. Enter into the joy"? Should we not reply, "With submission, sir, and if there is no objection, I'd rather be cleaned first." "It may hurt, you know"—"Even so, sir."[42]

The idea of Purgatory reflects the truth that no one is fit for life with God without purity, without a cleansing of our sinful habits and beliefs—a realigning of our selves with Reality. God forgives our sins but does not condone them, for when created selves meet Reality itself, there can be no compromise: no unreality may survive.

Put positively, the process of sanctification is about becoming able to share fully in the qualities of God's life—joy, peace, and self-giving love. All of our right desires—those that God gave us—will be fulfilled: "All that you are, sins apart, is destined, if you will let God have His good way, to utter satisfaction."[43] Lewis follows the ancient church in writing that God wants to bring us into our full flourishing as personal creatures that radiate "energy and joy and wisdom and love."[44] The journey is often long and involves many voluntary surrenders along the way as we leave the foothills of heaven and—becoming sanctified—journey into the High Mountains.

Although life in God involves surrender, it is not surrender of anything important to our fundamental humanity or personality, for it is only our false selves that we must abandon:

To enter heaven is to become more human than you ever succeeded in being on earth; to enter hell, is to be banished from humanity. What is cast (or casts itself) into hell is not a man: it is "remains." To be a complete man means to have the passions obedient to the will and the will offered to God: to have been a man—to be an ex-man or "damned ghost"—would presumably mean to consist of a will utterly centered in its self and passions utterly uncontrolled by the will.[45]

To become our truest selves, we must first give up our selves, a paradox that Lewis eloquently describes in *Mere Christianity*:

[T]here must be a real giving up of the self. You must throw it away "blindly" so to speak. Christ will indeed give you a real personality; but you must not go to Him for the sake of that. As long as your own personality is what you are bothering about you are not going to Him at all. The very first step is to try to forget about the self altogether. Your real, new self (which is Christ's and also yours,

and yours just because it is His) will not come as long as you are looking for it. It will come when you are looking for Him. . . . Keep back nothing. Nothing that you have not given away will be really yours. Nothing in you that has not died will ever be raised from the dead. Look for yourself, and you will find in the long run only hatred, loneliness, despair, rage, ruin, and decay. But look for Christ, and you will find Him, and with Him everything else [wonderful] thrown in.[46]

Lewis also expresses this point using two Greek terms, stating that *Bios* (the finite and perishable life of human selves) must be taken up into *Zoe* (the infinite and eternally joyous life of God).[47] To be in heaven—that is, to be united to the Trinitarian God—is the healing, integration, and wholeness of finite created personality that allows us to experience true happiness.

However, happiness—which is fulfillment of the universal human *telos* through surrender to God—does not mean cancellation of rich individual differences among persons. As Lewis says, "good, as it ripens, becomes continually more different, not only from evil but from other good."[48] Sarah Smith is a personality completely fulfilled in the Trinity—a common person with a common name on earth, but she loved greatly on earth and became celebrated in heaven as her gifts were ever more perfected. Even Frank could not manipulate her love, and even while Frank was diminishing, Bright Spirits sang, "The Happy Trinity is her home: nothing can trouble her joy."[49]

By contrast, hell—which is life apart from the Trinitarian God—is the continued disease, disintegration, and destruction of created finite personality. Evil is often portrayed in film and media as fascinating and alluring and good as boring and banal, but it is actually the reverse. Those in hell in *The Great Divorce* are doomed to the inescapable boredom of self-obsession and are hardly displaying a healthy, flavorful diversity of personalities. The tyrants residing in the grey town—Napoleon, Genghis Khan, and Julius Caesar—are all self-involved and therefore self-entrapped. All such persons fit Lewis's description of the Miltonian Satan: "The hell he carries with him is, in one sense, a Hell of infinite boredom."[50]

For Lewis to present hell as the disintegration and dissolution of created personality raises the question of *annihilationism* in his worldview. In *The Great Divorce*, we do not know the final outcome of many Ghosts who refused heaven, but we do know that Frank the Dwarf simply vanishes. Likewise, the Grumbler Ghost seems to lose her selfhood and become only a grumble.[51] Lewis's language of the "remains" of a person or an "ex-person" also seems annihilationist. However, traditional annihilationism holds that God directly removes persons from existence, whereas Lewis portrays persons adopting life orientations that necessarily result in not existing as persons or souls. Any person not connected to God will ultimately be in the state of "having been a human soul," as Lewis puts it, just as "gases, heat, and ash" remain after a log has been burned.[52] Similarly,

bad Narnians in the end cease to be talking beasts, but presumably remain beasts that then quickly disappear in Aslan's dark shadow, signaling the disintegration of the kind of thing they were.[53]

Christian philosopher Jonathan Kvanvig questions the internal consistency of Lewis's position, arguing that annihilationism is incompatible with the view that "something" persists which was once a person.[54] The reader may also remember Lewis's famous line—"you have never talked to a mere mortal"—which many take to imply that persons are inherently immortal.[55] However, Lewis's emphasis was always on the trajectory, not the ontology, of created personality. Although he did not systematically address the question of whether hell is self-annihilation, he consistently argued for the principle that increasing distance from God necessarily results in dehumanization. Speculatively, in the end, there may (or may not) remain "something" ontologically, but personhood is gone, reduced to zero.

While it would be ideal, Lewis commented, if universalism—the view that all persons will be in heaven and no persons in hell—were true, this form of determinism would pay the unacceptably high price of cancelling human freedom, without which authentic relationship to God is impossible: "If the happiness of a creature lies in self-surrender, no one can make that surrender but himself (though many can help him to make it) and he may refuse."[56] Thus, the possibility of relationship with God allows for the possibility of hell. "I willingly believe," Lewis wrote, "that the damned are, in one sense, successful, rebels to the end; that the gates of hell are locked on the inside."[57]

At the end of The Great Divorce, MacDonald tells Lewis that he is not dead but dreaming and can still choose his eternal destiny. As Lewis awakens and feels the urgency of making his own choice, the book comes to a close, leaving open the question of what he will do. The human future, Lewis indicates, is "open," not "closed," which means that we cannot know categorically about the final outcome of all things.[58] As MacDonald tells Lewis as narrator,

> "There are only two kinds of people in the end: those who say to God, 'Thy will be done,' and those to whom God says, in the end, 'Thy will be done.' All that are in Hell, choose it. Without that self-choice there could be no Hell. No soul that seriously and constantly desires joy will ever miss it. Those who seek find. To those who knock it is opened."[59]

Epilogue

C. S. Lewis and the Christian Worldview
in the Third Millennium

In the early years of the new millennium, interest in Lewis continues to be strong. Clearly, his prodigious creativity, mastery of diverse literary genres, and penchant for memorable prose account for much of his enduring popularity, but his ability to articulate the Christian worldview—weaving it implicitly into his stories, presenting it in his reasoned treatises, and addressing it in his formal essays—makes his work timelessly captivating. As we have seen, Lewis dedicated himself to being a "translator" of Christianity to the general public, offering Christianity to laypersons in a language they could understand, but he also frequently engaged many major philosophers and intellectuals of his day with a high level of sophistication.[1] The Christian worldview he conveys is, as he says, "something positive, self-consistent, and inexhaustible"[2]—indeed, it is the "enduring philosophy" he had long sought, the *philosophia perennis* that is relevant at all times to all people and cultures. Perhaps, then, it should be no surprise that readers, decade after decade, find his presentation of Christian belief and life both fascinating and enriching.

Of course, the intrinsic interest of the Christian worldview comes readily through the conduit of Lewis's writings because he invests himself so deeply in them—enlisting his wit, incisiveness, erudition, and frank honesty in the service of the most important things: God and the human need for God. Perhaps his focus on the permanent things should not be surprising either, since he spent many years of trial and error searching for the deepest truths about reality. In eventually finding and embracing Christianity, Lewis was confident that the Christian worldview provides the best explanation for the major phenomena of life and the world: rationality, morality, longing for meaning, and personhood itself. The difficult features of the world are also explained—from evil and suffering to nonbelief and resistance to God. Difficult challenges are likewise met—such as issues regarding science and religious diversity. Yet, as we know, Lewis emphasized that his personal search was driven by a desire for Joy, for something beyond this world that would give purpose and fulfillment to his life. His intellectual search and his existential search converged and led him to the Christian God, the ultimately real ground of all that is true and good and beautiful—and the source of our own genuine happiness.

C. S. Lewis and the Christian Worldview. Michael L. Peterson, Oxford University Press (2020).
© Oxford University Press.
DOI: 10.1093/oso/9780190201111.001.0001

Most centrally, for Lewis, the Christian worldview rests on a vision of the Trinitarian Life of God as a dynamic, joyous, and loving fellowship of the Divine Persons and the complete identification of the Second Person, Christ, the Son of God, with humanity in the Incarnation. In Jesus Christ, "Myth became Fact," God became Man, to show us how intimately God wants to be related to us. Thus, for Lewis, the question of the existence of the Christian God is not purely a speculative matter, which means that the whole framework of the Christian worldview is much more than a set of truths for answering our difficult questions. As Lewis wrote, "once [the question of the Christian God] has been answered in the affirmative, you get quite a new situation. . . . You are no longer faced with an argument which demands your assent, but with a Person who demands your confidence."[3] One has moved thereby, as Lewis continues, from the "logic of speculative thought" to the "logic of personal relations"—to considering how to orient one's life toward God in light of the truths that have been reasonably recognized. Here, for Lewis, the Christian worldview becomes not just an abstract philosophical explanation but a crucial existential map that can guide our free personal responses to God.

The Christian vision of life explains what Lewis found in personal experience: that God, as the source of reality, invites him and all persons to share in his own divine life of unending love and joy. Although each person's journey is unique, all persons search in their own ways for the same essential things that Lewis sought—the truth about the nature of the world and authentic happiness. The enduring appeal of Lewis is that he projects an attractive Christian picture of reality, shares how he found it in his journey, and encouragingly proclaims that that all honest seekers will find it in their own journeys.

A Timeline of Lewis's Journey

The following is a brief, selective sketch of key events in Lewis's life and career, drawn from a variety of sources, including Adam Barkman's *C. S. Lewis and Philosophy as a Way of Life*; Alister McGrath's *C. S. Lewis, A Life: Eccentric Genius, Reluctant Prophet*; *cslewis.org*; and *cslewis.drzeus.net/bio*.

1898	Born Clive Staples Lewis November 29 in Belfast, Northern Ireland, to Albert and Flora Lewis.
1908	His mother, Flora, died of cancer; his father, Albert, sent "Jack" (as his friends called him) and his brother Warren to boarding school, beginning a long stint of successive boarding schools.
1910–1913	Lost his Christian faith.
1909–1917	Lucretian/Epicurean materialism (materialism and strict empiricism).
1914–1916	Met Arthur Greeves; began private study with W. T. Kirkpatrick.
1917	Entered University College, Oxford; enlisted in the British army during World War I.
1917–1919	Pseudo-Manichean dualism (cosmic forces of Good and Evil in struggle).
1918	Wounded during the Battle of Arras; recuperated in hospital.
1919–1923	Stoical materialism/the "New Look" (realism defined as materialism and strict empiricism).
1919–1924	Resumed studies at Oxford, taking a First in Moderations (Greek and Latin Literature) in 1920, a First in Greats (Philosophy and Ancient History) in 1922, and a First in English in 1923. Tutored by philosopher E. F. Carritt.
1920	Bought his home ("The Kilns") jointly with brother Warren and Mrs. Moore, the mother of his friend Paddy Moore.
1923–1924	Absolute idealism phase (the all-encompassing Absolute is ultimate reality).
1924–1926	Subjective idealism phase (to be is to be perceived, Spirit/Mind projects us).
1924–1925	Served as philosophy tutor at University College while Carritt was on leave.
1925	Appointed Fellow in English Literature at Magdalen College, Oxford; met J. R. R. Tolkien and Hugo Dyson; held this post for twenty-nine years.
1925–1930	Lewis's "Great War" with Barfield regarding whether there are truths accessible to the imagination but not to reason.
1927–1929	Absolute idealism phase (again, but modified); called it "Hegelianism" and "pantheism."
1929	Subjective idealism (again, but with a philosophical, impersonal God).
1930	Lewis's theistic conversion, not 1929 as per his own account.
1931	Lewis's Christian conversion.
1933	*The Pilgrim's Regress* published. Lewis first convened "The Inklings," a group of friends that included J. R. R. Tolkien, Warren Lewis, Hugo Dyson, Charles Williams, Owen Barfield, Nevill Coghill, and others.

1935	Lewis agreed to write a volume on sixteenth-century English literature, which was published in 1954.
1936	*The Allegory of Love: A Study in Medieval Tradition* published, for which Lewis was awarded the Gollancz Memorial Prize for Literature in 1937.
1938	*Out of the Silent Planet*, the first novel in the Space Trilogy, published.
1940	*The Problem of Pain* published.
1941	*The Guardian* published *Screwtape Letters* in weekly installments. Lewis gave four BBC radio talks entitled "Right and Wrong."
1942	Inaugural meeting of the Socratic Club at Oxford on January 26. Lewis gave two sets of BBC radio talks entitled "What Christians Believe" and "Christian Behavior."
1943	*Perelandra*, the second novel in the Space Trilogy, published. Lewis delivered the Riddell Memorial Lectures at the University of Durham, subsequently published as *The Abolition of Man*.
1944	Lewis gave prerecorded BBC radio talks entitled "Beyond Personality." Lewis's BBC radio broadcast talks were eventually published as *Mere Christianity*. Lewis's *The Great Divorce* was published as weekly installments in *The Guardian*.
1945	*That Hideous Strength*, the last novel in the Space Trilogy, published.
1946	Awarded honorary Doctor of Divinity by the University of St. Andrews; passed over for Merton professorship of English Literature at Oxford.
1947	*Miracles* published.
1948	Helen Joy Davidman Gresham converts from Judaism to Christianity largely due to the influence of Lewis's books (later met Lewis in 1952).
1950	*The Lion, the Witch, and the Wardrobe*, first book of *The Chronicles of Narnia*, published.
1951	*Prince Caspian*, second book of *The Chronicles of Narnia*, published.
1952	*The Voyage of the Dawn Treader*, third book in *The Chronicles of Narnia*, published. Lewis met Joy Davidman Gresham for the first time.
1953	*The Silver Chair*, fourth book of *The Chronicles of Narnia*, published. Joy's divorce from William Gresham became final.
1954	Lewis accepted the Chair of Medieval and Renaissance Literature at Cambridge, giving as his Inaugural Lecture "De Descriptione Temporum." Taught his last tutorial at Oxford. *The Horse and His Boy*, fifth book of *The Chronicles of Narnia*, published.
1955	*The Magician's Nephew*, sixth book of *The Chronicles of Narnia*, published. *Surprised by Joy* published.
1956	*The Last Battle*, seventh and final book in *The Chronicles of Narnia*, published, for which Lewis received the Carnegie Medal. *Till We Have Faces* published. On April 23, Lewis was married to Joy in a civil ceremony to extend to her his British citizenship.
1957	On March 21, Lewis was married to Joy in a Christian ceremony in Wingfield Hospital as her death was considered immanent due to breast cancer that had metastasized to her bones.
1958	Joy seemed to experience a remarkable remission of her cancer, allowing her and Lewis to take an enjoyable holiday trip to Ireland. Lewis elected Honorary Fellow of University College, Oxford. *Reflections on the Psalms* published.

1960 Joy's cancer recurred, but she and Lewis were able to vacation in Greece with friends. On July 13, Joy died at the age of forty-five. "Studies in Words" and *The Four Loves* published.

1961 *A Grief Observed* published originally under the pseudonym of N. W. Clerk. *An Experiment in Criticism* published.

1963 On November 22, Lewis died after failing health, including a heart attack and kidney problems. Having earlier resigned his position at Cambridge, he was elected an Honorary Fellow of Magdalene College, Cambridge. (Also, on November 22, President John F. Kennedy was assassinated and author Aldous Huxley died.)

The Lewis–Van Osdall Correspondence

In 1963, Thomas Van Osdall, professor of chemistry at Ashland University, wrote Lewis to seek advice on a book that he wanted to write about the impact of science on culture, and Lewis wrote gracious letters in response. There are five extant letters in all dated in 1963, two by Van Osdall, written on May 27 and October 4, and three by Lewis, written on June 1, October 9, and October 26. Although we do not have the third letter by Van Osdall, Lewis's sympathetic response indicates that Van Osdall must have revealed the tragic loss of his only child, eighteen-year-old Thomas Van Osdall Jr., in a car accident in 1962. Lewis's third letter was one of the last letters he wrote before his own death on November 22, 1963. After Van Osdall's death in 2001, the correspondence was given by the Van Osdall estate to a family friend, Nancy Davis, who donated it to Ashland University in 2015. The Lewis–Van Osdall letters have never before been published and are reproduced here by permission of Ashland University Archives, Ashland University, Ashland, Ohio. Any grammatical infelicities in the correspondence have been preserved in order to be faithful to the original documents.

Letter 1

May 27, 1963

Professor Clive S. Lewis
Cambridge University
Cambridge, England

Dear Professor Lewis:

I do hope you will not consider me too presumptuous in addressing a letter to you. I seek your consideration and advice should you judge my letter worthy of your attention.

As a teacher of science, I am attempting to write an Introduction to Science which will point out the historical and philosophical place of science in man's total culture. It is my belief that a presentation of this kind may serve a very useful purpose in the liberal arts program of our colleges here in America.

The syllabus is based on the concept of mathematics as the language of science, this leading into the methods of science as related to the physical and the biological fields of study. I should like to follow this with a carefully developed presentation of the application of these principles to man's sociological and psychological environment.

Can I continue from here and show that "religion without science is blind and that science without religion is lame?" And, as Einstein has also said, "God does not play dice with the world." Some of my colleagues would discourage me from attempting to integrate these basic philosophies.

Your books have been a great help and inspiration to me. In the book, *Miracles*, you develop the idea that, "Men became scientific because they expected Law in nature, and they expected Law in Nature because they believed in a Legislator. Two significant developments have already appeared—the hypothesis of a lawless sub-nature, and the surrender of the claim that science is true."

Is your concern, at this point, with the problems of uncertainty, wave and particle dilemma, probability and free will?

In your considered opinion, will I run into trouble in attempting this fusion of ideas as a culminating point in my thesis?

I should like to quote quite heavily from your many books with your permission and that of the publishers.

Should you find it possible to comment on my questions, I shall be most grateful.

Yours sincerely,

Thomas C. Van Osdall
Professor of Chemistry

Letter 2

1 June, 1963

Dear Professor Van Osdall,

I am flattered that you should wish to use my rather amateurish remarks for your purposes, and of course you have my fullest permission to do so.

Warning: The paperback (Fontana) eds *Miracles* is to be regarded as the first text. In the earlier hardback, eds, I made a mess of one argument.

The statement that men first looked for law in Nature because they believed in a legislator is based, as you probably know on Whitehead.

When I spoke about the hypothesis of a lawless "subnature" I certainly had in mind "uncertainty wave—and particle dilemma," not Free Will. Random variability, and mechanical necessity, seem to me both equally—as it were, from opposite sides—the opposites of what we mean by freedom. I was not thinking about probability as understood in ordinary (neither mathematical nor philosophical) discourse.

That seems to me a characteristic not of the object or event we are studying but of the state at the moment of our knowledge

Of course you'll "run into trouble" but so you will, surely, in any work worth writing.

Yours sincerely,
C. S. Lewis

Letter 3

Oct. 4, 1963

Professor C. S. Lewis
Magdalene College
Cambridge University
Cambridge, England.

Dear Professor Lewis:

I sincerely appreciate your letter of 1 June 1963 in answer to questions concerning the book in which I am attempting to develop a summary of the principles of science and to relate these to the role of science in man's total culture.

I want to use the book as a part of a liberal arts program which will present science historically and philosophically beginning with the Greek science and leading to the seventeenth century, which Whitehead terms the century of genius. Using this background, I will then trace the problems of science to the present. I should like it to be more than a history or philosophy of science but, in addition to these, to also present a rigorous approach to the methods of science as they have been of value to all aspects of scientific endeavor.

Can it be that science and theology are actually traveling the same road and that someday both will meet at Chardin's Omega point? We can't have religion for our God any more than we can have science. We are faced, as you say, with the lawless sub-nature of science.

But, I must accept the miracles as the supreme example of God's gift and science must be made to accept the logic of this choice.

I have a sabbatical leave coming next year. If I were to enroll at Cambridge for part of this time, might I enlist your guidance, counsel, and criticism of my work? I do need your help in this task which has presented so many frustrating situations.

Were this to be possible for you to consider, I should like to initiate immediate action, both at our college and at Cambridge, for the coming year.

Your advice and comments will be most appreciated.

Yours sincerely,

Thomas C. Van Osdall
Professor of Chemistry

Letter 4

9 Oct 63

The Kilns, Headington Quarry

Oxford

Dear Professor Van Osdall,

Since I wrote to you my life has undergone a great change.

I nearly died in July and I have now resigned all my appointments and live on one floor of this house as an invalid. This doesn't prevent my being cheerful or comfortable but it may prevent my being of any use to you.

With hearty good wishes to you in your project.

Yours sincerely,

C. S. Lewis

Letter 5

26 Oct 63

<div align="right">

The Kilns
Headington Quarry
Oxford

</div>

Dear Mr. Van Osdall,

Thank you for your letter. You tell a most moving story. I too have lost what I most loved. Indeed unless we die young ourselves, we mostly do. We must die before them or see them die before us. And when we wish—and how agonizingly we do o how perpetually!—it is entirely for ourselves for our sakes not theirs.

I am very glad to hear of the work you propose to do. We need more of that kind. Not mind you, that I find real scientists (of which naturally I meet many) are usually our opponents. It is not the sciences but the popular "scientism" in the newspapers or literary (writer) that is really against us.

I am well supplied with reading matter, thanks, so don't send me anything. But by all means come and see me if you are in England.

<div align="right">

Yours sincerely,
C. S. Lewis

</div>

Glossary

Absolute idealism The philosophy that reality is one whole (often termed the Absolute) and is of the nature of Mind or Idea.

Antecedent probability Probability calculated or estimated that a certain event would occur on the assumption that some hypothesis is true.

Anti-realism Metaphysical version holds that objects of inquiry or supposed knowledge do not exist independently of the human mind. Epistemological version holds that the human mind contributes either the existence or structure of objects of knowledge.

Atheism (positive and negative) The outright denial that there is a god or the refusal to affirm that there is a god.

Classical Orthodox Christianity (orthodoxy) The framework of common or ecumenical beliefs endorsed by the Seven Great Councils of the early Christian centuries.

Coherence (logical) The relation among of beliefs that are not merely consistent (not inconsistent) but hang together by natural conceptual connections.

Compatibilism (compatibilist) In metaphysics, the view that free will is compatible with being determined.

Consequentialism Metaethical view that actions or rules are morally right or wrong based on their consequences.

Contradiction The logical relation obtaining between propositions such that if one is true the other must be false and vice versa. (See also *Law of Noncontradiction*.)

Cosmic dualism In religion, the doctrine that the cosmos is the context of a conflict between two opposite ultimate beings or principles, Good and Evil, Order and Chaos, and the like.

Darwinism The classical biological view advanced by Darwin that the mechanism of evolution is by natural selection but used in contemporary discussions to denote philosophical naturalism combined with evolution.

Deep Heaven (High Mountains) Imagery for the full presence of God.

Defeater In contemporary epistemology, a belief that, if accepted, makes it irrational to accept another belief that is in question.

Deontological ethics Metaethical view that actions or rules are morally right or wrong based on inner motivation.

Design argument One type of teleological argument that reasons that the order of the world requires an intelligent being to design using the analogy that artifacts of intelligent design (e.g., a watch) require an intelligent designer (e.g., a watchmaker).

Determinism The view that every event is caused to happen, by either some physical cause or divine causality, such that there is no genuine contingency in the world or nondetermined human free will.

Dualism In philosophy of mind, the metaphysical view that mind (soul) and body are distinct and separable substances.

Empiricism The epistemological view that knowledge comes only through sensory experience.

Enlightenment (the) An intellectual and cultural movement in Europe during the seventeenth and eighteen centuries, emphasizing the sufficiency of human rationality.

Epicureanism A version of hedonistic ethics which teaches that tranquil pleasures are preferable to intense pleasures because they tend to produce a long-term balanced life.

Epiphenomenon (epiphenomenalism) Mind and aspects of consciousness are considered merely as by-products of a physical entity and its activities.

Epistemology (epistemological, epistemic) The branch of philosophy dealing with belief and knowledge in terms of their ground, justification, and structure.

Eschatology The area of theology pertaining to the ultimate culmination of history and fulfillment of God's plans for creation and humanity.

Ethics The branch of philosophy that is concerned with right and wrong, good and bad, character and virtue.

Everlasting (everlastingness) Existing at every moment of time, having neither a beginning nor an ending. (Contrasts with *timeless*.)

Evolution In biology, the change in heritable traits of biological populations over successive generations, giving rise to diversity in individuals and among species.

Existential Having to do with the meaning of personal existence and the deep concern for personal meaning.

Fideism The view that religious faith and beliefs are immune to critical evaluation.

Forms (Ideas) From Plato, abstract ideas that exist apart from any mind and are the most fundamental kind of reality as opposed to the changing material realm.

Great War Historically, World War I (in which Lewis participated); also the friendly, multiyear debate between Lewis and Barfield over whether there are truths accessible by imagination but not by reason.

Hedonism (hedonist) The ethical view that the goal of morality is pleasure, which then admits of various definitions.

Homunculus (homunculize, dehomunculize) An abstract, inferred inner person in contrast to the real person.

Humanism The philosophical perspective that human life, thought, activity, and achievement are valuable; occurs in both secular and religious forms.

Idealism The philosophical view that mind or idea is more fundamental in the order of reality and that matter is either less important, less real, or unreal. (See also *absolute idealism* and *subjective idealism*.)

Imago Dei The theological term meaning "God's Image," which labels the view that humans reflect or resemble God in certain important ways, usually in regard to rationality, morality, personhood, and will.

Impassibility (of God) The view that God cannot be affected by human beings or other creatures.

Incarnation (incarnational) The Christian doctrine that God in the Second Person of the Trinity became one with the first-century person of Jesus.

Incompatibilism (incompatibilist) In metaphysics, the view that free will is incompatible with being determined. (Often called *libertarianism*.)

Inconsistency (inconsistent) The logical relation obtained between two or more propositions when they cannot all be true together.

Indeterminism The view that *determinism* is false, that there are some events that are not determined to occur as they do by anything in the past.

Joy Lewis's technical term for poignant desire or longing for "something"—such as meaning or fulfillment—beyond this world.

Law of (Human) Nature Moral law, rooted in our common human nature, that we can choose to obey or not. Distinct from a law of nature understood as a *scientific* (or *physical*) law.

Law of Noncontradiction The necessary principle of logic that a proposition and its denial cannot both be true simultaneously.

Libertarianism (libertarian) In metaphysics, the view that determinism is false and that free will is incompatible with being determined. (Often called *incompatibilism*.)

Materialism The philosophical view that everything that exists is material or physical in nature.

Mechanistic explanation The type of explanation that cites a physical cause or causes as bringing about the phenomenon in question. (Contrast with *teleological explanation*.)

Mentalistic philosophy A view of reality that gives mind or ideas fundamental, not derivative, status.

Mere Christianity C. S. Lewis's term for Christianity in its pure form unmixed with denominational preferences. (See *Classical Orthodox Christianity*.)

Metaethics The second-order discipline studying the grounds of ethical obligation, the structure of ethical arguments and reasons, and the meaning of ethical terms.

Metaphysics (metaphysical) The branch of philosophy dealing with the nature and structure of reality. (See also *ontology*.)

Methodological naturalism The philosophical position that science seeks natural causes for natural phenomena and cannot consider supernatural causes.

Middle knowledge (Molinism) The theory that God knows what free creatures would do in all possible circumstances.

Miracle Classically, a violation of a law of (physical) nature brought about by a supernatural being or force that otherwise would not have occurred.

Monism (monistic) The philosophy that reality is one neutral substance and that mind and matter are aspects or modalities of that substance.

Moral argument An argument for God's existence from the existence of an objective moral law.

Myth (mythology) Classically understood as a symbolic story containing important truths or themes, not a fraudulent story or outright falsehood.

Natural law Classically, the moral law, the law of our human moral nature; in modernity, can also mean *scientific* (or *physical*) *law*.

Natural law ethics An ethical theory emphasizing the basic moral principles which God has made inherent to human nature to reflect his own nature.

Naturalism (metaphysical) The philosophical view that only physical nature is real and there is no supernatural. (Often associated with materialism.)

Nihilism The view that nothing exists or has value.

Ockhamist (Ockhamism) The position taken by William of Ockham that God's will alone makes moral principles right. (See also *theological voluntarism*.)

Omnipotence (omnipotent) The attribute of God of having all of the power it is possible for God to have.

Omniscience (omniscient) The attribute of God of having all of the knowledge that it is possible for God to have.

Ontological proof An argument for the existence of God that begins with the idea of the most perfect being and concludes that this being necessarily exists.

Ontology (ontological) The branch of philosophy, often associated with metaphysics, that deals with what has being or what kinds of things have being.

Pantheism The view that the divine is not a unique personal being but an all-encompassing reality that includes all beings within itself.

Philosophia perennis The permanently true philosophy representing the enduring wisdom of the human race.

Platonism The philosophy of Plato, particularly its dualistic theory that Ideas are distinct from material objects.

Primary qualities Qualities or properties belonging to a material object independent of an observer. (See also *secondary qualities*.)

Problem of evil The philosophical argument to the effect that belief in God is false, improbable, or implausible in light of evil. Frequently divided into logical and evidential types of argument.

Providence God's wise guidance of the world; opinions vary regarding ideas of general or specific providential activity.

Quantum mechanics A major branch of physics that describes physical phenomena at the quantum level, atomic and subatomic.

Rationalism The philosophy that either the content or the form of knowledge is produced by the mind.

Realism Metaphysically or ontologically, the philosophical view that there is a real objective world that is not created by our minds; epistemologically, the view that we have cognitive powers that reliably know this world. Can be specific to domains of inquiry (science, theology, ethics, and so forth).

Reductionism (reductionist) Methodologically, the procedure of describing a complex phenomenon in terms of simpler or constituent parts; metaphysically, the view some phenomenon is merely the combination of its parts.

Relativism In ethics, the view that there is no universal, objective standard of moral conduct. In epistemology, the view that there is no objective truth.

Resurrection Centrally, in Christian theology, the unique miraculous event of the coming back to life of Jesus Christ three days after having been put to death by crucifixion. Derivatively, an event at the end of time when God restores dead finite persons to life.

Sacrament (sacramental) A common item considered as a tangible symbol of invisible divine grace.

Scientific law A general statement that a given cause brings about a certain effect under specified initial conditions. (Another meaning for *law of nature.*)

Scientism The representation of science as the paragon and exclusive form of knowledge, usually with implicit or explicit naturalist philosophical commitments.

Secondary qualities Qualities or properties attributed to a material object that are due to the subjective response of a perceiver. (See also *primary qualities.*)

Sensus divinitatis Literally, "sense of the divine" or "sense of God," which some views hold that humans possess.

Simple foreknowledge The view that God has complete and precise knowledge of the actual future, but not hypothetical knowledge concerning choices that persons would make under circumstances that never actually occur.

Skepticism (skeptic) The anti-realist view, usually in epistemology but sometimes in moral theory, that we cannot know certain claims to be true, either because of the subject matter being beyond us or because our powers of knowing have deficiencies.

Social Darwinism The philosophy of society, promulgated by Herbert Spencer and others, that the concepts of natural selection and survival of the fittest in biology can be applied to sociology, economics, and political theory in terms of a universal law of progress.

Solipsism The belief that only oneself exists and that there are no other selves or minds.

Stoic (stoicism, stoical) Term that reflects the Stoic philosophy recommending detachment and tranquility in the face of changing circumstances.

Stoical monism Lewis's philosophical combination of stark materialism with a Stoic outlook.

Subjective idealism The metaphysical view that only minds and their contents exist (associated with immaterialism).

Tao **(the)** Chinese term referring to "The Way" of moral action and life in general.

Teleological argument An argument for God's existence that attempts to explain the significant means-ends order or apparent goal orientation in the world.

Teleological explanation A type of explanation that refers to a purpose or intended end state, generally as the intention of an intelligent being. (Contrast with *mechanistic explanation.*)

Teleology The quality of being end directed or goal directed, either inherently or by direction of another.

Theism The belief in an omnipotent, omniscient, wholly good God (derivative of monotheism).

Theistic evolution The view that evolution can be combined with a theistic perspective.

Theodicy An explanation (involving one or more themes) regarding the reasons (or possible reasons) why God allows evil and suffering.

Theological determinism The belief that everything whatsoever that occurs is predetermined to occur by divine decision.

Theological voluntarism In meta-ethics, the view that God's will determines what is morally right or wrong.

Theology The intellectual discipline of formulating and systematizing knowledge of God, generally utilizing sources such as scripture and tradition.

Timeless Not existing in time, having neither duration nor temporal location. (Often used in contrast to *everlastingness.*)

Transcendence The characteristic of the divine being that it is distinct from and other than everything else in the created world.

Transposition (theory of) Lewis's idea that a richer system (with more elements) can be represented in a poorer system (with fewer elements), or that the poorer (lower) system can be "taken up into" the richer (higher) system.

Utilitarianism The ethical theory that the rightness of actions or rules is determined by their utility for the greatest number of people; a form of *consequentialism.*

Worldview A comprehensive, unified philosophical explanation of all major phenomena of life and the world—morality, rationality, personhood, and so forth.

Notes

Introduction

1. "Don v. Devil," *Time*, September 8, 1947, 67.
2. Chad Walsh, "Impact on America," in *Light on C. S. Lewis*, ed. Jocelyn Gibb (New York: Harcourt, Brace & World, 1966), 106.
3. Victor Reppert, *C. S. Lewis's Dangerous Idea* (Downers Grove: InterVarsity Press, 2003), 12.

Chapter 1

1. George Mavrodes, *Belief in God: A Study in the Epistemology of Religion* (New York: Random House, 1970), 86.
2. William P. Alston, "Philosophy of Religion, Problems of," in *The Encyclopedia of Philosophy*, ed. Paul Edwards (New York: Macmillan and The Free Press, 1967), 6:286.
3. William P. Alston, *A Realist Conception of Truth* (Ithaca, NY: Cornell University Press, 1996).
4. Alister McGrath, *C. S. Lewis, A Life: Eccentric Genius, Reluctant Prophet* (Carol Stream, UK: Tyndale House, 2013), 168, Kindle.
5. *FL* 137; "Christian Apologetics," *GID* 91. (Please see the preliminary pages of this volume for a list of abbreviations of Lewis's works.)
6. *SBJ* 249.
7. *SBJ* 263.
8. *SBJ* 260.
9. Letter to Owen Barfield, February 3, 1930 (*CLI* 882).
10. *SBJ* 266.
11. Andrew Lazo, "Correcting the Chronology: Some Implications of 'Early Prose Joy,'" *Seven: An Anglo-American Literary Review* 29 (2012): 51–62; McGrath, *C. S. Lewis, A Life*, 139–146.
12. Letter to Arthur Greeves, October 29, 1930 (*CLI* 942); *SBJ* 271.
13. Letter to Arthur Greeves, October 18, 1931 (*CLI* 976–977).
14. *SBJ* 275; W. H. Lewis, "Memoir of C. S. Lewis," in *Letters of C. S. Lewis*, ed. W. H. Lewis, rev. ed. (San Diego: Harcourt, 1993), 39; *Brothers and Friends: The Diaries of Major Warren Hamilton Lewis*, ed. Clyde S. Kilby and Marjorie Lamp Mead (San Francisco: Harper & Row, 1982), 86.
15. Letter to Arthur Greeves, October 1, 1931 (*CLI* 974).
16. *SBJ* 257.
17. *SBJ* 257.

18. *MC* preface.
19. *MC* preface.
20. St. Vincent of Lérins, *Commonitorium*, 2.6.
21. Thomas C. Oden, *Classic Christianity* (New York: HarperCollins e-books, 2009), xiii, Kindle.
22. Thomas C. Oden, *After Modernity . . . What?: Agenda for Theology* (Grand Rapids, MI: Zondervan, 1992), 117.
23. *MC* preface.
24. *MC* 165.
25. Adam Barkman, *C. S. Lewis and Philosophy as a Way of Life* (Allentown, PA: Zossima Press, 2009), 237.
26. Michael Ward, *Planet Narnia: The Seven Heavens in the Imagination of C. S. Lewis* (Oxford: Oxford University Press, 2008).
27. *LB* 160.
28. "Dogma and the Universe," *GID* 34; see also *M* 111–115.
29. Peter J. Schakel, *Imagination and the Arts in C. S. Lewis* (Columbia: University of Missouri Press, 2002), 114.
30. *EL* 4.
31. Plato, *Republic*, 296a.
32. "The Weight of Glory," *WG* 31.
33. *LB* 161.
34. Mary Carman Rose, "The Christian Platonism of C. S. Lewis, J. R. R. Tolkien, and Charles Williams," in *Neoplatonism and Christian Thought*, ed. Dominic J. O'Meara, 203–212 (Norfolk, VA: International Society for Neoplatonic Studies, 1992).
35. *GID* preface.
36. *SC* 6–7.
37. *SC* 18–19.
38. Mark 12:30.
39. "Cross-Examination," *GID* 292.
40. "Learning in War-Time," *WG* 55–57.
41. "Learning in War-Time," *WG* 56.
42. Frederick Buechner, *Wishful Thinking: A Theological ABC* (New York: Harper One, 1973), 95.
43. *LWW* 86.
44. Letter to Mary Willis Shelburne, March 19, 1956 (*CLIII* 720).
45. Devin Brown, "C. S. Lewis on Vocation: The Integration of Faith and Occupation," in *Past Watchful Dragons: Fantasy and Faith in the World of C. S. Lewis*, ed. Amy H. Sturgis, 139–152 (Altadena, CA: Mythopoeic Press, 2007), 142.
46. Brown, "C. S. Lewis on Vocation," 142.

Chapter 2

1. Letter to Arthur Greeves, October 12, 1916 (*CLI* 230–231).

2. Letter to Eric Fen (BBC), April 12, 1943 (*CLII* 568); Letter to the Editor of *The Listener*, March 9, 1944 (*CLII* 605).

3. David C. Downing, *The Most Reluctant Convert* (Downers Grove, IL: InterVarsity Press, 2002), 15.

4. Letter to Paul Elmer More, October 25, 1934 (*CLII* 145).

5. *PR* 200.

6. *PR* 205.

7. C. S. Peirce, "Pragmatism and Abduction" (1903), in *Collected Papers of Charles Sanders Peirce*, ed. Charles Hartshorne and Paul Weiss (Cambridge, MA: Belknap Press, 1974), 5:189.

8. *SBJ* 133.

9. Kai Nielsen, *Naturalism and Religion* (Amherst, MA: Prometheus Books, 2001), 29.

10. John R. Searle, *Mind: A Brief Introduction* (Oxford: Oxford University Press, 2004), 48.

11. *PR* 200.

12. *SBJ* 243.

13. *SBJ* 238.

14. *SBJ* 238; Bertrand Russell, "A Free Man's Worship" (1903), in *Why I Am Not a Christian and Other Essays on Religion and Related Subjects*, ed. Paul Edwards, 104–116 (New York: A Touchstone Book, 1957).

15. Russell, "A Free Man's Worship," 110.

16. Russell, "A Free Man's Worship," 107.

17. *SBJ* 239.

18. *SBJ* 242.

19. *SBJ* 243.

20. *SBJ* 243.

21. Downing, *The Most Reluctant Convert*, 81.

22. *SBJ* 230, 237, 246; Henri Bergson, *Creative Evolution*, trans. Arthur Mitchell (London: Macmillan, 1911).

23. Letter to Arthur Greeves, July 24, 1917 (*CLI* 330–331); cf. George Berkeley, *Principles of Human Knowledge and Three Dialogues* (Oxford: Oxford World's Classics, 1999).

24. Letter to Arthur Greeves, May 29, 1918 (*CLI* 374).

25. Letter to Arthur Greeves, September 12, 1918 (*CLI* 397).

26. Letter to Arthur Greeves, May 23, 1918 (*CLI* 371).

27. Adam Barkman, *C. S. Lewis and Philosophy as a Way of Life* (Allentown, PA: Zossima Press, 2009), 30–34.

28. "Good and Evil," *GID* 4.

29. *M* 47.

30. "Good and Evil," *GID* 5.

31. *M* 49.

32. *MC* 42–43.

33. *MC* 43.

34. *MC* 43–44.

35. *MC* 44–45.

36. Erik Wielenberg, *God and the Reach of Reason: C. S. Lewis, David Hume, and Bertrand Russell* (Cambridge: Cambridge University Press, 2008), 72, Kindle.

37. Augustine, *City of God*, 9.9.

38. Aquinas, *De Malo*, 3, 9 ad. 4.

39. *MC* 42–45.

40. Letter to Arthur Greeves, July 24, 1917 (*CLI* 331).

41. Berkeley, *Principles of Human Knowledge and Three Dialogues*.

42. Lionel Adey, *C. S. Lewis's "Great War" with Owen Barfield* (Victoria, BC: ELS Editions, 1978), 73–82.

43. F. H. Bradley, *Appearance and Reality: A Metaphysical Essay* (Oxford: Clarendon Press, 1930), 125.

44. F. H. Bradley, *The Principles of Logic* (London: Oxford University Press, 1928), 2:591.

45. *SBJ* 243.

46. *SBJ* 244.

47. *SBJ* 244.

48. *SBJ* 259.

49. *SBJ* 259–260.

50. Barkman, *C. S. Lewis and Philosophy as a Way of Life*, 47.

51. "The 'Great War' Letters," series I, letter 8, to Owen Barfield, January 1928 (*CLIII* 1646).

52. Barkman, *C. S. Lewis and Philosophy as a Way of Life*, 46ff; *PR* 262ff.

53. *SBJ* 262.

54. *SBJ* 247–248.

55. *SBJ* 207.

56. *SBJ* 248.

57. Euripides, *Hippolytus*, lines 742–751.

58. Devin Brown, *A Life Observed: A Spiritual Biography of C. S. Lewis* (Grand Rapids, MI: Brazos Press, 2013), 129, Kindle.

59. *SBJ* 258.

60. *SBJ* 263.

61. *SBJ* 264.

62. *SBJ* 264.

63. *SBJ* 264.

64. *SBJ* 266.

65. Brown, *A Life Observed*, 125.

66. *SBJ* 267.

67. *SBJ* 269.

68. *SBJ* 269.

69. *SBJ* 260.

70. George Sayer, *Jack: A Life of C. S. Lewis* (Wheaton, IL: Crossway Books, 1994), 222–223.

71. *SBJ* 273.

72. *AMR* 431–432.

73. Alister McGrath, *C. S. Lewis, A Life: Eccentric Genius. Reluctant Prophet* (Carol Stream, UK: Tyndale House, 2013), 149.

74. McGrath, *C. S. Lewis, A Life*, 169.

75. Rolland Hein, *Christian Mythmakers* (Chicago: Cornerstone Press Chicago, 1998).

76. *SBJ* 274.

77. Letter to Arthur Greeves, October 1, 1931 (*CLI* 974).

78. "Is Theology Poetry?" *WG* 141.

Chapter 3

1. *SBJ* 276.

2. *PR* 205–206.

3. Peter Williams, *Lewis vs the New Atheists* (Milton Keynes, UK: Paternoster, 2013), 62–91; Peter Kreeft, *Heaven: The Heart's Deepest Longing* (San Francisco: Ignatius Press, 1980), 201–232; Adam Barkman, *C. S. Lewis and Philosophy as a Way of Life* (Allentown, PA: Zossima Press, 2009), 67–99; John Haldane, "Philosophy, the Restless Heart and the Meaning of Theism," *Ratio* 19, no 4. (December 2006): 429; Arend Smilde, "Horrid Red Herrings: A New Look at the 'Lewisian Argument from Desire'—and Beyond," *Journal of Inkling Studies* 4, no. 1 (April 2014): 37.

4. *SBJ* 89.

5. Barkman, *C. S. Lewis and Philosophy as a Way of Life*, 67–99.

6. Plato, *Phaedrus*, 249e–250e.

7. *SBJ* 201.

8. *PR* 202.

9. *LB* 162.

10. Rudolf Otto, *The Idea of the Holy: An Inquiry into the Non-rational Factor in the Idea of the Divine and Its Relation to the Rational*, trans. John W. Harvey (London: Oxford University Press, 1970), 6–10.

11. "Is Theism Important?" *GID* 189–190.

12. *LWW* 64.

13. *SBJ* 6.

14. "The Weight of Glory," *WG* 30, 43.

15. *SBJ* 18.

16. *LWW* 29.

17. *DI* 94; *GD* 61.

18. *TWHF* 75–76.

19. "The Weight of Glory," *WG* 26ff.

20. *PR* 106.

21. *MC* 134.

22. Devin Brown, *A Life Observed: A Spiritual Biography of C. S. Lewis* (Grand Rapids, MI: Brazos Press, 2013), 5, Kindle.

23. *PP* 150–152.

24. Bertrand Russell, *The Selected Letters of Bertrand Russell: The Public Years, 1914–1970*, ed. Nicholas Griffin (London: Routledge, 2001), letter 279.

25. Augustine, *Confessions*, 1.1.

26. Aquinas, *Summa Theologiæ*, 1a2æ.5.

27. "Religion Without Dogma?" *GID* 137.

28. John Beversluis, *C. S. Lewis and The Search for Rational Religion* (Grand Rapids, MI: Wm. B. Eerdmans, 1985), 8.

29. Peter Kreeft, "C. S. Lewis's Argument from Desire," in *The Riddle of Joy: G. K. Chesterton and C. S. Lewis*, ed. Michael H. Macdonald and Andrew A. Tadie (Grand Rapids, MI: Eerdmans, 1989), 249–272.

30. *MC* 136–137.

31. "The Weight of Glory," *WG* 33–34.

32. *PR* 204–205.

33. Robert Holyer, "The Argument from Desire," *Faith and Philosophy* 5, no. 1 (1988): 61–71.

34. Gregory Bassham, ed. *C. S. Lewis's Christian Apologetics Pro and Con* (Leiden: Brill Rodopi, 2015), 68.

35. Roger Lancelyn Green and Walter Hooper, *C. S. Lewis: A Biography* (New York: Harcourt Brace Javanovich, 1974), 113; see also Andrew Lazo, "Correcting the Chronology: Some Implications of 'Early Prose Joy,'" *Seven: An Anglo-American Literary Review* 29 (2012): 51.

36. John Beversluis, *C. S. Lewis and The Search for Rational Religion*, rev. and updated ed. (New York: Prometheus Books, 2007), 42.

37. *PR* 205.

38. Bassham, *C. S. Lewis's Christian Apologetics Pro and Con*, 51.

39. Beversluis, *C. S. Lewis and The Search for Rational Religion* (2007), 68.

40. Richard L. Purtill, *C. S. Lewis's Case for the Christian Faith* (San Francisco: Harper & Row, 1981), 21.

41. Joe Puckett, *The Apologetics of Joy A Case for the Existence of God from C. S. Lewis's Argument from Desire* (Eugene, OR: Wipf & Stock, 2012), 31–32, Kindle.

42. *PR* 205.

43. Smilde, "Horrid Red Herrings," 58.

44. Smilde, "Horrid Red Herrings," 83.

45. Smilde, "Horrid Red Herrings," 84.

46. Smilde, "Horrid Red Herrings," 40.

47. Alister McGrath, *C. S. Lewis, A Life: Eccentric Genius. Reluctant Prophet* (Carol Stream, UK: Tyndale House, 2013), 224–225, Kindle.

48. Alister McGrath, *The Intellectual World of C. S. Lewis* (Malden, MA: Wiley-Blackwell, 2014), 120, Kindle.

49. *SBJ* 258.

50. *PH* 29–30.

51. Letter to Sheldon Vanauken, December 23, 1950 (*CLIII* 75).

52. *SC* 16–17.

53. *MC* 50.

Chapter 4

1. Letter to the editor of *The Oxford Magazine*, June 13, 1946 (*CLII* 715–716).

2. *M* 56.

3. Daniel Dennett, *Consciousness Explained* (Boston: Little, Brown and Company, 1991), 454.

4. Jerry Fodor, "The Big Idea: Can There Be a Science of Mind?" *Times Literary Supplement* no. 4657 (July 3, 1992): 5.

5. *M* 38.

6. J. B. S. Haldane, *Possible Worlds* (1927; repr., New York: Routledge, Haldane 2017), 209.

7. *M* 18–20.

8. Appendix B, Letter 2.

9. *M* 38.

10. *M* 43.

11. *M* 38.

12. *M* 177.

13. Victor Reppert, *C. S. Lewis's Dangerous Idea* (Downers Grove, IL: InterVarsity Press, 2003), 72.

14. *M* 21–22.

15. *M* 19–20; Bertrand Russell, "The Relation of Sense Data to Physics," in *Mysticism and Logic and Other Essays* (London: Longmans, 1918), 108–131.

16. *M* 18.

17. "Is Theology Poetry?" *WG* 140.

18. A. N. Wilson, *C. S. Lewis: A Biography* (New York: W. W. Norton & Company, 1990), 211–215.

19. Appendix B, Letter 2.

20. Jerry Root, "Dispelling Myths about C. S. Lewis," *The Official Website of C. S. Lewis*, January 11, 2016, http://www.cslewis.com/dispelling-myths-about-c-s-lewis/.

21. *M* 22–23.

22. *M* 27.

23. *M* 27.

24. *M* 27–28.

25. Reppert, *C. S. Lewis's Dangerous Idea*, 101–104.

26. Alvin Plantinga, *Warrant and Proper Function* (Oxford: Oxford University Press, 1993), 197, Kindle; Richard Dawkins, *The Blind Watchmaker* (New York: W. W. Norton & Company, 2006), 9.

27. Plantinga, *Warrant and Proper Function*, 225.

28. Plantinga, *Warrant and Proper Function*, 234.

29. Daniel Dennett and Alvin Plantinga, *Science and Religion: Are They Compatible?* (Oxford: Oxford University Press, 2011), 51–52.

30. *M* 36.

31. Reppert, *C. S. Lewis's Dangerous Idea*, 103.

32. *M* 43.

33. *M* 8–9.

34. *M* 42.
35. *M* 43.
36. *M* 44–45.
37. *M* 91–92.
38. *M* 50–52.
39. *M* 218.
40. *M* 215–216.
41. *M* 173.
42. *M* 174.

Chapter 5

1. *MC* 23.
2. *MC* 23, 29.
3. Robert Holyer, "C. S. Lewis: The Rationalist?" *Christian Scholar's Review* 18, no. 2 (1988): 148–167.
4. *MC* 3.
5. *MC* 4.
6. *M* 54.
7. *M* 53–54.
8. J. L. Mackie, *Ethics: Inventing Right and Wrong* (New York: Penguin Books, 1977), 48–49.
9. *MC* 5–6.
10. *MC* 10.
11. *MC* 10–11.
12. Charles Darwin, *The Descent of Man*, 2nd ed. (Chicago: Thompson & Thomas, 1874), 113.
13. Darwin, *The Descent of Man, and Selection in Relation to Sex*, 112–115.
14. "De Futilitate," *CR* 82.
15. *MC* 13–14.
16. *MC* 8.
17. *MC* 24.
18. *MC* 24.
19. Erik Wielenberg, *God and the Reach of Reason: C. S. Lewis, David Hume, and Bertrand Russell* (Cambridge: Cambridge University Press, 2008), 63, Kindle.
20. *MC* 29.
21. *MC* 26, 36, 43.
22. *MC* 21–22.
23. *MC* 22.
24. Adam Barkman, "Negative Happiness," *Kritike: An Online Journal of Philosophy* 3, no. 1 (June 2009): 72–77, https://doi.org/10.25138/3.1.a.6.
25. *SBJ* 132–133.
26. *SBJ* 265.

27. Letter to Arthur Greeves, June 3, 1918 (*CLI* 379).

28. *MC* 19.

29. *VDT* 150.

30. *MC* 76–81.

31. *MC* 79–80.

32. Aristotle, *Nicomachean Ethics*, 1098a.

33. *PP* 99.

34. Steward Goetz, *A Philosophical Walking Tour with C. S. Lewis: Why It Did Not Include Rome* (New York: Bloomsbury, 2015), 35–38, Kindle; Adam Barkman, *C. S. Lewis and Philosophy as a Way of Life* (Allentown, PA: Zossima Press, 2009), 395ff.

35. "Hedonics," *PCE* 54–55.

36. *MC* 71–72.

37. *MC* 79–80.

38. *MC* 81.

39. Aquinas, *Summa Theologiæ*, 1a2æ.1.4 and 1a2æ.1.8.

40. Aquinas, *Summa Theologiæ*, 1a.61.1.

41. *MC* 74.

42. Letter to Canon Oliver Chase Quick, January 18, 1941 (*CLII* 464).

43. *AOM* 19.

44. *AOM* 44–45.

45. *AOM* 75–76.

46. *DI* 153.

47. *AOM* 37.

48. *AOM* 73–76, 80–81.

49. *AOM* 20.

50. *MC* 47–50; *PP* 64–86.

51. Mark D. Linville, "The Moral Argument," in *The Blackwell Companion to Natural Theology*, ed. William Lane Craig and J. P. Moreland (Malden, MA: Wiley-Blackwell, 2012), 444–445.

52. Plato, *Euthyphro*, 10a.

53. Plato, *Euthyphro*, 11a–b.

54. "The Poison of Subjectivism," *CR* 98.

55. *PP* 100.

56. "The Poison of Subjectivism," *CR* 98.

57. Louise Antony, "The Failure of Moral Arguments," in *Debating Christian Theism*, ed. J. P. Moreland, Chad Meister, and Khaldoun A. Sweis (Oxford: Oxford University Press, 2013), 110–111, Kindle.

58. See Michael L. Peterson, "A Theological Evaluation of Evolutionary Ethics," in *The Cambridge Handbook on Evolutionary Ethics*, ed. Michael Ruse and Robert J. Richards (Cambridge: Cambridge University Press, 2017), 273–288.

59. "The Poison of Subjectivism," *CR* 98.

60. *PP* 100.

61. Aquinas, *Summa Theologiæ*, 1.2.93.

62. David Baggett and Erik Wielenberg, "The Moral Argument," in *C. S. Lewis's Christian Apologetics Pro and Con*, ed. Gregory Bassham (Leiden: Brill Rodopi, 2015), 121–169.

63. Psalms 136; Proverbs 8:22–31; Jeremiah 10:12.

64. John 1.

65. Letter to Clyde S. Kilby, January 11, 1961 (*CLIII* 1227).

66. "The Poison of Subjectivism," *CR* 99.

67. Letter to Clyde S. Kilby, January 11, 1961 (*CLIII* 1226–1227).

68. *GMA* xxxviii–xxxix.

69. *FL* 1–9.

70. "On Ethics," *CR* 55.

71. "Man or Rabbit?" *GID* 113.

72. "The Novels of Charles Williams," *OS* 27.

73. *MC* 31.

74. J. Budziszewski, *What We Can't Not Know: A Guide* (Dallas, TX: Spence, 2003), 234.

75. *MC* 31–32.

Chapter 6

1. *M* 173.

2. Henry Bettenson and Chris Maunder, eds., *Documents of the Christian Church*, 4th ed. (Oxford: Oxford University Press, 2011), 27.

3. *MC* 157.

4. *MC* 173–174.

5. Colossians 1:16–17.

6. Bettenson and Maunder, *Documents of the Christian Church*, 27–28.

7. Bettenson and Maunder, *Documents of the Christian Church*, 54.

8. *MC* 179.

9. Anselm, *Why God Became Man*.

10. Athanasius, *On the Incarnation of the Word of God*, 1.3.

11. *PP* 81.

12. *LB* 132–133.

13. *LWW* 66.

14. *MN* 103.

15. *MN* 105.

16. *CLII* 632.

17. *SL* 36–37; David G. Clark, *C. S. Lewis: A Guide to His Theology* (Malden, MA: Blackwell Clark, 2007), 85.

18. *PP* 77.

19. Claude Tresmontant, *Christian Metaphysics*, trans. Gerard Slevin (New York: Seed and Ward, 1965), 85.

20. J. R. R. Tolkien, *Tolkien on Fairy-Stories*, expanded edition, ed. Verlyn Flieger and Douglas A. Anderson (London: HarperCollins, 2008), 78.

21. Letter to Arthur Greeves, October 18, 1931 (*CLI* 977).

22. Joseph Pearce, *C. S. Lewis and the Catholic Church* (San Francisco: Ignatius Press, 2003), 38.

23. James George Frazer, *The Golden Bough: A Study in Magic and Religion*, 12 vols. (1976; repr., London: The Macmillan Press, 1890).

24. Joseph Campbell, *The Hero with a Thousand Faces*, 2nd ed. (Princeton, NJ: Princeton University Press, 1968).

25. James Menzies, *True Myth: C. S. Lewis and Joseph Campbell on the Veracity of Christianity* (Eugene, OR: Wipf and Stock, 2014), 102–119, Kindle.

26. Humphrey Carpenter, *The Inklings* (London: George Allen and Unwin, 1978), 44.

27. Pearce, *C. S. Lewis and the Catholic Church*, 38–39; cf. "Myth Became Fact," *GID* 58.

28. Letter to Arthur Greeves, October 18, 1931 (*CLI* 977).

29. "Myth Became Fact," *GID* 59.

30. *M* 180.

31. *SBJ* 274.

32. "What Are We to Make of Jesus Christ?" *GID* 169.

33. *M* 274.

34. Letter to Mrs. Hook, December 29, 1958 (*CLIII* 1004).

35. Albert Schweitzer, *The Quest of the Historical Jesus* (1906; repr., London: SCM Press, 2000).

36. Rudolf Bultmann, *New Testament and Mythology and Other Basic Writings*, trans. Schubert M. Ogden (Philadelphia: Fortress, 1984), 3.

37. "Modern Theology and Biblical Criticism," *CR* 189.

38. Robert W. Funk, Roy W. Hoover, and The Jesus Seminar, *The Five Gospels: What Did Jesus Really Say?* (San Francisco: HarperSanFrancisco, 1993); Robert W. Funk and The Jesus Seminar, *The Acts of Jesus: What Did Jesus Really Do?* (San Francisco: HarperSanFrancisco, 1998).

39. Marcus Borg, *Meeting Jesus Again for the First Time: The Historical Jesus and the Heart of Contemporary Faith* (New York: HarperOne, 1995), 119.

40. C. H. Dodd, *History and Gospel* (London: Nisbet & Co., 1938); *The Founder of Christianity* (London: Macmillan, 1970); N. T. Wright, *Jesus and the Victory of God* (Minneapolis, MN: Fortress Press, 1996).

41. Marcus Borg and N. T. Wright, *The Meaning of Jesus: Two Visions* (New York: HarperCollins e-books, 2009), Kindle.

42. R. G. Collingwood, *The Idea of History* (1946; repr., Oxford: Oxford University Press, 2005).

43. Letter to Clyde S. Kilby, July 5, 1959 (*CLIII* 1046).

44. Letter to Corbin Scott Carnell, March 5, 1953 (*CLIII* 319).

45. "What Are We to Make of Jesus Christ?" *GID* 169.

46. "Modern Theology and Biblical Criticism," *CR* 191.

47. *ROP* 54.

48. *ROP* 54.

49. Philip Schaff, ed., *Creeds of Christendom* (Grand Rapids, MI: Baker Book House, 1919), 2:69.

50. *ROP* 56.

51. *LYC* vi–vii.

52. *ROP* 53–54.

53. Letter to Mrs. Johnson, November 8, 1952 (*CLIII* 246).

54. *ROP* 54.

55. "Transposition," *WG* 105.

56. *MC* 52.

57. *MC* 52–53.

58. Letter to Owen Barfield, August 1939 (*CLII* 269).

59. Christopher Hitchens, *God Is Not Great: How Religion Poisons Everything* (New York: Twelve, 2009), 120.

60. John Beversluis, *C. S. Lewis and The Search for Rational Religion*, revised and updated ed. (New York: Prometheus Books, 2007), 137.

61. Adam Barkman, "Con: Lewis's Trilemma: Case Not Proven," in *C. S. Lewis's Christian Apologetics Pro and Con*, ed. Gregory Bassham (Leiden: Brill Rodopi, 2015), 191.

62. Barkman, "Con: Lewis's Trilemma," 192.

63. See *PP* 14; "What Are We to Make of Jesus," *GID* 166–171, "Rejoinder to Dr Pittenger," 192–199.

64. John 10:20; Mark 3:21.

65. Jim Perry, "The Trilemma: Lord, Liar or Lunatic?" The Secular Web, 1995, https://infidels.org/library/modern/jim_perry/trilemma.html.

66. Quentin O. Hyder, "On the Mental Health of Jesus Christ," *Journal of Psychology and Theology* 5, no. 1 (Winter 1977): 8–9.

67. Hyder, "On the Mental Health of Jesus Christ," 9.

68. Daniel Howard-Snyder, "Was Jesus Mad, Bad, or God? . . . Or Merely Mistaken?" *Faith and Philosophy* 21, no. 4 (October 2004): 456–479.

69. Peter Kreeft and Ronald Tacelli, *Handbook of Christian Apologetics* (Downers Grove, IL: InterVarsity Press, 1982), 159.

70. Howard-Snyder, "Was Jesus Mad, Bad, or God?" 463.

71. Howard-Snyder, "Was Jesus Mad, Bad, or God?" 475–477.

72. Howard-Snyder, "Was Jesus Mad, Bad, or God?" 458–462.

73. Howard-Snyder, "Was Jesus Mad, Bad, or God?" 462.

74. Stephen T. Davis, "The Mad/Bad/God Trilemma: A Reply to Daniel Howard-Snyder," *Faith and Philosophy* 21, no. 4 (October 2004): 483; also see Davis, "Was Jesus Mad, Bad, or God?" in *The Incarnation: An Interdisciplinary Symposium on the Incarnation of the Son of God*, ed. Stephen T. Davis, Daniel Kendall, and Gerald Collins (Oxford: Oxford University Press, 2002), 221–245.

75. Davis, "The Mad/Bad/God Trilemma," 487.

76. *MC* 51.

77. *M* 174.

78. *MC* 51–56.

79. *MC* 56–57.

80. *MC* 57.

81. *MC* 58.

82. Gregory of Nazianzus, *Epistles*, 101.

83. *MC* 54.

Chapter 7

1. Viktor Frankl, *Man's Search for Meaning* (New York: Simon and Shuster, 1985), 129.
2. Aristotle, *Nicomachean Ethics*, 1095b.
3. Paul Tournier, *The Meaning of Persons*, trans. E. Hudson (New York: Harper & Row, 1957).
4. Lewis cited in Walter Hooper, *C. S. Lewis: A Complete Guide to His Life and Work* (San Francisco: HarperSanFrancisco, 1996), 252.
5. *TWHF* 294.
6. *PP* 71.
7. *PP* 71.
8. *MC* 142.
9. *PP* 62.
10. "The Poison of Subjectivism," *CR* 97.
11. *PP* 61.
12. *PP* 76–77.
13. Henri Frankfort, H. A. Frankfort, John A. Wilson, Thorkild Jacobsen, and William A. Irwin, *The Intellectual Adventure of Ancient Man: An Essay of Speculative Thought in the Ancient Near East* (1946; repr., Chicago: University of Chicago, 1977).
14. *PP* 44.
15. H. P. Owen, *Christian Theism* (Edinburgh: T & T Clark, 1984), 65.
16. *Catechism of the Catholic Church* (Vatican City: Libreria Editrice Vaticana, 1994), 7.
17. *MN* 100ff.
18. J. R. R. Tolkien, *The Silmarillion*, ed. Christopher Tolkien (New York: Houghton Mifflin Harcourt, 2012), 3–4, Kindle.
19. *MC* 174.
20. Henry Bettenson and Chris Maunder, eds., *Documents of the Christian Church*, 4th ed. (Oxford: Oxford University Press, 2011), 28.
21. Philip Schaff, ed., *Creeds of Christendom* (Grand Rapids, MI: Baker Book House, 1919), 2:66.
22. Michael Durrant, *Theology and Intelligibility* (London: Routledge and Kegan Paul, 1973).
23. *PP* 20–21.
24. See *GD*, chap. 16.
25. Karl Rahner, *The Trinity*, trans. Joseph Donceel (1967; repr., London: Burns and Oats, 2001), 22.
26. John Zizioulas, *Being as Communion: Studies in Personhood and the Church* (Crestwood, NY: St. Vladimir's Seminary Press, 1985), 17.
27. *MC* 41.
28. *MC* 41–42.
29. Peter van Inwagen, *God, Knowledge and Mystery* (Ithaca, NY: Cornell University Press, 1995), 220.
30. *MC* 175.
31. *MC* 175.
32. *MC* 175.

33. Nonna Verna Harrison, "Perichoresis in the Greek Fathers," *St. Vladimir's Theological Quarterly* 35, no. 1 (January 1991): 54; see also Gregory of Nazianzus, *Epistles*, 101.

34. Paul S. Fiddes, *Participating in God: A Pastoral Doctrine of the Trinity* (London: Darton, Longman & Todd, 2000), 73.

35. Will Vaus, *Mere Theology: A Guide to the Thought of C. S. Lewis* (Downers Grove, IL: InterVarsity Press, 2004), 16; Adam Barkman, *C. S. Lewis and Philosophy as a Way of Life* (Allentown, PA: Zossima Press, 2009), 196n175.

36. See Fiddes, *Participating in God*; Rahner, *The Trinity*; Baxter Kruger, *The Great Dance* (Jackson, MS: Perichoresis Press, 2011).

37. Aquinas, *Summa Theologiæ*, 1a.13.

38. "Membership," *WG* 164.

39. *DI* 55.

40. *SIL* 96.

41. *PER* 214.

42. *PER* 215.

43. *PER* 216.

44. Jaime Vidal, "The Ubiquitous Center in Bonaventure and Lewis with Application to The Great Dance on Perelandra," *CSL: The Bulletin of the New York C. S. Lewis Society* 6, no. 5 (March 1975): 1–4.

45. *PER* 216–217.

46. *PER* 217.

47. *PER* 218–219.

48. *AT* 142.

49. *PER* 216.

50. *MC* 47–48.

51. *MC* 48.

52. Alvin Plantinga, *God, Freedom, and Evil* (New York: Torchbooks, 1974), 29.

53. "The Trouble with 'X' . . . " *GID* 163.

Chapter 8

1. David Hume, "Evil Makes Belief in God Unreasonable," excerpt from *Dialogues Concerning Natural Religion* (1776), parts X and XI, in Michael L. Peterson, ed., *The Problem of Evil: Selected Readings*, 2nd ed. (Notre Dame, IN: University of Notre Dame Press, 2017), 64.

2. J. L. Mackie, "Evil and Omnipotence" (1955), in Peterson, *The Problem of Evil*, 82.

3. *PP* 17.

4. *PP* 17.

5. Alvin Plantinga, *The Nature of Necessity* (1974; repr., Oxford: Clarendon Press, 2006), 165–195; *God, Freedom, and Evil* (New York: Torchbooks, 1974).

6. William L. Rowe, "The Problem of Evil and Some Varieties of Atheism," *American Philosophical Quarterly* 16, no. 4 (October 1979): 335–341.

7. *PP* 17; cf. Aquinas, *Summa Theologiæ*, 1a.25.4.
8. *PP* 19.
9. *PP* 20.
10. *PP* 23.
11. *PP* 64.
12. J. L. Mackie, "Evil and Omnipotence" (1955), in Peterson, *The Problem of Evil*, 90–91.
13. Plantinga, *God, Freedom, and Evil*, 33–44.
14. *PP* 29.
15. *PP* 31.
16. *PP* 32.
17. *PP* 33.
18. *PP* 40.
19. *PP* 43.
20. *PP* 47.
21. *PP* 47.
22. *PP* 48.
23. *PP* 71.
24. *PP* 77.
25. *PP* 95.
26. *PP* 72.
27. *PP* 92, 94.
28. *PP* 95.
29. *PP* 96.
30. *PP* 94, 120.
31. *PP* 99–101.
32. John Hick, *Evil and the God of Love*, rev. ed. (San Francisco: Harper & Row, 1966).
33. *PP* 77.
34. *PP* 80–81.
35. *PP* 47.
36. *PP* 98–99.
37. *PP* 89.
38. *PP* 45.
39. Aquinas, *Summa Theologiæ*, 1a2æ.28.1.
40. *MC* 202.
41. *GO* 5.
42. Nevill Coghill, "The Approach to English," in *Light on C. S. Lewis*, ed. Jocelyn Gibb (New York: Harcourt, Brace & World, 1965), 51–66.
43. *GO* 37.
44. *GO* 8.
45. Nicholas Wolterstorff, *Lament for a Son* (Grand Rapids, MI: William B. Eerdmans, 1987), 33.
46. *GO* 3–4.
47. *GO* 21.
48. *GO* 22.

49. John Beversluis, *C. S. Lewis and the Search for Rational Religion*, rev. and updated ed. (New York: Prometheus Books, 2007), 284.
50. *GO* 24.
51. Beversluis, *C. S. Lewis and the Search for Rational Religion*, 284.
52. *GO* 28.
53. *GO* 29.
54. *GO* 51.
55. Beversluis, *C. S. Lewis and the Search for Rational Religion*, 284.
56. *GO* 25, 28.
57. *GO* 51.
58. Michael Ward, "On Suffering," in *The Cambridge Companion to C. S. Lewis* (Cambridge: Cambridge University Press, 2010), 207, Kindle.
59. *GO* 51–52.
60. *GO* 52.
61. *GO* 39.
62. *FL* 121.
63. *GO* 60.
64. Lewis in William Griffin, *Clive Staples Lewis: A Dramatic Life* (San Francisco: Harper & Row Griffin 1986), 441.
65. *GO* 24.
66. *GO* 25.
67. *GO* 28.
68. *GO* 29.
69. Appendix B, Letter 5.
70. Appendix B, Letter 4.

Chapter 9

1. Richard Olson, *Science Deified and Science Defied: The Historical Significance of Science in Western Culture*, 2 vols. (Berkeley: University of California Press, 1982–1990).
2. *SBJ* 161.
3. Leo Baker, "Near the Beginning," in *Remembering C. S. Lewis: Recollections of Those Who Knew Him*, ed. James T. Como (San Francisco: Ignatius Press, 2005), 66.
4. David C. Downing, *The Most Reluctant Convert* (Downers Grove, IL: InterVarsity Press, 2002), 49–50.
5. Letter to Arthur Greeves, October 12, 1916 (*CLI* 230).
6. Peter Williams, *Lewis vs the New Atheists* (Milton Keynes, UK: Paternoster, 2013), 9, Kindle.
7. *SBJ* 200; cf. *AMR* 281–286.
8. *M* 274n1; "Myth Became Fact," *GID* 54–60; "Is Theology Poetry?" *WG* 130.
9. *SBJ* 73.
10. Francisco Diego, interviewed in *Stephen Hawking's Universe: The Big Bang* (New York: Educational Broadcasting, 1997), DVD.

11. *DI* 18.
12. "Religion and Science," *GID* 69–70.
13. "Religion and Science," *GID* 69–70.
14. *DI* 22; cf. "Religion and Science," *GID* 66–70.
15. *DI* 17.
16. *SBJ* 236.
17. *PR* 63.
18. Letter to Arthur Greeves, October 12, 1916 (*CLI* 231).
19. Daniel Dennett, *Breaking the Spell: Religion as a Natural Phenomenon* (New York: Penguin Books, 2007), 114–115, Kindle.
20. *MC* 22.
21. Lewis in Chad Walsh, *C. S. Lewis: Apostle to the Skeptics* (1949; repr., Eugene, OR: Wipf and Stock, 2008), 129.
22. *MC* 23.
23. Owen Gingerich, in *Christian Herald*, December 1978, 34.
24. Richard Dawkins, *The Blind Watchmaker* (1986; repr., New York: W. W. Norton & Co., 2006), 10.
25. "Answers to Questions on Christianity," *GID* 41.
26. Herbert Spencer, "Progress: Its Law and Cause," *Westminster Review* LXVII (1857): 244.
27. Charles Darwin, *The Autobiography of Charles Darwin (1809–1882)*, ed. N. Barlow (London: Collins, 1958), 109.
28. "The Funeral of a Great Myth," *CR* 103.
29. H. G. Wells, *A Short History of the World* (1922; repr., Project Gutenberg, 2011), VI, http://www.gutenberg.org/ebooks/35461.
30. "The Funeral of a Great Myth," *CR* 109–110.
31. "The Weight of Glory," *WG* 32–33; "Is Theology Poetry?" 137; *MC* 27.
32. Francis S. Collins, *The Language of God: A Scientist Presents Evidence for Belief* (New York: Free Press, 2006).
33. "The Funeral of a Great Myth," *CR* 103, 107.
34. "Is Theology Poetry?" *WG* 138.
35. G. B. Fengren and Ronald L. Numbers, "C. S. Lewis on Creation and Evolution: The Acworth Letters, 1944–1960," *American Scientific Affiliation* 49 (1996): 28–34.
36. Appendix B, Letters 1–3.
37. *PP* 68, 73.
38. *PP* 73.
39. "Two Lectures," *GID* 229.
40. *PP* 70.
41. Letter to Dorothy L. Sayers, March 4, 1954 (*CLIII* 435–437).
42. Walsh, *C. S. Lewis: Apostle to the Skeptics*, 129–130.
43. *THS* 70.
44. *VDT* 175.
45. "The Empty Universe," *PCE* 81.
46. "The Empty Universe," *PCE* 81–82.

47. *DI* 215.

48. "The Humanitarian Theory of Punishment," *GID* 333.

49. *AOM* 73.

50. *AOM* 69; see also "*De Descriptione Temporum*," *SLE* 1–14.

51. B. F. Skinner, *Beyond Freedom and Dignity* (New York: Alfred A. Knopf, 1971), 200–201.

52. Ray Kurzweil, *The Singularity Is Near: When Humans Transcend Biology* (New York: Viking Press, 2005), 136.

53. *AOM* 74.

54. Charles Darwin, *The Descent of Man*, 2nd ed. (Chicago: Thompson & Thomas, 1874), 81.

55. Timothy Shanahan, *The Evolution of Darwinism: Selection, Adaptation, and Progress in Evolutionary Biology* (Cambridge: Cambridge University Press, 2004), 288.

Chapter 10

1. John 3:16–18; I Timothy 2:4–6.

2. Joseph Campbell, *The Inner Reaches of Outer Space: Metaphor as Myth and as Religion* (1986; repr., Novato, CA: New World Library, 2012), 27.

3. Letter to Arthur Greeves, October 12, 1916 (*CLI* 231).

4. Letter to Arthur Greeves, June 3, 1918 (*CLI* 379).

5. Letter to Arthur Greeves, December 22, 1929 (*CLI* 850).

6. *SBJ* 266.

7. "Christian Apologetics," *GID* 102.

8. "Christian Apologetics," *GID* 101.

9. "Religion Without Dogma?" *GID* 138.

10. "Religion Without Dogma?" *GID* 138.

11. "Religion Without Dogma?" *GID* 138.

12. "Religion Without Dogma?" *GID* 138.

13. "Christian Apologetics," *GID* 102.

14. Ernst Troeltsch, *The Absoluteness of Christianity and the History of the Religions*, trans. David Reid (1901; repr., Louisville, KY: Westminster John Knox Press, 2005), 25–41.

15. Wolfhart Pannenberg, "Toward a Theology of the History of Religions," *Basic Questions in Theology*, vol. 2 (Louisville, KY: Westminster Press), 65–118.

16. *MC* 64.

17. Linda Zagzebski, "Religious Luck," *Faith and Philosophy* 11, no. 3 (July 1994): 397–413.

18. Thomas Talbott, *The Inescapable Love of God*, 2nd ed. (Eugene, OR: Cascade Books, 2014).

19. John Hick, *An Interpretation of Religion* (New Haven, CT: Yale University Press, 1989), 240.

20. Michael Peterson, William Hasker, Bruce Reichenbach, and David Basinger, *Reason and Religious Belief: An Introduction to Philosophy of Religion*, 5th ed. (New York: Oxford University Press, 2013), 323–324.

21. Karl Rahner, *The Trinity*, trans. Joseph Donceel (1967; repr., London: Burns and Oats, 2001), 283.
22. *LB* 104.
23. *LB* 105.
24. *LB* 156–157.
25. *LB* 126.
26. *PP* 120.
27. *PP* 121.
28. *LB* 156.
29. James Sennett, "Worthy of a Better God: Religious Diversity and Salvation in *The Chronicles of Narnia*," in *The Chronicles of Narnia and Philosophy*, ed. Gregory Bassham and Jerry L. Walls (Chicago: Open Court, 2005), 233, Kindle.
30. Sennett, "Worthy of a Better God," 233.
31. "Christian Apologetics," *GID* 102.
32. *MC* 64.
33. *MC* 209.
34. John Wesley, "On Living Without God" (1790), in *The Works of John Wesley*, vol. 4, *Sermons*, ed. Albert C. Outler (Nashville, TN: Abingdon Press Wesley, 1987), 15.
35. Matthew 7:23; 25:24–46.
36. Letter to Mrs. Johnson, November 8, 1952 (*CLIII* 245).
37. *VDT* 208–209.
38. *MC* 154.
39. Kathryn Lindskoog, *C. S. Lewis: Mere Christian*, 4th ed. (Chicago: Cornerstone Press, 1997), 88.
40. *THS* 229–230.

Chapter 11

1. Letter to Sister Penelope CSMV, February 15, 1954 (*CLIII* 428).
2. C. S. Lewis, unfinished manuscript on prayer (Wheaton, IL: Marion E. Wade Center, Wheaton College, n/d).
3. "Answers to Questions on Christianity," *GID* 36–53; *ROP* 5.
4. *LTM* 11, 18.
5. Joseph P. Cassidy, "On Discernment," in *The Cambridge Companion to C. S. Lewis*, ed. Robert MacSwain and Michael Ward (Cambridge: Cambridge University Press, 2010), 132–133, Kindle.
6. *LTM* 20–21.
7. *LTM* 114.
8. *LTM* 115.
9. *LTM* 82.
10. *LTM* 23.
11. *LTM* 22.
12. *LTM* 90.

13. *LTM* 95.
14. *LTM* 97.
15. *LTM* 12.
16. *LTM* 82.
17. "Work and Prayer," *GID* 104.
18. "Work and Prayer," *GID* 104.
19. "Work and Prayer," *GID* 105.
20. "Work and Prayer," *GID* 106.
21. "Work and Prayer," *GID* 106.
22. "Work and Prayer," *GID* 106.
23. "Work and Prayer," *GID* 106.
24. Eleonore Stump, "Petitionary Prayer," *American Philosophical Quarterly* 16, no. 2 (April 1979): 81–91; Aquinas, *Summa Theologiæ*, 2a2æ.83.2.
25. Stump, "Petitionary Prayer," 90.
26. *LTM* 36.
27. "Petitionary Prayer," *CR* 175–186.
28. Matthew 21:21.
29. Letter to Don Giovanni Calabria, January 14, 1953 (*LDGC* 79).
30. Letter to Don Giovanni Calabria, March 17, 1953 (*LDGC* 83).
31. "Petitionary Prayer," *CR* 179.
32. "Petitionary Prayer," *CR* 185.
33. "Petitionary Prayer," *CR* 185.
34. "Petitionary Prayer," *CR* 185.
35. Marjorie Lamp Mead, "Letters to Malcolm with Marjorie Lamp Mead," C. S. Lewis Institute, Falls Church, VA, April 29–30, 2011, http://www.cslewisinstitute.org/Letters_to_Malcolm.
36. "The Efficacy of Prayer," *WLN* 3–4.
37. "The Efficacy of Prayer," *WLN* 4.
38. "The Efficacy of Prayer," *WLN* 4; see also *LTM* 48.
39. "The Efficacy of Prayer," *WLN* 5.
40. "The Efficacy of Prayer," *WLN* 5.
41. "The Efficacy of Prayer," *WLN* 5.
42. Francis Galton, "Statistical Inquiries into the Efficacy of Prayer," *Fortnightly Review* 12 (1872): 125–135, repr. in *International Journal of Epidemiology* 41, no. 4 (August 2012): 923–928; Herbert Benson, Jeffery A. Dusek, Jane B. Sherwood, Richard Friedman, Patricia Myers, Charles F. Bethea, Sidney Levitsky, Peter C. Hill, Manoj K. Jain, Stephen L. Kopecky, Paul S. Mueller, Peter Lam, Herbert Benson, and Patricia L. Hibberd, "Study of the Therapeutic Effects of Intercessory Prayer (STEP) in Cardiac Bypass Patients," *American Heart Journal* 151, no. 4 (April 2006): 934–942.
43. "The Efficacy of Prayer," *WLN* 6.
44. Richard P. Sloan, *Blind Faith: The Unholy Alliance of Religion and Medicine* (New York: St. Martin's Griffin, 2006), 241–242.
45. "The Efficacy of Prayer," *WLN* 8.
46. "The Efficacy of Prayer," *WLN* 8.

47. "The Efficacy of Prayer," *WLN* 7.
48. *GO* 23.
49. *LTM* 48.
50. *LTM* 48.
51. *LTM* 109.
52. Boethius, *Consolation of Philosophy*, 5.6.
53. *M* 274.
54. *MC* 170.
55. See *MC* 166–171 and *M* app. B.
56. Luis de Molina, *On Divine Foreknowledge Part VI of the Concordia*, trans. Alfred J. Freddoso (Ithaca, NY: Cornell University Press, 1988); also Nolan Whitaker, "What Would Aslan Do? A Molinist Approach to C. S. Lewis," Nolan Whitaker (blog), May 17, 2015. https://nolanwhitaker.wordpress.com/2015/05/17/what-would-aslan-do-a-molinist-approach-to-c-s-lewis/
57. *PP* 101ff.
58. *MN* 158.
59. William Hasker, *God, Time, and Knowledge* (Ithaca, NY: Cornell University Press, 1989), 155–156.
60. Cassidy, "On Discernment," 138.
61. Michael Peterson, William Hasker, Bruce Reichenbach, and David Basinger, *Reason and Religious Belief: An Introduction to Philosophy of Religion*, 5th ed. (New York: Oxford University Press, 2013), 149–152.
62. Nicholas Wolterstorff, "God Is Everlasting," in *Philosophy of Religion: Selected Readings*, 5th ed., ed. Michael Peterson, William Hasker, Bruce Reichenbach, and David Basinger (New York: Oxford University Press, 2014), 259–265.
63. *MC* 171.

Chapter 12

1. Joseph Pearce, *C. S. Lewis and the Catholic Church* (San Francisco: Ignatius Press, 2003), 101–114.
2. *GD* 1, 13.
3. David G. Clark, *C. S. Lewis Goes to Heaven: Reader's Guide to The Great Divorce* (Hamden, CT: Winged Lion Press, 2012), Part II, Kindle.
4. *GD* 20.
5. *GD* 23–25.
6. *GD* 66.
7. *GD* 68.
8. "The Trouble with 'X' . . ." *GID* 165.
9. "Religion and Science," *GID* 69–70.
10. *GD* preface.
11. Plato, *Republic*, 391c–395d, 396a.
12. *GD* 70.

13. *GD* 71.
14. *PPL* 93.
15. *PPL* 93.
16. *PPL* 93.
17. *GD* preface.
18. *GD* preface.
19. Matthew 10:39.
20. *M* 263–265.
21. *GD* 70–71.
22. *GD* 70–71.
23. *LB* 140.
24. *PER* 81.
25. *SL* 44.
26. *PPL* 99–100.
27. *LWW* 28–29.
28. *LWW* 71.
29. *GD* 99.
30. *GD* 100.
31. *GD* 114.
32. *MC* 226.
33. *MC* 132.
34. Clark, *C. S. Lewis Goes to Heaven*, chap. 2.
35. *MC* 74.
36. *SL* 39.
37. "A Slip of the Tongue," *WG* 191.
38. *GD* 126.
39. *GD* 129.
40. *MC* 212.
41. *GD* preface.
42. *LTM* 108–109.
43. *PP* 153.
44. *MC* 206.
45. *PP* 128–129.
46. *MC* 226–227.
47. *MC* 141.
48. *GD* preface.
49. *GD* 134.
50. *PPL* 100.
51. *GD* 77.
52. *PP* 128.
53. *MN* 105–106; *LB* 102–103.
54. Jonathan L. Kvanvig, *The Problem of Hell* (Oxford: Oxford University Press, 1993), 122.
55. "The Weight of Glory," *WG* 47.

56. *PP* 121.
57. *PP* 131.
58. *GD* 140.
59. *GD* 75.

Epilogue

1. "Rejoinder to Dr Pittenger," *GID* 199.
2. *IOTI* 6.
3. "On Obstinacy in Belief," *WLN* 26.

Index

Printed in the USA
CPSIA information can be obtained
at www.ICGtesting.com
CBHW072136200924
14371CB00001B/5